Digital Imaging for Photographers

Digital Imaging for Photographers

Fourth edition

Adrian Davies and Phil Fennessy

Focal Press

OXFORD AUCKLAND BOSTON JOHANNESBURG MELBOURNE NEW DELHI

Focal Press
An imprint of Butterworth-Heinemann
Linacre House, Jordan Hill, Oxford OX2 8DP
225 Wildwood Avenue, Woburn, MA 01801-2041
A division of Reed Educational and Professional Publishing Ltd

 A member of the Reed Elsevier plc group

First published as *An Introduction to Electronic Imaging for Photographers* 1994
Second edition published as *Electronic Imaging for Photographers* 1996
Reprinted 1998
Third edition 1998
Reprinted 1999
Fourth edition 2001

British Library Cataloguing in Publication Data
Davies, Adrian, 1953–
 Digital imaging for photographers. – 4th ed.
 1. Photography – Digital techniques 2. Images, Photographic
 I. Title II. Fennessy, Phil
 621.3'67

Library of Congress Cataloguing in Publication Data
Davies, Adrian, 1953–
 Digital imaging for photographers/Adrian Davies and Phil Fennessy – 4th ed.
 p. cm
 includes bibliographical references and index.
 ISBN 0-240-51590-0
 1. Images, Photographic. 2. Photography – Digital techniques.
 I. Fennessy, Phil. II. Title.

 TR222. D378
 778.3 – dc21 2001033385

ISBN 0 240 51590 0

Composition by Scribe Design, Gillingham, Kent
Printed and bound in Italy by Printer Trento S.r.l.

Contents

1 Introduction

Digital imaging, electronic imaging – the terms mean different things to different people. To the photographer it might mean filmless cameras, and an end to the processing and printing of film in darkrooms; to the darkroom technician it might mean image enhancement on a computer monitor; to the picture archivist it might mean the storage of images in digital format, whilst to the printer it might mean the scanning of images into desktop publishing programs and outputting straight to printing plate without the need for producing expensive separations etc.

It is really only within the last five years or so that digital imaging has started to become an important and affordable tool to these people. But while digital cameras have had a long and somewhat 'awkward' gestation period, desktop computers (without which none of the other technology could exist) have advanced extremely rapidly, with prices falling, and power increasing dramatically. A commonly used adage in computing is that prices halve every two years whilst power doubles every two years, and at present this shows no sign of slowing down! Another truism, often quoted, is that 'if you already own it, it's out of date!'

For the photographer, whose technology has remained virtually unchanged for more than fifty years, the change has been, and will continue to be, dramatic. To some, very exciting with great potential, to others, a highly stressful period involving a steep learning curve and possibly large capital investment. But there is no doubt that digital imaging is here to stay, and whilst film will continue to be used for a considerable time yet (the introduction of APS – the Advanced Photographic System, in late 1995 by a consortium of the world's leading photographic suppliers, has been successful in revitalizing the amateur photographic market with a new film system), no photographer can afford to ignore and at least understand the potential of digital imaging.

The digital imaging chain can be compared with the traditional silver-based photographic chain. With a film-based system, the image is exposed in the camera, processed, then printed. With electronic imaging a similar chain can be seen, with image capture, image processing and image output.

Figure 1.1 illustrates some of the elements of digital imaging, from image capture, either by digital camera or by the scanning of 'silver-based' images, to image processing by computer, image storage and finally output by a number

of different methods. Many photographers may only be involved in just one part of the chain (capture or processing, for example) but should still be aware of all parts of the cycle to ensure best possible results. The traditional skills of the photographer, lighting, composition, dealing with models, are all still essential. But digital imaging also opens up a host of new possibilities for photographers. Portfolios can now be stored on CD-ROM, duplicated, and sent to agencies all round the world, photographers can now market their services on the Internet, and distribute their images electronically. Also, image-processing programs offer the creative photographer enormous scope for new types of imagery to offer their clients.

THE IMAGING CHAIN

Figure 1.1 The imaging chain. Digital images can be obtained from both analogue and digital sources. Analogue video images can be digitized using frame-grabbers, whilst silver-based photographs can be scanned with a variety of scanning devices. Increasingly, digital cameras are being used, producing 'photographic quality' images. The modern desktop computer is very much the hub of the imaging chain, and a good working knowledge of the hardware and software is essential for photographers using digital technology. Generally, digital images are large, and require a large amount of storage space. Again, a working knowledge of the various media and file formats for storing images is important. The computer can perform a large number of operations on images from simple enhancement to radical manipulation of the image. The quality of the final output, be it print or monitor display is paramount, and a good knowledge of the various print options and methods of achieving consistent results is again very important if the best quality is to be obtained.

But there are problems too. Photographers increasingly need to know about areas such as pre-press and desktop publishing, things which in the past have been the domain of graphic designers and reprography houses. Achieving acceptable colour, consistently, from camera or film, to computer to the final printed page is still some way off, as is the production of inexpensive large runs of colour prints. By the same token, it is likely that many designers and others employed in the graphic arts industry will start to capture their own images with digital cameras, and manipulate and enhance them digitally.

Manipulation of images, whilst always possible photographically, is now much easier. Whilst this will lead to the generation of creative images for advertising, for example, it will also be abused by some newspapers, who already construct images on computers. The question of whether digitally manipulated images are admissible in photographic competitions or not is being actively debated around the world. Organizers of wildlife photography competitions, for example, are having to come to terms with the fact that whilst they may have a ruling banning digitally manipulated images, if these are done to a high enough standard then no one will ever know! Also, many picture libraries may see their markets eroded with the advent of 'royalty free' images distributed on CD-ROM.

But it is not only professional photographers who are using digital imaging. Over the last couple of years there has been a huge growth in the number of digital cameras available for 'consumers', costing from around £1000 down to less than £200. Whilst the quality from these cameras is inferior to film, it is adequate for many people, enabling them to send images via e-mail, or put into Web sites on the Internet. The huge improvements in the quality of inexpensive ink jet printers means that the traditional high street photo-lab now has competition, and will need to evolve to match it. Already, systems like Kodak's Image Magic and Ilford's Printasia enable people to take prints into high street mini-labs, get them scanned, retouched and printed very quickly, for example. Many companies now offer services for printing images from digital cameras.

It is estimated that during 1999, 97 billion photographs were taken, world-wide, of which 7 billion were shot on digital cameras. The market in the United Kingdom has grown from virtually nothing in 1993 to about £80 million in 1997. During 1997, approximately 80 000 digital cameras were sold, mostly at the low end of the market, and it is estimated that by the year 2001, sales will reach 200 000 units, and account for around £160 million.

A frequently asked question is 'when do we jump in?' When is the right time to make the investment in digital imaging? Of course, there is no simple answer. With the rapid development of digital cameras, desktop computers, software and printers, machines can be become 'obsolete' (though not useless!) within months of their purchase. One way to answer the question is to say that the investment is justifiable when clients start demanding digital services. Another is to look at one's overheads, and see if digital technology can reduce them. A typical

catalogue photographer, for example, may spend £40 000–50 000 per year on film and processing. If this can be replaced with a digital camera and computer then the cost is justified, *pro ided that the quality is good enough!* The customer, of course, will also save on the cost of scanning.

Many photographers are adding new services for clients, such as retouching and manipulation, or brochure design. The first newspaper in the United Kingdom to go totally digital was the *Birmingham Post and Mail*, who announced in January 1998 that they would be using digital cameras, laptop computers and modems to send their images back to the picture desk. They estimate that they would save around £40 000 in film and processing costs during 1998. Major sporting events in the year 2000 – the European Football Championships, and the Olympic Games – were recorded digitally.

For many photographers, the answer may be never – stick with film, and use a specialist facility whenever the need arises.

There are many other downsides to digital imaging as well. Imagine someone finding a stack of CD-ROMs in their attic in a hundred years' time. What will they play them on, because sure enough, CD players in their present form will not exist then (just look at the history of the gramophone record!).

This book is an attempt to explain the new technologies of digital imaging to people without a computing or electronics background. It is not our intention to persuade everyone to 'convert' overnight to digital imaging, but instead to show the potential of the technology, to enable the reader to decide for themselves whether they wish to pursue it or not. One thing is certain – no one involved in the photographic or printing industry can afford to ignore it!

2 Digital images – basic terminology

Before looking in detail at how digital images are obtained or processed, it is perhaps necessary at this stage to consider the basic terminology associated with them and describe some of their characteristics.

Analogue to digital

The world in which we live is an analogue environment. Time passes, not as discrete seconds or minutes but as a continuum, without breaks. We divide time into discrete seconds for our own convenience. The same goes for sound – if the sound of someone's voice is conveyed via a microphone onto an oscilloscope screen the signal is seen as a continuous wave. But modern computers can only recognize digital data (discrete numbers), and the fundamental job of digital cameras and scanners is to convert analogue images into digital values. In some ways, it could be said that photographic images are digital too, in that silver halide crystals are either converted to silver or not, but for practical purposes, they can be thought of as analogue, with a continuous range of tones and colours.

In electronic terms, analogue signals are continuously variable over a range of data points, each being represented by a point on a curve (Figure 2.1). Continuously varying quantities such as voltage or frequency represent the image brightness over a given area.

In order to process this analogue data within a digital computer it needs to be converted into a digital form. The analogue signal is 'sampled' to get specific values from particular points on the curve, as shown in Figure 2.2. Whilst this may appear to be a rather crude process, if the sampling is done often enough, then an extremely good representation of the curve can be gained. In the case of audio signals, for example, the sampling rate to convert them into digital data is around 44 000 per second (44.1 kHz).

In digital cameras or scanners, the sampling process is performed by the image sensors or CCD chips. These consist of a large number of individual elements ('picture elements', or 'pixels'), each of which 'samples' or measures the intensity of light reflected or transmitted from an image. Each pixel can be thought of as a light meter, measuring the amount of light falling upon it. (Pixels are the digital equivalent of film grain, but unlike film, where the grains vary in shape

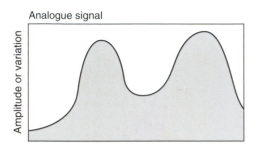

Figure 2.1 Analogue signal – a continuously variable signal.

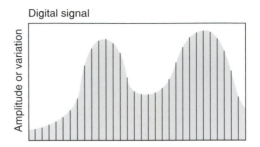

Figure 2.2 Digital signal – the analogue signal has been 'sampled' to produce a series of discrete values.

and size, all pixels within an image are the same size and shape, i.e. square!) Each pixel generates a voltage in proportion to the amount of light received, and a stream of voltage values is generated by the sensor. However, this information is in an analogue format, and must be converted to digital data.

This process is performed by an analogue to digital converter (ADC), which is usually situated between the CCD sensor and the storage device, or memory buffer. In the case of connecting an analogue video camera to a computer, for example, the ADC would consist of a special card ('frame-grabber') which would usually be fitted into an 'expansion slot' inside the computer.

In the case of a system capturing 8-bit monochrome images, for example, any discrete portion of the image would be represented by eight binary digits (Figure 2.2). This would give a possible 256 levels of brightness between black and white in the resulting image – black, white and 254 shades of grey (Adobe Photoshop uses the convention of a value of 0 for black, and 255 for white).

Spatial resolution

Digital images are composed of picture elements or 'pixels', and the resolution or quality of a digital image will be largely, but not totally, dependent upon the total number of pixels which make up the image.

The total number of pixels in an image is derived by multiplying the number of pixels horizontally by the number of pixels vertically in the image sensor. An image composed of 640 × 480 pixels has a total of 307 200 pixels. An image composed of 1024 × 680 has a total of 696 320 pixels, more than twice as many. If the two images are viewed at a small size, then they may well appear to be the same quality, but if they are enlarged, then the one with more pixels will appear to have higher resolution. This is rather like film, where a 20-inch × 16-inch print will, in general, be better from a 5-inch × 4-inch negative rather than 35 mm (see Figure 2.3).

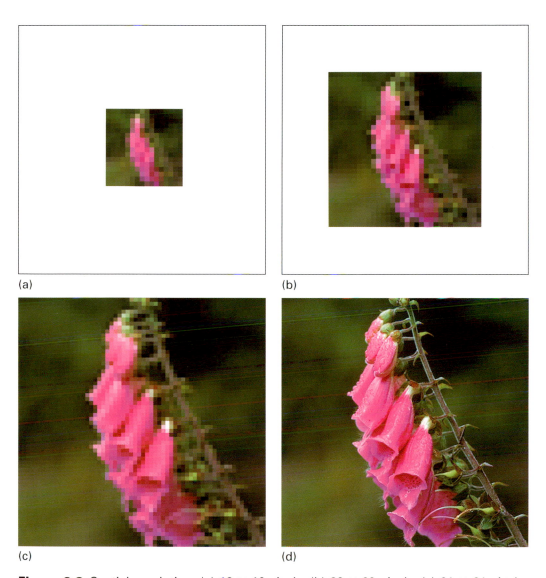

Figure 2.3 Spatial resolution. (a) 16 × 16 pixels, (b) 32 × 32 pixels, (c) 64 × 64 pixels, (d) 950 × 950 pixels.

In the case of a flatbed scanner, if the linear CCD sensor is 8.5 inches wide and contains 2540 elements, then the maximum resolution possible is 2540 divided by 8.5, giving approximately 300 pixels per inch (sometimes referred to as 'samples per inch').

Other terminology

The terminology associated with resolution can be confusing, and many of the terms are often used interchangeably in error, even though they have very specific definitions. More details will be given later about each of them, but a brief overview is given here.

Pixels per inch

This is the resolution of the digital image in pixels. A scanning device may have a resolution of 300 ppi, for example (this may be referred to sometimes as 'samples per inch'). Unfortunately, many people mistakenly use the term dots per inch when referring to scan resolution. Input devices such as scanners produce pixels. Output devices such as ink jet printers produce dots to print their images!

Dots per inch

This is the resolution of the output device, such as a printer or imagesetter. It refers to how many halftone dots can be placed on a page by the printing device.

Lines per inch

This is the scale used to define the screen ruling used by printers when using halftone screens for reproducing continuous-tone photographs in publications. It refers to the number of lines [of dots] per inch used in the screen – typical figures are 85l pi (newspapers) or 133 lpi (this book).

Bit depth

The bit depth of an image is concerned with the number of possible values for each pixel. Digital data is made up of a series of 0s and 1s (or 'on–off' switches – in fact, many switches on electrical devices have the symbols 0 and 1 to indicate off and on). In computing, one bit is the smallest amount of data that can be processed by a computer. A single bit can either be on or off, 0 or 1, or black or white in imaging terms. One-bit images are those composed either of black or white tones (line art). Photographers use special high-contrast line or lith film to achieve this effect.

If 2 bits are allocated to each pixel, four combinations of 0s and 1s are possible, i.e.

00, 01, 11, 10 (black, white and two shades of grey)

Similarly, 3 bits gives eight combinations, 4 bits gives sixteen combinations, 8 bits gives 256 combinations and so on.

In mathematical terms the numbers are derived from a power of two, e.g.

$2^2 = 4$
$2^3 = 8$
$2^8 = 256$

For black and white imaging, 256 grey levels (8 bits) are necessary for the eye to see a continuous range of grey tones without any noticeable banding.

Colour images

When describing colour images the situation becomes slightly more complex. Digital colour images, rather like colour film, are composed (usually) of three primary colours, red, green and blue (they may be converted afterwards to four: cyan, magenta, yellow and black, but for display on a monitor they are three coloured). Eight bits per pixel are required for each of the three colours in order to display a continuous tone, or 'photo-realistic' image, so a single pixel can have a possible 8 bits or 256 values for the red component, 256 values for the green and 256 values for the blue. Therefore, any pixel can have 24 bits associated with it: $256 \times 256 \times 256$ (2^{24}) giving 16 777 216 possible values! A 24-bit colour image therefore requires three times as much storage space as an 8-bit image. Images are often referred to by their bit depth: 1 bit, 8 bit, 24 bit.

For reproduction in books, magazines and the like, four printing plates are required, cyan, magenta, yellow and black. Each of these 'separations' requires 8 bits, so the resulting CMYK image is 32-bit rather than 24-bit, and will be one third larger than its RGB equivalent (see Figure 2.4).

Several digital cameras and scanners offer the facility of capturing images in 10, 12, 14 or even 16 bits per colour. This data will not be used, but allows a wider range of tones, particularly in shadow areas, to be captured. The process is known as 'supersampling'. Some image-processing programs can work with 16 bits per channel data, prior to down-sampling to 8 bits per channel for output.

Digital images may also be displayed in other 'modes' such as duotone, indexed colour or Lab colour. These will be discussed later in Chapter 6.

Bits and bytes

The size of digital images is described by the number of bytes, kilobytes or megabytes that the stored image takes up. An understanding of these terms is also essential for users of digital imaging.

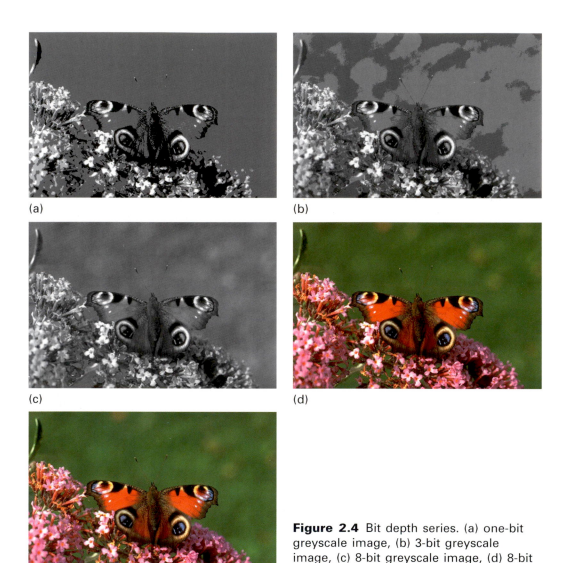

(a)

(b)

(c)

(d)

(e)

Figure 2.4 Bit depth series. (a) one-bit greyscale image, (b) 3-bit greyscale image, (c) 8-bit greyscale image, (d) 8-bit colour image, (e) 24-bit colour image.

Strictly speaking, computers should be called digital computers, because they can manipulate only digital data. In fact, this digital data must be in the form of binary signals, with only two possible values, on or off, pulse or no-pulse, just like an electrical switch. One item of digital data, represented by a 1 or a 0, is called a 'bit' (short for 'binary digit'). It is when several bits are strung together that meaningful instructions can be given. Two bits can give four instructions (i.e. 0 and 1 can be configured in four different ways: 00, 11, 10 and 01). A group

of eight bits or switches gives 256 ($2^8 = 256$) possible combinations of 0s and 1s, and represent single letters, or other characters, for example. This is called a 'byte'. Eight bits is sufficient for all the upper- and lower-case characters and other symbols required on a standard computer keyboard. For example, a lower-case 'a' is represented by the binary code: 01100001. Twenty-four bits give 16.7 million combinations. As we have seen, with digital images, a 1-bit system displays either black or white. With a 2-bit system, black, white and two shades of grey are displayed: 00, 01, 10, 11. With 8-bit images, 2^8 shades are possible, i.e. black, white plus 254 shades of grey. Greyscale images are generally 8-bit (except for some medical images such as X-rays which use 12-bit). In the 1930s experiments were carried out into human perception to see how many shades of grey people could perceive. In a large sample of people, variations from 157 to 315 individual shades were found, the average being 214. The nearest digital equivalent is 256 shades (8-bit).

The following terminology is used when talking about bits and bytes:

8 bits = 1 byte
1024 bytes = 1 kilobyte (Kb)
1024 kilobytes = 1 megabyte (Mb)
1024 megabytes = 1 gigabyte (Gb)
1024 gigabytes = 1 terabyte (Tb)

(Strictly speaking, the prefixes kilo, mega, etc. refer to 1000, but because we are dealing with a binary system, the numbers operate in a doubling fashion: 2, 4, 8, 16, 32, 64, 128, 256, 512, 1024, etc.)

File size

A simple formula can be used to calculate the approximate file size of an image:

Total no. of pixels × (bit depth divided by 8) = total no. of bytes

for example:

Image has 1200 × 800 pixels = 960 000 pixels
960 000 × (24/8) = 2 880 000 bytes (2.8 Mb)

A simple rule of thumb can be used if only an approximate figure is required – multiply the number of pixels by 3, and that will be the size in megabytes. For example, if an image has 1.5 million pixels, without compression it will be approximately 4.5 Mb in size.

The final file size will, however, be determined by the file format used to save it. Many formats have compression capabilities which will reduce the size of the stored file.

Vectors versus bitmaps

Pixel-based images are known as 'bitmapped images' or 'bitmaps'. Each pixel has an address (an 'x' 'y' coordinate) and either a single value describing its density (greyscale) or three values describing the relative amounts of colour describing the pixel. Thus, a pixel having a density value of 125 would be mid-grey, whilst a pixel with values of R255, G255, B0, would be yellow (red + green). To store this image, all the information about each pixel has to be recorded.

Bitmapped images will exhibit 'aliasing' where curved or diagonal lines cross the square grid of the bitmap. This can lead to extraneous colour artefacts in some cases. This problem, and ways to minimize it, are discussed in Chapter 6. Vector-based images are those generated by graphics programs such as Adobe Illustrator or CorelDraw. Mathematical formulae are used to define the character of shapes and lines (for example, a circle can be described by $x^2 + y^2 = z^2$). These will take up far less space than bitmaps but cannot be used for photographic quality images.

3 Image capture

Several methods are available for acquiring images and inputting them into a computer. Conventional silver-based photographs, in the form of negatives, transparencies or prints, can be scanned, using a variety of scanning devices. Digital still cameras which capture images directly in digital form have become commonplace, offering both amateur and professional photographers the opportunity of replacing film and associated chemical processing with instant electronic capture. Still images can also be 'grabbed', either from analogue video cameras or video tape, or by using digital video cameras, which offer the facility of capturing either video sequences or still images.

History

Electronic photography has been in existence since the 1930s, when two rivals, Philo Taylor Farnsworth and Vladimir Kosma Zoworykin, produced imaging tubes known as the Image Dissector and Iconoscope respectively, both based on glass tubes using thermal valve principles. The Iconoscope, produced by Westinghouse, proved the most successful. In the United Kingdom, EMI produced the Emitron camera, based on the Iconoscope design, and this was the camera used by the BBC for its first television transmission from Alexandra Palace on 2 November 1936. Cameras based on imaging tubes were the standard capture method in the television broadcast industry until recent times when the lighter and more robust CCD (Charge-Coupled Device) was perfected. This technology is based on solid-state semiconductor principles.

Although the theory of such devices had been proposed as early as 1948, its use in camera imaging devices did not take place until 1972, when Bell Systems in America built the first viable design. Since then, their increasingly small size, low cost and reliability have led to the introduction of domestic video cameras or 'camcorders'. The tube system is still used in industrial and scientific imaging where the definition and spectral response are of paramount importance.

The first indication that the photographic community received of a digital camera came in August 1981, when Sony announced the Mavica (**Ma**gnetic

Video **Ca**mera – the name 'Mavica' is still used by Sony for some of its cameras, but these are now true digital models). They described this as a 'revolutionary video still camera'. This was, in fact, an analogue device, storing up to 50 images (and sound if required) onto a small 2-inch (50 mm) floppy disk called a Mavipak. It employed a CCD containing 280 000 pixels. To import the images into a computer, they first needed to be digitized through a 'frame-grabber' – an analogue to digital converter. Several similar examples followed, including the Canon Ion.

During the late 1980s and early 1990s several manufacturers demonstrated still video cameras, but it was Kodak, in 1991, who introduced the first true digital camera, the DCS100. Designed primarily for the photojournalist, this camera was a standard Nikon F3 body, with a 2/3-inch 1.5 million pixel CCD sensor in place of the film. Images were stored in a large and heavy Digital Storage Unit, which had to be linked to the camera at the time of exposure, and worn over the shoulder rather like a rucksack! It could store 158 uncompressed images, or 400–600 compressed images. These could be viewed 'in the field' on an LCD monitor, and if necessary captioned and transmitted via a keyboard supplied with the unit. The camera was available in either black and white or colour versions.

Following the introduction of that model, a slow but steady stream of digital cameras appeared. The Kodak DCS 200 had an integral hard disk for storing images, and later models, such as the DC420, had removable PCMCIA disks which could be loaded into computers.

Today, there are several hundred digital cameras on the market, ranging from simple 'toys' such as the Barbie Cam (a digital camera with a Barbie doll!) and Gameboy camera, through to high-end professional models costing many thousands of pounds.

The capture of an image using a digital camera has obvious advantages to the photographer. The image is immediate, requiring no chemical processing, thus removing the cost of film and processing. It can be assessed immediately in the studio or 'in the field' without instant Polaroid film for composition and exposure. The image can be imported directly into a desktop publishing program or into image analysis and image-enhancement programs without requiring any further process. It is also in a format suitable for transmission via networks, phone systems or radio transmission to a remote site.

However, it should be noted that the digital camera is still in its infancy compared with its film counterparts, which have over 150 years of history behind them, and there will surely be many improvements over the next few years. The thorny question of whether they are as good as film depends almost entirely on the intended use of the images, but certainly a large proportion of press images are shot now on digital cameras, as well as increasing numbers of commercial, advertising and medical images.

The imaging sensor

At the heart of all digital cameras is the imaging sensor, a solid-state chip which samples the image projected by the lens, converting it into a stream of electrical signals. Most digital cameras use CCDs, though several other types are available as well.

The manufacture of a CCD chip is a highly complex and difficult task (imagine any other manufacturing process where a 2/3-inch square surface has perhaps 2 million or more individual components, all of which must function!). The exacting precision required means a high failure rate in production (a failure rate of 25 per cent or more of units is not uncommon in some of the larger sensor arrays), and high cost, though standards will undoubtedly improve in the future and costs will fall rapidly.

We have included here a basic technical explanation of their operation, with an analysis of the various types and their characteristics. Like film, it is not necessary to understand fully the chemical processes involved, but a basic knowledge does help to achieve the best results.

The CD-ROM provided includes animated diagrams to enhance the explanation of CCD operation.

Digital capture

The fundamental principle at the heart of the digital camera system is the CCD sensor. These devices rely on the physical conversion of light or photons to an electronic charge, in much the same way as a photographic light meter. The charge is generated by electrons excited from the polysilicon valence band to the silicon dioxide conduction band due to a reaction between the silicon and the impending light. This will be stored as a potential in the silicon substrate layer. The number of electrons created for a given wavelength of light, therefore, will be a linear function of the number of photons per unit time and per unit area. Thus, the charge generated is directly proportional to the amount of light received (Figure 3.1).

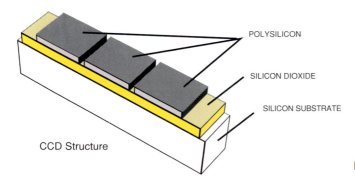

POLYSILICON

SILICON DIOXIDE

SILICON SUBSTRATE

CCD Structure

Figure 3.1 CCD sensor chip.

The CCD is created by using photoetching techniques to create a sensor with thousands or millions of separate elements, or pixels. In general, the greater the number of pixels, the greater the detail in the resulting image.

The current market favours two types of device, the full frame CCD and the interline CCD. They differ in both quality and cost.

Full frame CCD

This is a simpler technology but, due to the purpose-built nature of its design, it is the most expensive type to manufacture. The major advantage with the full frame CCD is the 'fill factor' – the area of the sensor that is given over to capturing charge solutions – nearly 70 per cent (Figures 3.2 and 3.3). The greater the area of active silicon in the sensor the more responsive the device. This relates directly to the film speed setting on the camera – the larger the charge area, the higher the ISO. Large here is a relative term, as each site is between just 6–13 microns in size!

Figure 3.2 Full frame sensor.

Figure 3.3 Full frame showing CC filters and cover glass.

Operation

The sensor is mounted in the film plane of the camera. The camera shutter is used to expose the sensor to light, which is converted into an electric charge. Note the drain channel at the edge of the pixel row. This prevents the sensor

from spilling charge into adjacent rows if a bright area, such as a specular highlight within the image, forms a large charge. When the shutter closes, the CCD is prevented from forming any new charge. The main objective now is to move the generated charge from the surface of the sensor.

Step 1 Recording the image (Figure 3.4)
In this figure the areas show the electrical state of the sensor. The orange areas correspond to the active pixel sites; the green and yellow are barriers to electricity. The camera shutter opens and the light (blue arrows) forms an electrical potential (blue cylinders) at each of the sensor sites. Each site is insulated from the next by two walls. The camera shutter now closes preventing any further charge.

Step 2 Moving the stored charge (Figure 3.5)
With the shutter closed, the charge bias on the insulating walls to the left of the charge is dropped. This has the effect of attracting the charge away from the active pixels.

Step 3 Resetting the system (Figure 3.6)
The charge level on the active pixel is increased, trapping the change in its new position.

Figure 3.4 Recording the image.

Figure 3.5 Moving the stored charge.

Figure 3.6 Resetting the system.

Figure 3.7 Moving the charge again.

Figure 3.8 Reading out the charge.

Step 4 Moving the charge again (Figure 3.7)

The bias to the cells to the left of the change is dropped again and the charge attracted one space to the left. Note the charge on the far left has moved completely off the sensor and into a readout gate that allows the data to be transported elsewhere.

Step 5 Reading out the charge (Figure 3.8)

All the rows of sensors are carrying out the same operation, so the readout gate has a complete column of data. After all columns are read out the active pixels are reset and the shutter can be opened to allow the CCD to capture another image.

Interline CCD

The interline sensor owes its history to the video industry where it was designed to capture 'live' action at 25 frames per second (Figure 3.9). The high volume of production means that significant savings in manufacturing cost can be made, bringing down the price of the sensor.

The only active area of the sensor is the red shutter gate, which means that only 30 per cent of each site records light. The operation of the sensor does not require a shutter. Light falls on the sensor site and forms a charge. The charge on a complete row is then moved across the surface of the sensor. The sites and the adjacent vertical readouts act as full frame shift units. The vertical readout is masked, effectively having a roof over it protecting the charge from the effect of any light forming on the surface of the sensor. In this way an image can be read off the sensor whilst another image is being formed on the sensor site. This ability to operate without the need for a shutter allows the production of a stream of

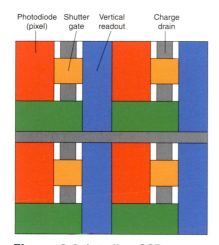

Figure 3.9 Interline CCD.

Figure 3.10 Interline CCD showing CFA filters and lenslets.

images. The main issue with this type of sensor in the photographic field is the fill factor. This is low compared to the full frame CCD, typically just 30 per cent of the area of the sensor. This can be compensated for to a certain extent by the use of a microlens placed over each sensor (Figure 3.10). A process of liquid tension using photo-resist creates these minute lenses. Although this can increase the fill factor, the lens adds complexity to the production process and can cause unwanted optical effects especially wide-angle lenses, where illumination can become uneven across the sensor, sometimes resulting in vignetting.

Interline shift operation
(Figure 3.11)
Step 1 Without a shutter the light forms a charge on the active pixel (red area)
Step 2 The bias is dropped on the adjacent pixel and the charge attracted
Step 3 The active pixel is reset
Step 4 The charge is drawn again to the left, and is protected from light by the cover over the readout area
Step 5 = Step 1 The whole process can be repeated whilst the charge is read out and a new charge formed.

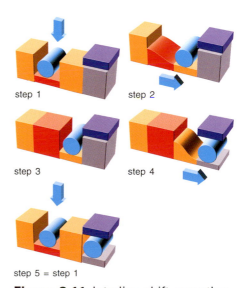

Figure 3.11 Interline shift operation.

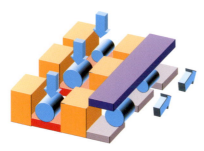

Figure 3.12

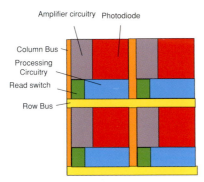

Figure 3.13 CMOS sensor.

Figure 3.14 CMOS showing CFA filters and lenslets.

This process is happening to all the sensors in a row, so a complete image can be read out during the period that another image is being recorded (Figure 3.12).

CMOS (complementary metal oxide semiconductor)

The CCD sensor is not the only design of image sensor to be used in digital cameras. Another type uses different materials in its construction and is known as a CMOS sensor (Figures 3.13 and 3.14). This sensor shares many features with the interline CCD, but includes more processing elements in its construction. The technology is currently used to manufacture approximately 90 per cent of all semiconductors, including most memory devices and microprocessors. It is being adapted to the digital camera industry, and already several digital cameras use CMOS chips rather than CCDs. CMOS sensors are specialized integrated circuits (ICs) that combine photodiode and transistors in each picture element (pixel) to select, amplify and transfer the photodiode charge. They also have much lower power consumption than their CCD counterparts.

This 'all-in-one' combination of sensor-processing circuitry means that image processing can take place on the sensor during capture rather than at a later point. This allows processes such as video encoding, sharpening and noise reduction to be programmed into the circuitry. The sensor also has one major advantage over CCD technology in that, due to the column and row bus construction, the signal from any individual pixel can be accessible. The ability to access an individual pixel is also

enhanced by the fact that the pixel can be 'read' without affecting the charge. With all these advantages CMOS sensors hold great potential as the next generation of imaging sensors. There are, however, certain technical issues to be resolved.

- Poor dynamic range – it is relatively easy to fabricate sensors that record low light levels (around 0.1–1.0 Lux), but most current sensors will overexpose in very bright sunlight.
- Pattern noise – the individual sensors have different responses in generation of charge resulting in a recognizable pattern in the resulting image.
- Inherent noise – the signal-processing circuitry generates noise in the image signal.
- Poor colour – the sensor has a much poorer response across the visible spectrum than the CCD.

Readout methods compared

In terms of reading the signal the three systems offer different opportunities (Figure 3.15). The full frame CCD requires a shutter but the interline can operate without a shutter and can offer the opportunity to feed real-time video signals of the image prior to capture (to an LCD display on the rear of the camera, for example). The CMOS sensor offers both read and capture from the same sensor allowing the opportunity to use the sensor to meter the image prior to capture.

The sensor provides the basic engine that creates the electronic signal from the image. In order to turn this device into a camera, more elements are needed (Figure 3.16).

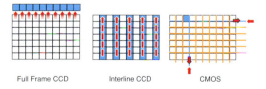

Full Frame CCD Interline CCD CMOS

Figure 3.15 The three readout systems.

Figure 3.16 Increasing the number of elements.

Digital camera system

Analogue to digital converter

The charge from each sensor is an analogue electrical signal, but before the computer can read it, it needs to be converted into a digital form. The device

that performs this operation is called an analogue to digital converter (ADC). The computer can recognize only binary code, and the role of the ADC is to convert a voltage into a binary number. In Figure 3.17, a CCD is capable of producing 1 volt in the brightest part of the image. The system will record this signal using 8 bytes of data. With 8 bits the system will record 256 different levels of brightness from black to white.

Using this system, a voltage of 0.8 volt is converted into level 204, and is represented by the binary series 11001100, thus recording the information using eight binary numbers. This gives the CCD camera a method of recording images with a variety of grey tones.

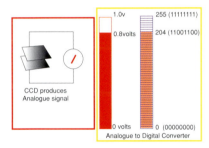

Figure 3.17 Using an ADC.

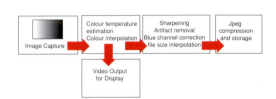

Figure 3.18 Consumer camera image processing.

Image processing

With photographic film, the film itself is both the image recording and the image storage medium. In the digital camera there are separate stages to the same processes, the choice of which can have major implications on the image quality and uses of the camera. The image-processing stage in the system is the one that separates the 'point and shoot' type of compact camera from the professional photographers' tool. This image processing will be linked to the storage medium. The amount of space that an image takes up when stored depends largely on the file format used to save it. The file format type is critical depending on the end use for the image (Figure 3.18).

Typical image processing path for 'point and shoot' compact camera

With consumer types of digital camera, the user has no control over the software processing. The main criterion for the system is to make the files as small as possible due to the nature of the storage medium. Typically, consumer cameras have flashcard storage with capacities of 8–30 megabytes. Given that most digital cameras currently have between 2 and 4 megapixels, each uncompressed file would be around 6–12 megabytes, allowing only two to three images to be stored on a card. Therefore the only option is to compress the images using JPEG or

a similar system. It must be remembered that JPEG is a lossy compression routine, so some data will be lost during the compression process. Because the JPEG is a finished file with the data set, some image-processing decisions have to be made at the time of saving the file – for example, the way in which information regarding colour temperature of the light source is stored.

The light illuminating the subject will have an inherent colour bias depending on its colour temperature. Manufacturers of film supply emulsions balanced for tungsten or daylight sources. Consumer digital cameras use one of two techniques for dealing with colour temperature changes:

1 **White balance setting** On some models the user can photograph a white area of the image, or a white card, and the camera will attempt to remove any bias and remember the correction for subsequent images.
2 **Scene balance algorithm** Using this method, the image is integrated to grey and the colour bias removed. This method relies on the fact that the image is 'average' and contains equal amounts of all colours. Any image with a predominance of one colour will give incorrect results (Figure 3.19).

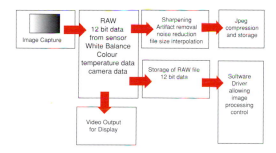

Figure 3.19 Professional camera image process.

Professional camera image path
In the professional camera the critical factor is the storage medium. These cameras can use storage disks of up to 1 Gigabyte in size (e.g. PCMCIA cards or IBM MicroDrives), allowing the user to store the captured data in an unprocessed form (RAW) if necessary and process later. This has several advantages. For example, the colour temperature information for images is usually created by one of three methods:

1 The user creates a white balance in a similar way to the simpler cameras.
2 The user chooses a colour temperate setting from a pre-set selection on the camera – Daylight, Tungsten, Flash, etc.
3 The camera has a built-in colour temperature meter.

The interesting point is that in a RAW file the choice is recorded as a marker and the file remains unprocessed, so if a mistake has been made then it can be

corrected afterwards. This ability to reprocess the data means that under- and over-exposure can be corrected to some extent when the 12-bit data is converted into 8-bit for the computer.

The use of a RAW file format allows users to set all the parameters of the processing to match the needs of any particular workflow. It also allows them to produce images for different workflows, as the 'digital negative' is still available to be reprocessed. There are some circumstances where photographers will need to store images as JPEG files, for transmission for example, and the camera can create both RAW and JPEG for a single file.

Capturing colour

There is a critical difference between film and digital capture in the way the two different systems capture colour. In 1861 James Clerk Maxwell invented a process to produce a colour photograph. He used three separate photographic plates and exposed one through a red filter, one through a green filter, and one through a blue filter. He then projected them in register, and placed the same filter over the image as was used to take it. So, the red image was projected through the red filter, and so on. Using this method he produced a remarkable colour image of a tartan scarf (even though film at that time was not sensitive to red light – it is thought that impurities in the dyes used contributed to the colour effect) filtered through a green and the blue filtered through a blue filter. This basic system is fundamental to all forms of colour reproduction used today.

Film

The modern digital camera has all the controls of its film counterpart – film speed, shutter speeds and apertures etc. – but there are fundamental differences in the response of the two systems.

Film uses three different layers to record the red, green and blue information (Figure 3.20). The green data is stored in a magenta layer, which will transmit any red or blue data through to the layers below, the red data in a cyan layer allowing blue data to pass through to the bottom layer where the blue data is recorded in a yellow layer. Colour negative film produces a negative of the original subject, so a green area of the image will be recorded as a clear area in the magenta layer. To restore the image to its original form the negative is projected onto a photographic paper containing the same three layers (Figure 3.21).

By projecting white light through the negative the original image can be reconstituted. For example, a green area recorded in the negative is clear in the

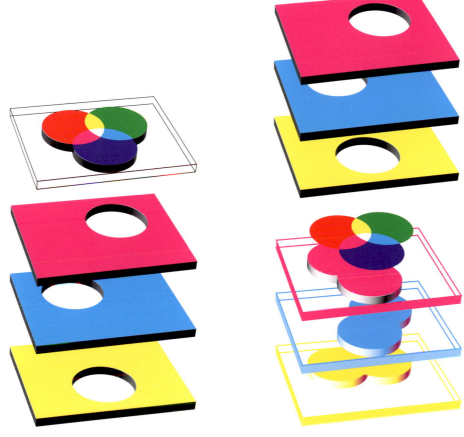

Figure 3.20 The three layers of red, green and blue.

Figure 3.21 Projection of the three layers onto photographic paper.

magenta layer, which means that the white light has to pass through cyan + yellow dye layer = green light. This green light will react with the silver and dyes in the printing paper in the cyan and yellow layers combining to recreate the green in the original image.

Digital camera colour

Because CCD devices are opaque, the option of having three separate layers is not available. Digital camera manufacturers have, over the years, tried several different methods for producing colour, all of which rely on the same red, green and blue separation technique developed by Clerk Maxwell a hundred years ago, but each of which will have different advantages and disadvantages.

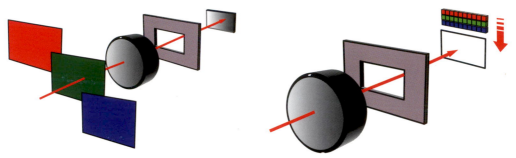

Figure 3.22 The colour wheel filter. **Figure 3.23** Linear array CCD.

The colour filter wheel

This is an attachment to a monochrome camera that will take three images in succession through red, green and blue filters respectively (Figure 3.22). This will have the effect of creating the required red, green and blue channels needed for a colour image. The major drawback is that three exposures are required, meaning that the system can only be used to record still-life objects.

'Scanback' systems

The next alternative is to use a linear sensor with one row for each of red, green and blue pixels (Figure 3.23). This 'linear array' CCD is mounted in the focal plane of the camera, and is driven by a motor system that causes the CCD to scan the projected image. Starting at the top of the image the first row is recorded and the entire row of the CCD sensor moved down by the width of a single CCD and the next row recorded. This process is carried out until the whole image is recorded. This system has two fundamental drawbacks – first, the light source must be continuous, and second, the exposure time can be several minutes' long, limiting its use to still-life subjects.

The three-chip camera

One alternative method is to place three separate CCD sensors inside the camera body, and to split the light into its component parts using a beam splitter or prism assembly (Figure 3.24). The CCDs are filtered with red, green and blue filters respectively. Although this would give very good colour fidelity, the system has two major drawbacks:

- Cost – the CCD is the most expensive part of a digital system, and having three effectively triples the price of the camera.
- Weight – in order to divide the image into three parts the camera would require a beamsplitting prism in the lens assembly which would be fairly heavy.

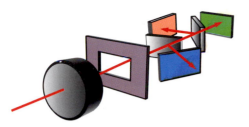

Figure 3.24 Prism assembly.

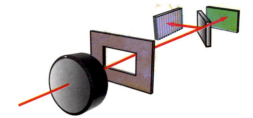

Figure 3.25 Twin CCD camera.

Twin CCD camera

This is a variation on the three-chip camera, and uses two separate CCDs, one recording the green channel in the image and the second recording both the blue and the red information (Figure 3.25). The second CCD has a checkerboard pattern of red and blue filters over the surface of the sensor.

Single CCD

The implications of using a single layer to record colour mean that the most practical method is to pattern the sensor with a layer of dyes to form a matrix of red, green and blue filtered pixels. In its simplest form, the matrix is divided into cells, or clusters of four pixels (Figure 3.26). These subgroups form a 'committee' to decide what colour all four of the cells will be.

The colour filter array (CFA) is made up from two layers of complementary coloured organic dyes (Figure 3.27). So the red dye is composed of magenta and yellow, the blue from cyan and magenta, and the green from cyan and yellow layers.

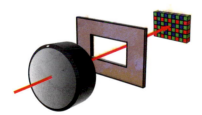

Figure 3.26 Single CCD.

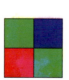

Figure 3.27 Colour filter array.

The array uses blocks, or clusters, of four colours, one red, one blue and two green pixels (this pattern is designed to match the colour sensitivity of the human eye and is often referred to as the Bayer pattern) to decide the colour for all four pixels. The basic operation is as follows (Figure 3.28).

Blue=Blue Green+Red=Yellow Blue+Green=Cyan

Figure 3.28

In the case of an area of blue, only the blue element of the cluster will record light, the group reports no green or red. The result is that all four pixels will be blue. The reverse situation would be a yellow area. Under this condition, the red and green filtered pixels respond, whilst the blue pixel does not. The problem with this type of system is when the frequency of the information is greater than the frequency of the colour filter groups. Under these circumstances an effect called 'aliasing' becomes apparent.

Aliasing

Aliasing is the inability of a digital system to record the structure of an image due to system limitations. The effect is most noticeable in fine detail structure. The key to understanding aliasing is spatial frequency.

Spatial frequency

Spatial frequency is the terminology used for the amount of detail contained within an image. The definitive description is to record pairs of black and white lines or cycles per mm. The highest frequency that the CCD will record is termed the 'Nyquist frequency'. At frequencies higher than the Nyquist frequency, information will be lost. The Nyquist frequency (Nf) is found by the formula:

Nf = $(1/2*p)$ cycles per mm
where p = pixel pitch of the sensor

For example, for a sensor with a pitch of 9 µm:

Nf = $(1/2*9$ µm$)$ = 55.6 line pairs per mm

There are two aliasing issues that need to be discussed: monochrome and colour.

Monochrome

For monochrome images, Figures 3.29–3.31 show the signal at the top and the resulting image being formed on the CCD array. The resulting image formed by the CCD is shown at the bottom. At the Nyquist frequency the sensor will record all the data exactly.

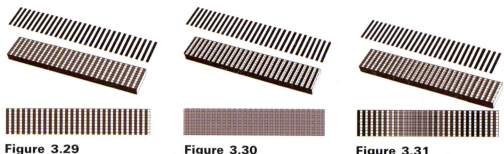

Figure 3.29 **Figure 3.30** **Figure 3.31**

It is, however, interesting to note that even at the Nyquist frequency accurate recording relies on the CCD and the input signal being in register. A half-pixel shift to the signal will result in an image that is recorded as a flat grey.

At higher frequencies than the Nyquist the CCD fails to record the data. The image contains a banding of grey instead of the required pattern of cycles.

Colour

For colour images there are other issues, principally that the Nyquist frequency for the blue and red samples differs from the green samples (Figure 3.32).

CCD colour sampling areas

Using this pattern, the Nyquist frequency of the green plane will match the frequency of the monochrome version of the sensor. However, the blue and red sampling will have a Nyquist frequency of half the Nyquist frequency of the monochrome array (Figure 3.33).

The red and blue arrays have a strong aliasing component due to the sparse nature of their sampling. This will result in the strongest effects of aliasing appearing in the red and blue channels of the image.

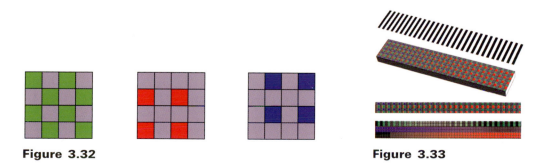

Figure 3.32 **Figure 3.33**

Figure 3.34

Figure 3.35

Aliasing – correction or removal

In Figure 3.34 the result of aliasing manifests itself as 'Christmas tree lights' in fine black and white detail. In the enlarged area in Figure 3.35 there are three areas of interest. The image with no correction shows the typical aliasing problem in area 1 in the text on the sign. Area 2 shows the same effect on a yellow background. Note the colour saturation of the tiles in area 3.

Generally, there are three different methods of correcting the problems caused by chromatic aliasing:

1 Optical correction
2 Software processing
3 CCD dithering

1 Optical correction

This is theoretically the best solution; the process involving the elimination of the problem at source. The solution is to introduce a filter (an 'anti-aliasing filter') into the imaging path that will effectively 'blur' the incoming light in such a way that all frequencies beyond the Nyquist frequency are eliminated from the image. The term 'blur' becomes confused with 'out of focus' in the minds of many users. This process will not affect any data prior to the Nyquist frequency. However, it does require a sharpening process to visually restore the image after capture.

The key to the process is a birefringent optical material such as quartz or lithium niobate. Quartz is the preferred material due to its low cost. However, the larger the CCD, the thicker the quartz required. For a 35 mm sensor the

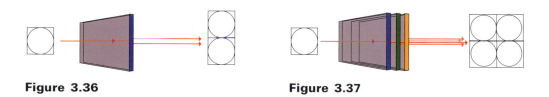

Figure 3.36 **Figure 3.37**

quartz filter would be several millimetres thick so lithium niobate is a better but more expensive solution as the equivalent filter would be much thinner. The filters work by splitting the incoming light into two parallel beams.

By careful arrangement of four pieces of material the image can be split into four parallel beams (Figure 3.36). By arranging the frequency of this filter to match the Nyquist frequency of the CCD any aliasing is removed from the image (Figure 3.37).

The filter can be placed either on the surface of the sensor, or anywhere in the optical path between the CCD and the lens, as shown in the illustration here. Figure 3.38 shows a Kodak DCS 620 camera showing the lithium niobate anti-aliasing filter mounted in front of the shutter.

In Figure 3.39 the filter in place has eliminated the problem from areas 1 and 2 but note the colour saturation has been maintained in the yellow sign, and in area 3 the colour has been maintained in the tiles.

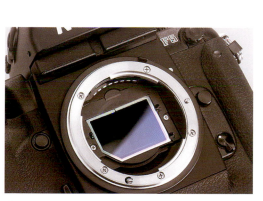

Figure 3.38 **Figure 3.39**

2 Software processing

The alternative to an optical filter is to correct the problem after capture using image-processing software. The commonest method is to separate the luminance

Figure 3.40

(detail) from the chrominance (colour) data. The colour aliasing artefacts will appear as noise in the two colour channels. Applying a blur filter to these channels in turn can reduce the problem.

In Figure 3.40 the result has worked well in the text in area 1. However, the saturation of the red and yellow has been reduced. The issue occurs in the tiles in area 3, where the technique has decided that the red tiles are a problem rather than part of the image.

Dedicated software

There are several software programs dedicated to aliasing issues. Quantum Mechanic, written by Dennis Walker (http://www.camerabits.com/), is designed to let the user tune the effect on the colour channels with a much greater degree of control. Since it applies a single filter rather than two separate operations it allows an instant feedback of the end result and greater control. The latest version of the filter allows for colour detail to be retained solving the issue in area 3 with the tiles. Running the image though Quantum Mechanic Pro results in the image in Figure 3.41.

Figure 3.41 Screen shot of image being processed in Quantum Mechanic software.

Figure 3.42

Applying an adaptive filter that carefully decides which neighbouring pixels to include in each pixel's median calculation allows a large median radius to safely be used to remove large amounts of noise without destroying fine colour detail. In Figure 3.42 areas 1 and 2 can be filtered without detrimental effect on the colour saturation, and area 3 maintains the tile detail.

3 CCD dithering

This process involves moving the sensor rapidly during the exposure to allow the separate recording of red, green and blue for each pixel. Although not a widely adopted system it does provide an interesting solution to the problem.

Digital cameras – basics

Most digital cameras are basically the same as film cameras, with a lens, and shutter and aperture controls admitting a controlled amount of light onto the light-sensitive surface – the CCD chip. They generally consist of three basic elements:

1 A system of exposing the light-sensitive CCD sensor
2 A means of converting the analogue electrical signal into digital format
3 A system of storage within the camera when requiring multiple images
4 A system of sending single images to a computer

Whilst there are many different types of digital camera available, they fall broadly into two categories, depending on the type of CCD employed: either those using 'area array' rectangular CCDs or those using 'linear array' CCDs.

Cameras utilizing area array CCDs

Area array CDs are rectangular (occasionally square) chips containing a grid of picture elements, or pixels. They vary both in size, from around 5 × 5 mm to approx. 6 × 6 cm, and in the number of elements they contain. A 'low-end' camera, costing perhaps £500 or so might have a CCD containing a grid of 640 × 480 pixels (307 200 pixels) whilst a chip from a 'high-end' digital camera costing several thousand pounds might have a grid containing 3062 × 2036 pixels (6 million pixels) or more. An example used in several high-end cameras is the Philips T32 sensor, with 2000 × 3000 pixels. The 'low-end' models tend to be cameras of the '35 mm compact' type, with fixed lenses, non-reflex viewfinder systems, automatic exposure systems (generally with no manual override), built-in flash and facilities for recording data about the images such as date and time. They are generally not designed for professional work, where photographers require control over shutter speed and aperture, or need interchangeable lenses, though an increasing number, such as the Nikon CoolPix 990, do have extra lens sets, and offer manual adjustment of shutter and aperture. Many have excellent macro facilities. Many of these digital cameras have a small LCD display on the rear of the camera, so that the subject is viewed and composed 'live' on the screen. This screen can also be used for viewing images already captured by the camera and stored on disk internally. It is sometimes difficult to view the image well if the camera is used in bright sunlight, or when viewing the screen at an angle.

Angle of view

A major problem associated with area array CCDs is the size of the chip in relation to the focal length of lenses. The 'standard' focal length of lens for a given format is derived from the length of the diagonal. So with a 35 mm image, whose dimensions are 24 × 36 mm, the diagonal is 43 mm, which is usually rounded up to 50 mm, whilst with 6 × 6 cm cameras, the standard lens is usually 75 mm. The dimensions of the 1.5 megapixel chip used in some of the Kodak DCS cameras, for example, are 14 × 9.3 mm (Figure 3.43). This means that the 'standard' focal length for this chip is approximately 24 mm. For sport, and other photographers who routinely use long lenses, this can be of great benefit, meaning that, in effect, their lenses immediately become slightly more than double their focal length, but for those photographers requiring wide-angle lenses, then this becomes more difficult. To get the equivalent of 24 mm on 35 mm film will require a 10 or 12 mm lens, which are not only very expensive but can distort the image as well.

Professional quality cameras of this type operate in exactly the same way as a film camera, allowing full use of a range of shutter speeds and apertures, and the use of conventional lighting such as electronic flash, tungsten or daylight. In many of the models, the sensitivity of the CCD chip can be altered. For example, the CCD in the Kodak DC620 camera has a nominal equivalent rating of 200

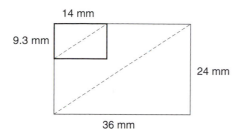

14 mm

9.3 mm

24 mm

36 mm

Figure 3.43 The difference between 35 mm film format and the 1.5 million pixel CCD used in many digital cameras. The standard focal length lens for the 35 mm is 43 mm (usually rounded up to 50) while the standard for the CCD is 17 mm (usually rounded up to 20–24 mm).

ISO, but this can be altered to make it 200, 400 or 800 ISO. Just as increasing film speed generally gives rise to an increase in grain size in film, so increasing the sensitivity of a CCD can increase the amount of 'noise' present in an image. This can be minimized using various filtration techniques in programs such as Photoshop, either by using noise-reduction filters such as the 'median' filter or a specifically written Photoshop 'plug-in', called Quantum Mechanics, marketed by the American company CameraBits, and designed specifically to improve the quality of images from digital cameras. A 'try-out' version of the plug-in can be downloaded from the companies' Web site and used for a limited period.

Most models have one or sometimes two LCD displays on the back of the camera for displaying images and other data such as control menus and the like. The Kodak DCS620 and Nikon D1 can display the image histogram along with the recorded image, allowing the photographer to assess the exposure characteristics of the image in the field.

Several models offer the facility of recording sound captions with an image, particularly useful for press or medical photographers, for example.

Once captured, the images can be downloaded into an image-processing program such as Adobe Photoshop, usually using a small piece of software called a 'plug-in'. This allows users to view the images taken and stored on the disk, preview and alter the colour balance if required on low-resolution versions of the images before downloading the high-resolution versions (Figure 3.44).

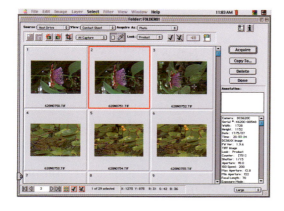

Figure 3.44 The Kodal Acquire Module for its range of SLR-type digital cameras. Note the exposure and other data associated with the selected image.

Multi-shot cameras

Much of the discussion up to now has concentrated on using area array CCDs like film, i.e. with a single exposure. Several models are available, primarily as digital backs for medium- and large-format cameras, where three exposures are made in rapid succession, one for each of the three primary colours, red, green and blue. The three exposures are then combined in the software following the exposures. This obviously limits the use of these cameras to still-life subjects, but superb quality results can be obtained using the method.

New developments in digital camera design.

In May 2000 Kodak announced a radical new way of filtering the CCD sensor. Instead of the now traditional RGB filtering in the Bayer pattern, Kodak introduced a chip filtered instead with cyan, magenta and yellow. The main advantage to this system was an increase in effective sensitivity of the sensor. Primary coloured filters absorb two thirds of incident light, and transmit one third (a red filter absorbs green and blue, and transmits red). On the other hand, complementary coloured filters absorb only one third of incident light, and transmit two thirds (a cyan filter absorbs red, and transmits blue and green light). The sensor was first seen in a new version of the Kodak DC620 camera, the 620X.

Another interesting idea which at least one company Silicon Film (www.imagek.com) is developing is to manufacture a universal insert for 35 mm SLR type cameras, converting them into a digital camera. The device looks like a 35 mm cassette with a metal tongue protruding from the aperture. This tongue sits in the focal plane, and consists of a 1.5 megapixel CMOS sensor. The cassette part can store up to 24 images, and the images can be downloaded in the field into a storage system. The major problem with the idea apparently is that not all 35 mm cameras have the same interior design, and a different model has had to be devised for different cameras.

Cameras utilizing linear array CCDs

Often referred to as 'scan-backs', this system basically places a scanner (see the section on scanners later in the chapter) in the film plane. The scanning device is a single row, or 'linear array', of pixels. This array scans the image projected by the lens to record a series of array rows the depth of the image (or a selected part of it). The main advantage of the system is that the array can be moved at different speeds changing the vertical sampling rate and therefore the resolution of the image. The horizontal resolution can be altered by either sub-sampling the array or by moving the array half or a quarter a sensor site to the

left or right, and sampling the same vertical row twice or four times, thus doubling or quadrupling the resolution. The major drawback is the time taken to move the array – this will result in exposures of several seconds or even minutes. This means that the subject must be perfectly still and the illumination constant. This system lends itself to studio still-life subjects, and many of these scan-backs are manufactured by companies such as Sinar, BetterLight and PhaseOne, to fit the medium- and large-format cameras used by photographers for such work. All the movements of the large-format cameras are available to help the photographer maximize depth of field and control image shape.

Lighting considerations for scan-backs

Many of the systems require continuous, flicker-free lighting which doesn't interfere with the scanning lines. Tungsten filaments flicker due to the heating and cooling of the filament at a rate of 50 Hz (UK mains frequency). Several of the backs recommend either high-frequency fluorescent (usually using 30–50 kHz supplies), HMI light sources, or halogen lights running from a ripple-free DC power source. HMI (hydrargyrum medium arc iodide) lighting uses a metal halide arc to provide a high-intensity, daylight-balanced light source, and is commonly used in the film industry. They are highly efficient – a 500 watt unit will give roughly the same light output as a standard 2000 watt conventional halide source. These are expensive, and add considerably to the cost of setting up a digital studio. Generally, high-frequency fluorescent lighting is not as powerful as HMI, and tends to be bulky due to the 'strip' nature of the fluorescent tubes. Units usually contain six tubes arranged either in a rectangular array within a softbox or bunched together in a cluster. Neither system offers photographers the flexibility of conventional studio lighting. The HMI emits a large amount of infrared radiation, and many manufacturers of digital camera backs supply an infrared absorbing filter (the Tiffen 'Hot Metal' filter) to absorb this (CCDs are inherently sensitive to infrared radiation) (see Figure 3.45).

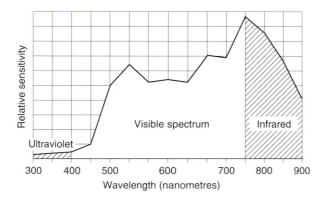

Figure 3.45 Spectral response of typical CCD.

Figure 3.46 Screen shot of control software for Leaf DCB/Catchlight camera, showing tone curve, exposure controls and preview image. (Courtesy: Silicon Imaging Ltd.)

Many of these scanning types of cameras can have effective resolutions of over 40 million pixels, and are currently being used in the UK by photographers shooting still-life shots for mail order catalogues, museums and art galleries, and the like. Generally, the software supplied with them is very powerful, allowing the photographers a great deal of control over the exposure and dynamic range of the image before it is captured in high resolution (Figure 3.46).

Infrared recording

As mentioned above, CCD sensors are inherently sensitive to ultraviolet and infrared radiation. Most chips have glass ultraviolet absorbing filters cemented over them at the time of manufacture, but most are still highly sensitive to infrared. Manufacturers of earlier SLR single-shot types recommend that they were used in conjunction with 'Hot Mirror' filters, to absorb the infrared (many now have anti-aliasing filters built into the camera body, incorporating the Hot Mirror filter). Many camera models, though, are still highly sensitive to infrared, and it is worth experimenting with an infrared transmitting filter (Kodak Wratten 87A, for example). On models with continuous LCD displays, the infrared image will be displayed on the screen.

Simulated false colour infrared images

A technique for simulating false colour infrared images, similar to that given by false colour Ektachrome film, is given in Chapter 6.

Storage of the image

The digital images produced by the camera must be stored if it is to be a portable unit. Several options are available:

1 Storing the images directly on a portable computer. In this case the term portable refers to the portability of the host computer.
2 The signal can be stored within the camera body in an integrated random access memory chip. This type of storage is available in different types. Normal RAM, such as that used in computers, has the disadvantage of losing the stored data if the power supply is removed or interrupted. The solution to this problem is to use Static RAM or erasable programmable random access memory (EPROM) which will retain the information without a power supply. The installation of memory within the camera requires the physical connection of the camera to the computer to retrieve the images.
3 A better solution is to provide a removable storage system that can be read by the computer. Laptop and notebook computers, and most digital cameras have adopted a system of removable storage cards or disks. These cards, sometimes known as 'PC cards' (or PhotoCards), can be regarded as 'digital film', which can be replaced in the camera when they are full. Unlike film however, they can be erased to store new images. There are basically two technologies in use – disk systems, and 'flash memory'.

Disk systems

Several types of removable disks have been devised for use in cameras (indeed the original Sony and Canon Still Video cameras used 2-inch video floppy disks, and the current Sony Mavica uses a standard 3.5-inch floppy disk), but most now conform to a set of standards from the Personal Computer Memory Card International Association (PCMCIA). This small group of companies was formed in 1989 to devise a standard memory system for computers and other digital devices. There are three types of PCMCIA card: I, II and III. Types I and II were introduced in 1990, followed in 1992 by the larger type III in 1992. Most laptop computers have a double PCMCIA card port, which accepts a single type III or two types I or II. Many cards offer functions other than memory, such as modems, or network connection, and Kodak are currently developing a type II modem card which will allow images to be transmitted directly from the camera via a mobile phone, without the use of a computer.

They are all roughly the size of a credit card (54 × 88 mm) though vary in thickness depending on the type, have 68 pins, and those used in digital cameras are available in three types:

- **Type I** Theses are 3.3 mm thick static RAM devices, with no moving parts, which are used for 'ATA Flash Memory' cards with capacities from 4 to 128 Mb.
- **Type II** This classification covers such devices as network connect cards, modems, and other connection units and is not directly applicable to digital camera storage. They are used for ATA/IDE Flash Cards with current capacities from 4 to 128 Mb.
- **Type III** These 10.5 mm thick cards contain miniature hard drives using the same mechanics as the hard drive unit in a desktop computer. Due to their small size they require less power than a desktop unit, and they can record hundreds of images using the batteries within the camera. In terms of storage they can currently store up to 500 Mb of information. Due to the large amount of storage available there is no requirement to compress the image if appropriate. As the disks have moving parts they are quite delicate, and should be treated with care. A relatively new system is the IBM Microdrive, introduced in 1999. This device is much smaller than a conventional PCMCIA card, being the size of a type II CompactFlash card. Currently, the disks are available in two sizes: 170 and 340 Mb, but it is likely that larger capacities will become available.

There are basically two types of PC storage card available: SRAM (static RAM), and Flash Memory. In the SRAM, a small lithium battery is used to retain the data, and work just like a hard disk, where the data changes frequently. In the Flash Memory type, used most often in digital cameras, data is stored and erased as required. Some earlier types didn't allow the space vacated by erased data to be used until the disk was reformatted, but in later 'ATA/IDE' types, small microprocessors solve this problem. Type II format flash memory cards have capacities up to 85 Mb, whilst type III cards can reach 175 Mb.

Obviously, disks with moving parts are more fragile than solid-state cards and they are still too bulky for many of the new compact digital cameras coming onto the market. Several manufacturers have developed Small Format Flash (SFF) cards of various types.

CompactFlash

The Compact Flash system was developed by a group of manufacturers (the Compact Flash Association, formed in 1995), including Apple, Canon, Kodak and Hewlett-Packard. Capacities of the disk currently go from 2 to 64 Mb, but, as with all these technologies, these will surely rise! They are about the same size, though rather thicker than SmartMedia cards. Their main advantage is a 50-pin connector, which can be used in an adapter to enable its use in a 68-pin

PCMCIA slot. Both 3.3 V and 5 V versions are available, the two types being interchangeable. The 3.3 V version tends to use batteries at a lower rate.

SmartMedia

Another system is the Solid State Floppy Disk Card (SSFDC), developed by Toshiba, also known as the SmartMedia card. It is the smallest of the cards, measuring 37 × 45 mm, and there are two types, 5 V and 3.3 V. Whilst some cameras will accept both types, do check which type the camera uses. Because of their simple design they are relatively cheap to produce.

FlashPath

Olympus have designed a device called FlashPath adapter which allows Smart-Media cards to be read in a standard 3.5-inch floppy disk drive. It is powered by small batteries.

Sony Memory Stick

This card was developed by Sony for its range of digital still and video cameras. It is flash-memory system, with capacity currently up to 64 Mb. Adapters are available to enable the use of memory sticks with PCMCIA slots, for example.

All these card systems have the basic job of storing images, being the equivalent of 'digital film'. Currently, there is no universal standard, but, like the VHS/Betamax contest some years ago, it is likely that one of these systems will become standard, and prices will fall. Many external readers are available which plug into the USB port on computers if you do not have a PCMCIA port. For most of the cards, a card reader is available. This is basically a card socket on the end of a cable which plugs into the USB port on a computer.

Camera-to-computer connection

The alternative solution is to physically connect the camera and computer to 'unload the film' or transfer the images to the hard drive of the computer. The modern computer offers two methods of connection to input devices.

The printer or serial port has a single pair of wires with which to connect to external devices. Although, as the name suggests, the information is being sent from the computer, in fact the connection contains a two-way flow of information (when a printer runs out of paper, it must send that information back to the computer). Connection using this port provides a simple method of attaching the camera, but the information transfer will be slow, and a single 1 Mb image can take a minute

to be transferred using this system. It does, however, have the advantage that the computer need not be switched off when connecting the camera. However, the slow speed is less important with cameras capturing relatively small files. The system also has the advantage that all computers are fitted with a serial port.

The second method of connection of devices is via a 'SCSI' board. This system is the most popular as the transfer rate of the image can be much faster – typically a 4.5 Mb image can be downloaded in about 15 seconds. The nature of the SCSI system requires that the computer be switched off when a new device is attached, thus causing a delay on viewing images recorded away from the computer. The SCSI port required is not a standard item on all computers, and will probably require installation in the case of the PC platform.

Kodak has recently introduced a 'wireless' connection using 'IrDA' technology. This is a serial interface standard using infrared radiation for communications instead of a cable, transferring data at a maximum rate of 115 Kilobytes per second. The computer needs an infrared receiver connection in order to utilize the facility.

A relatively new system for connecting peripherals such as digital cameras and scanners is known as FireWire. It uses a single thin cable to carry data at speeds of up to 25 Mb per second – this can be still images, but also digital video and sound. Like SCSI, devices can be 'daisy-chained' (the system having the capacity for up to 63), but has the advantage that the computer does need to be switched off whilst the devices are being plugged in. In order to use the FireWire system, an extra card is required in the computer, with several companies including Radius manufacturing them.

USB (Universal Serial Bus)

This relatively new interface for Macintosh and PCs is a high-speed connection for scanners, cameras, printers and other peripherals. One major advantage is that devices are 'hot swappable', i.e. they can be plugged in or removed without having to restart the computer, which is the case with SCSI.

Scanners

The other main method by which images can be loaded into the computer is through the scanning of photographic materials – transparency, negative or print. Several types of scanner are available, giving a range of resolutions, speed and price. One factor often overlooked is that of scanning speed. Many picture libraries are currently digitizing their collections, and if they have several thousand images to convert, then this will be an extremely time-consuming business on a slow scanner!

Historical perspective

Traditionally, the scanning of images was carried out in reproduction houses by highly skilled operators using drum scanners. These gave superb results, but were extremely expensive devices. Over the last few years, developments in scanner technology have been very rapid, and scanners for film and print have become commonplace in the home and photographic studio. Many scanners are now available which are beginning to rival the quality of drum scanners, though it will still be some time before they are replaced completely.

Drum scanners

The drum scanner is specifically designed to scan film or print materials at extremely high resolution, often in the region of 1800 to 2400 pixels per inch (ppi) and can operate in two ways, scanning either by reflected or transmitted light.

Reflection scanning

For scanning prints, the print is secured with tape to a rotating drum (Figure 3.47). A light source is shone onto the print and a series of three detectors, 'photomultiplier tubes' (PMTs), measure the respective amounts of red, green and blue light reflected by each sample of the print. PMTs consist of an evacuated glass tube containing a light sensor (photocathode). Electrons released from the photocathode are multiplied by a process known as secondary emission. An analogue electrical signal is generated, in proportion to the light received, which is converted by an ADC into a digital signal.

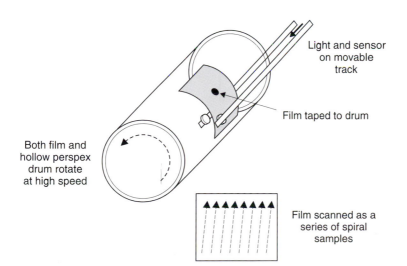

Figure 3.47
Drum scanner.

Light and sensor on movable track

Film taped to drum

Both film and hollow perspex drum rotate at high speed

Film scanned as a series of spiral samples

As the drum rotates, the light source and PMTs are moved across the surface of the print measuring the amount of reflected light. The action is to read the image in a helical path from top-left to bottom-right. The scanner operator can modify the resolution of the image by adjusting the number of samples per rotation and the number of samples across the print. The equipment is equipped to produce the correct level of image sharpening and conversion from the PMT's red, green and blue into the required cyan, magenta, yellow and black format needed for publication.

Transparency scanning

The operation is similar except that the drum is transparent, and the light source is transmitted through the film to the receiving PMT array. The film needs to be coated with an oil to ensure perfect contact with the drum surface (this must obviously be cleaned off carefully following scanning, with the inherent risk of damaging the transparency).

The calibration and operation of traditional drum scanning systems requires highly skilled trained operators to ensure correct colour and tonal reproduction. The major advantage with the majority of drum scanning systems is that they are usually operated within the environment of a publishing establishment, and can therefore be calibrated exactly to the parameters of the printing press on which the image will finally appear. The final file supplied to the user from a drum scanner will be in CMYK format (for producing the four colour separations used in four-colour printing – cyan, magenta, yellow and black) and requires conversion to RGB if any retouching work is required.

The PMT technology used in drum scanner units is generally capable of resolving a much greater 'dynamic range' than the CCDs used in desktop devices (Figure 3.48). This means that the shadow and highlight detail available

Maximum densities of various imaging systems:

1. D max limit of best PMT scanner
2. D max limit of best transparency
3. D max limit of Photo CD scanner
4. D max limit of good desktop scanner
5. D max limit of reflective print and printed page

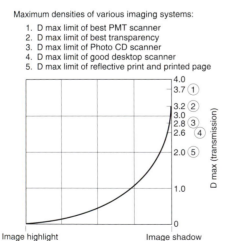

Figure 3.48 Dynamic range of various imaging systems.

in transparency film is maintained in the final image. Another advantage to the system is the ability to mount up to 30 individual film originals on the drum, and, providing that the image is given a geographical identity code, the scanner needs be operated only once to scan all the images, thus reducing the operation timer. The scanner operator will calibrate each scan to the highlight and shadow detail specific to that image. These settings can be saved for future use.

Drum scanners cannot scan negative film as the integral orange mask causes problems when reading the colour information. The system is also slow and difficult to use with small formats of film. However, drum scanners do provide the highest quality of image from medium- and large-format film. Their major drawback is that all critical decisions regarding cropping and placement must be made via communication between the scanner operator and designer.

With the advent of desktop computers capable of handling large images, the need for a method of inputting images directly onto the page led to the development of the desktop scanner. Here there are basically two types, film scanners and flatbed scanners, designed primarily for print, but which can also be converted to scan transparent materials.

Desktop flatbed scanners

The cheapest and most widely available form of scanner technology is the 'flatbed' scanner. Originally designed to digitize line drawings or text for 'optical character recognition' (OCR), these units currently can cost less than a hundred pounds, and can produce remarkably good quality results from a wide range of originals. The flatbed scanner consists of a platen or flat piece of glass onto which the photograph or artwork is placed. There are basically two modes of operation:

- **Line art/monotone mode** This is an image which consists only of black or white, with no grey tones. The record of this image therefore needs only to record the presence of a line or its absence, a binary function. This is the easiest medium to scan as the only parameter which needs to be decided is the threshold (grey tone) level which records as black.
- **Photographic mode** This is the mode used for scanning continuous-tone prints, either greyscale or colour. Do not scan a monochrome print in colour mode as the image will be three times the size that it needs to be!

The flatbed scanner

The scanner has a light source and a recording unit which uses CCD technology (Figure 3.49). This is a 'linear array CCD', a single row of pixels the width of the scanners' operating plate. The larger the number of CCDs, the faster the operation. Monochrome scanners will have a single row of picture elements,

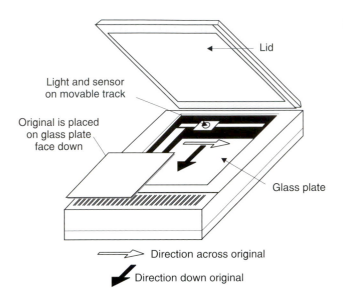

Figure 3.49 Flatbed scanner.

Lid

Light and sensor on movable track

Original is placed on glass plate face down

Glass plate

Direction across original

Direction down original

whilst colour scanners usually have three rows of pixels, filtered to red, green and blue, known as a 'tri-linear array'.

The CCD is mounted on a moving element which transports a light source (usually a single cold cathode white xenon lamp) and the CCD in small steps between each scan. The scanner light reflects off the original as the light moves across it and the CCD detects variations in light reflected from the tones in the original. In operation the scanner starts in the home position at the upper right-hand corner of the scanner glass. Since the original is placed face down, the home position corresponds to the upper left-hand corner of the original. Therefore, from the point of view of the scanner, it scans the first line from left to right across the original or in the case of a row of CCDs each line at a time. It then moves down the original and scans the next line. This process is continued until a complete image of the original is built up when the scanning head returns.

The resolution of the scanner is determined primarily by the number of pixels in the CCD array. If the CCD is 8.5 inches wide, and contains 2540 elements, then the maximum resolution possible is 2540 divided by 8.5 = approximately 300 per inch – usually referred to as 'pixels per inch' (sometimes 'samples per inch').

Many flatbed scanners can be converted into transmission scanners for scanning film originals. Here, light from a light source in the lid of the scanner is transmitted through the negative or transparency onto the CCD. This method of scanning film is best suited to medium- and large-format transparencies. The average sampling rate of a flatbed scanner would be in the range of 75–300

pixels per inch, and although this can give excellent results from a 10-inch × 8-inch piece of film the result from 35 mm film would be poor. The best results from smaller film formats are obtained from purpose-built film scanners.

One problem sometimes found with cheaper flatbeds is uneven lighting across the bed. A relatively simple test can be carried out by scanning a white or grey piece of paper, and checking the resulting image for uneven exposure. A novel technique used by many photographers is to use the flatbed scanner for scanning 3D objects. Items such as jewellery are often scanned to produce images for insurance purposes, but other objects can be placed on the 'bed'. Interesting effects can be obtained if the object has a significant depth. Try to mask off the unwanted area of the bed with black card, and perhaps place a black box over the top of the object to prevent flare. For scientific purposes, items such as electrophoresis gels can be scanned using a flatbed scanner with a transparency option.

Similarly, film scanners can sometimes be used for scanning microscope slides, using the scanner rather like a macro camera.

Flatbed film scanners

An innovation is the introduction of dedicated flatbed film scanners. These units use the same basic principle of the glass platen with a moving scan but provide much higher resolution and dynamic range suitable for the recording of film or printed originals. These units are primarily designed for the print industry, and allow the calibration of highlight and shadow detail, and automatically convert the image into the required size and resolution and CMYK file format for publication. Although expensive compared with a standard flatbed, they are designed to provide a production tool for publishing requirements without the level of scanner operator skill required by a drum scanner unit.

Film scanners

Scanning film rather than prints offers certain advantages. A print, by definition, is a 'second generation', having been through an optical system, and will never hold as much detail as the original negative. Also, many picture libraries store their images in the form of transparencies.

Desktop film scanners

Typically these units will scan only 35 mm or medium-format film (Figure 3.50). The method used to produce an image on a desktop scanner uses one of two methods:

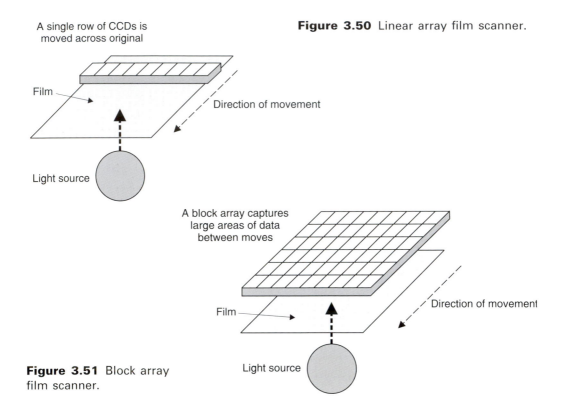

Figure 3.50 Linear array film scanner.

Figure 3.51 Block array film scanner.

- **Linear sensor** In this system a linear array CCD is moved across the surface of the film using stepper motors. The physical resolution is dependent on the number of cells in the array and the accuracy of the motor. The colour information is recorded either by a three-pass system once for each of red, green and blue elements of each pixel or by a filter coating on the CCD surface to record colour in a single pass. Physical resolution is increased by reducing the distance moved by the stepper motors between samples.
- **Block sensor** In the block sensor system three consecutive images are captured using red, green and blue light (Figure 3.51). Although generally more expensive, this system produces much better results and is quicker than the linear sensor method. Physical resolution can be increased by moving the sensor a half pixel distance and combining two sets of the three colour images.

Controlling the scanner

One major problem with many scanners is that there is no universal set of commands for controlling the various operations which tended to restrict the

number of software packages that could be used with scanners. An attempt to solve this led to the development of the 'TWAIN standard' in 1991, by Caere, Aldus, Hewlett-Packard, Logitech and Kodak, all leading scanner software and hardware companies. (Although not intended as an acronym, TWAIN is often thought to refer to 'Technology Without an Interesting Name'!)

TWAIN is a programming protocol for 'image acquisition' devices, usually scanners, though sometimes digital cameras as well. It provides a set of standard functions such as scanning resolution, brightness, contrast and sharpening, and a control panel for controlling the functions of the device (Figure 3.52).

For the very best quality scans, drum scanners are still the best choice, in terms of both resolution and ability to capture a wide range of image brightnesses. They are usually operated by skilled technicians who can produce specific scans for various purposes. Modern desktop flatbed and film scanners now offer photographers themselves the chance to digitize their originals, and, if used carefully, can produce excellent results.

Figure 3.52 Screen dump for TWAIN device.

PhotoCD

Although not strictly a capture device, PhotoCD is a very convenient way for photographers to get high-resolution scans of their images at relatively low cost. PhotoCD is the name given to Kodak's own specific type of compact disc image storage system. It should not be confused with PictureCD, which is aimed at the amateur market, and not designed for professional quality work.

The Photo Imaging Workstation

Kodak PhotoCD disks are created on a Photo Imaging Workstation or PIW. These units represent a substantial investment in equipment and will only be

found in environments such as imaging bureaus and photographic laboratories. The major factor in the cost of such units is the intensive computing power required and the need for very high speed film scanners. These units can be regarded as factories for the production of PhotoCDs and as such require large numbers of images to be scanned and written to disk to justify their expense.

A PhotoCD consists of two components:

1 The disc: A CD type disc playable in Apple Macintosh and IBM PC machines and also viewable on a domestic television using a PhotoCD or CDI player
2 The Image 'Pacs'. On the disc, each image is recorded at five (or six) different resolutions or qualities of picture. The disc will also have an index print showing visually the contents of the disc (see Table 3.1).

Table 3.1 Image pac for a Master PhotoCD

Resolution	Dimensions	Size	Usage
Base/16	128 × 192 pixels	72 k	Thumbnail for database
Base/4	256 × 384 pixels	288 k	Large thumbnail for database
Base	512 × 768 pixels	1.1 Mb	Television quality
4Base	1024 × 1536 pixels	4.5 Mb	HDTV quality
16Base	2048 × 3072 pixels	18 Mb	Publication quality scan

The combination of the 'image pac' on a CD disc is termed PhotoCD.

The Master PhotoCD is made from any type of 35 mm film: transparency or negative, either colour or black and white. Each disc can have a combination of any of the three types of film. The consumer service is offered by the majority of film-developing outlets, and subsequent films can be added to the disc at later dates to a maximum of around 100 images per disc.

Most image-processing programs can open PhotoCD images directly, but Photoshop-compatible plug-ins are available from Kodak to offer more sophisticated control before opening the images (the current version is PhotoCD acquire module version 3, available to download from the Kodak Web site) (see Figures 3.53–3.55). The best way of opening PhotoCD images in Photoshop is to use file>open>PhotoCD>images folder. Select the required image and click open. This will bring up a PhotoCD dialog box. First, select the required resolution for the intended output. Next select the 'source' and 'destination' for the image. The source is the type of original film material used – C41 negative, E6 or Kodachrome type transparency (click on the various profiles to find the one which best describes your image, e.g. pcdekycc is the profile for Universal E6 film). The destination determines how you want to open the image (RGB, Lab mode, etc.). For example, pslabint opens the image in Photoshop Lab mode.

Figure 3.53 Kodak PhotoCD Acquire Module for Photoshop showing various facilities such as sharpening, automatic colour balancing and resolution selection.

Figure 3.54 The PhotoCD source – K14 (Kodachrome).

Figure 3.55 The PhotoCD destination – CIELab.

ProPhotoCD

The launch of PhotoCD was followed by ProPhotoCD. The main difference between the two systems is that the Pro disc can scan larger formats than 35 mm, up to 5 inches × 4 inches. The maximum file size is 72 Mb, having 4096 × 6144 pixels. The information for the 72 Mb file, the 64base image, is held in a special area of the disc known as the Image Pac Extension (IPE). This can be accessed through Kodak's PhotoCD plug-in for Photoshop, currently version 3 (available from Kodak's Web site, and on the enclosed CD). The maximum number of ProPhotoCD images which can be put onto a disc is approximately 30.

The reason behind the differing sizes of image is that the software makes the assumption that the image being scanned has the proportions of 35 mm. Therefore any image not in the 35 mm format is packed with blank pixels. Table 3.2 shows the information content of the unpacked image.

Table 3.2 ProPhotoCD formats

Format	16Base pixels	64Base pixels
35 mm	2035 × 3072	4096 × 6144
6 × 4.5 cm	2035 × 1536	4096 × 3072
6 × 6 cm	2035 × 2048	4096 × 4092
35 mm	2035 × 2390	4096 × 4780
6 × 9 cm	2035 × 3072	4096 × 6144
5 × 4 inches	2035 × 2615	4096 × 5230

Bureaus will charge more than the standard consumer service for the ProPhotoCD but they provide far more in terms of control over the image scan and can, if required, provide a much quicker service. The Pro disc will be produced by a professional bureau and the service offered can be regarded as the difference between having film processed at a high street mini-lab or a professional photographic laboratory.

PhotoCD structure

A CD disc is a 4.75-inch disc of polycarbonate plastic with an ultra-thin layer of gold bonded to the top surface of the disc. A protective surface is then coated onto the gold layer for protection. The PhotoCD is produced by burning a series of pits into a dye layer onto the underside of the gold layer writing from the inside of the disc out toward the edge. This information is then read by a laser diode in the CD drive and converted into image information.

The PhotoCD stores all images in YCC format. The Photo imaging workstation scans the film and produces the top resolution image. This file is duplicated, and the copy examined. Every alternate pixel of information is discarded to produce a file half the height and half the width, therefore one quarter the resolution. This process is repeated four times (for further details see the section on Image compression in Chapter 5). The workstation then holds the five images in its memory. It then records the three lowest (base/16, base/4Base) as normal files. It then interpolates (invents) a 4 times Base (4Base) image from the base resolution and compares it with the real 4Base image. Where the two images' data matches it does nothing, but where the interpolated file is incorrect it saves the information from the real file. It repeats this process with the 16Base image and saves only the differences between the real and invented file (residuals). By this method 24 megabytes of information can be reduced to some 5 megabytes.

YCC colour space

The YCC colour space records information in three channels, one for Luminance (brightness), and two for Chrominance (colour). The principal advantages of this system are:

- It allows high levels of visually lossless compression of the image.
- It provides a system that provides consistent representation of images from negative or positive originals.
- It provides the widest gamut of colour space in which to store colour information.

Physical file structure

On opening a PhotoCD disc the information is divided into two directories. The disc itself will be numbered according to the individual number which is printed on the centre of the disc. The first directory is called CDI and this contains all the relevant information to play the disc on any Philips CDI-compatible system. The second directory is called PhotoCD and within this directory reside several files pertaining to the images:

1 INFO.PCD:1 A file with global information about the disc including its creation date, last update, and serial number.
2 OPTIONS.PCD:1 The type of disc.
3 OVERVIEW.PCD:1 The assembled contact sheet used to print the cover of the disc.
4 STARTUP.PCD; 1 The PhotoCD logo shown at the start of all viewing sessions on a player.
5 A subdirectory: IMAGES containing the image packs for each image.

Photographic control

To obtain best results with the PhotoCD system (and indeed any scanned images), certain photographic requirements are necessary. The first is the exposure of the film. Wherever possible the exposure should be controlled to give a density range of no greater than **2.8** (this applies to any scanning process utilizing CCD technology). Many photographers often underexpose transparency material by half a stop to increase colour saturation. In the case of PhotoCD, aim to give the film the 'correct' exposure. Whilst supersaturated transparencies may look good on an art director's light box they cannot always be reproduced successfully in print! The photographer can control the density range of the emulsion by the use of reflectors, fill-in flash and the like. Where control is not possible it is recommended that colour negative film is used rather than transparency film. Colour negative film normally exposed and processed gives a density range of 2.0 in the highlights, making it an idea film type for the reprographic process.

PhotoCD was originally developed for the consumer market, enabling people to view images on their domestic television sets using special PhotoCD players. Sequences of images could be programmed, and simple manipulations such as zooming and rotating images were possible. They had limited success for this application, having found far more success with professional photographers and other imaging professionals. PhotoCDs can also be played on the CDI players marketed by Philips.

Advanced Photo System

Whilst not strictly a digital imaging system, the APS system launched in 1996 by a consortium of leading camera and film manufacturers uses conventional silver-based film but also records digital data. The format uses 24 mm wide cartridge-loading non-sprocketed film in a specially designed cartridge. After processing, the film is wound back into the cartridge, reducing the risk of damaging the negatives. The system allows for three formats on the same roll of film:

C (Classic) format: 3:2 aspect ratio
H (HDTV) format 16:9 aspect ratio
P (Panoramic) format: 3:1 aspect ratio

A basic concept within the system is to transfer data such as date, exposure, use of flash or daylight and the like to the photofinishing equipment. This is carried out by recording digital data onto a transparent magnetic layer coated onto the back surface of the film base, and 'ix information exchange circuitry'. The system is thus a 'hybrid' one using both analogue photographic and digital technologies. Several film scanners have adapters for holding the special APS cartridge, and automatically scanning the enclosed negatives.

Capturing images from video

Still images can be captured ('grabbed') from video cameras and video tape. Most video cameras are currently analogue devices, recording their signal onto video tape of various formats. To obtain the images, the signal must be passed through a 'frame-grabber', or analogue to digital converter – an extra circuit board which fits into one of the expansion slots inside the computer. Many boards will take a variety of video signals such as composite video and SVHS. Many newspapers 'grab' still images from transmitted television pictures.

Recently, a new generation of digital video cameras has been introduced, recording video sequences onto either Mini DV cassettes or type III PC cards. Being recorded in digital format means that the images can be imported directly into a computer with the right software, usually at a resolution of 640×480 pixels.

Most of the digital camcorders currently on the market have 1/3-inch CCDs with 670 000 pixels. The signal is split into a 'Y' signal – the luminance part of the image, and two 'colour difference' components, known as the R–Y and B–Y channels. The analogue values in these channels are digitized by ADCs built into the camera, and the digital signals are recorded directly onto the recording tape.

Modern digital video cameras employ MPEG compression to allow up to 20 minutes of full-motion video, at a resolution of 352×240 pixels or more, to be recorded on to a 260 Mb PC card, or up to 3000 individual still images (or 1000 images each with a 10-second audio caption) at a resolution of 704×480 pixels, using JPEG compression.

4 Computers for imaging

Most photographers involved with digital imaging use either the IBM PC Compatible type (PC) or the Apple Macintosh computer. Over the last few years there have been great debates about which platform is best, but the situation today is that, to all intents and purposes, both systems will perform the same functions for around the same price, and that the choice becomes one of personal preference.

Traditionally the Apple Macintosh computer has become very popular, almost a cult, with artists, designers and photographers as it is extremely easy to use. It was originally designed so that a small child could operate it without any knowledge of computers at all. More recently, the PC type of computer has also adopted the GUI approach of the Apple with its Windows operating system, and most professional imaging and desktop publishing programs, previously only available for Apple computers, are now available for PCs as well. A significant difference for many photographers are the colour management tools built into the operating systems. Apple uses ColorSync, whilst Windows has ICM. The relative merits of these will be discussed in Chapter 9 on colour management.

Many companies and other institutions, particularly in the UK, are PC based, and it would not make sense to introduce a new computer system into the institution, although Apples and PCs can easily be connected together on networking systems such as Ethernet for the sharing and transfer of files.

Before investing in a system for imaging purposes, photographers need to ask themselves several questions:

- **What type and quality of output will be required?** Whilst it is possible to produce various types of print directly from digital files, many photographers will still need to output onto film for many purposes. If this is to be a high-resolution 10-inch × 8-inch transparency, a specifically designed imaging workstation may the best answer, but these are very expensive. Much controversy exists regarding the size of files required to give sufficient quality for such purposes, and this will be discussed in depth in Chapter 7. Output to 5-inch × 4-inch and smaller film, or thermal print, can be achieved quite easily on a desktop computer, though it will invariably need to be equipped with a large amount of RAM.
- **What software/hardware is available?** Some hardware devices such as scanners or cameras and some programs are specific to a particular computer

platform, though this situation is becoming less of a problem. Does the computer need specific interfaces such as FireWire or SCSI?

- **What other types of work will the computer have to carry out?** Will the machine be required to carry out other work, such as video editing, manage large amounts of information in a database, or perform maths-intensive work in complex spreadsheets? Will the computer be required to run more than one application program at the same time, and swap data between them?
- **How upgradable is the machine?** Is it capable of being upgraded with the latest software, or can it be fitted with extra circuit boards such as frame-grabbers or accelerator cards? How much memory can be fitted? Imaging software generally requires a large amount of RAM, and for high-quality output and efficient working, the machine will need at least 128 Mb. Many photographers now have 1 Gb of RAM fitted to their machines!
- **What is the budget?** This is obviously the major consideration for most people. Over the last couple of years, prices of desktop computers have fallen dramatically, but even so, computers for imaging have special requirements of memory and speed which makes them relatively expensive. Remember to cost all of the extra items required for imaging purposes, such as extra memory, additional storage systems such as removable hard disks, CD writers, USB connectors and the like if these are not included in the basic price of the machine.

In this chapter we will consider some of the basic operations of computers and their application in imaging, and will make some broad generalizations as to the type and size of machine most useful. This is not a computer book, and more detailed descriptions about the various machines will be found elsewhere. We will concentrate on the two commonest platforms as far as general photographers are concerned, the Apple Macintosh and the IBM PC (others such as those based on the Unix operating system are beyond the scope of this book). The speed of development of computers at present means that by the time this book is published, any specific models mentioned would have been superseded, so we have tried to discuss them in general terms. Also, new processing chips and operating systems are constantly being developed which will mean that future computers will be able to perform more complex tasks to larger images at much faster rates.

When buying a computer system it is strongly recommended that you see the machine in action and run the *actual* programs that you will be using on the *actual* monitor you are considering. If possible, take some of your own images with you to the dealer. Very often, different programs run at particular speeds irrespective of the processing chip in the computer. Magazines often publish speed tests in order to compare one computer or piece of software against another. These must be treated with caution as there are very many variables, and often, when one machine performs one type of operation very quickly, it

may not do so with another. It is essential too that the program is installed on the computer correctly, so that the memory allocation is optimized to give the best performance. If you intend using a computer for specific applications, then get your dealer to let you try it out. Try to perform the same set of operations, such as rotating a large image through a specified number of degrees, or apply a certain filter to the same image to compare speeds of operation. As with cars, it is not essential to know how a car works in order to drive it, but an understanding of the basic principles does help to drive it more efficiently and safely. So with computers, most operate more efficiently if set up correctly. Most programs have specific requirements as far as memory allocation goes, and it is important that you at least know how to configure this.

The hardware

This term refers to the actual components of the computer system, which is generally divided into three main areas: the processor ('computer'), the monitor display, and the keyboard and mouse. Many peripheral devices can be connected to computers, either for inputting of data such as digital cameras, scanners, and graphics tablets, or for the outputting of data from the computer to external storage devices, or printers.

The main requirements for any photographic computer imaging system are large amounts of memory (RAM), large amounts of storage space, speed of processing the data, and a good high-resolution monitor display.

The processor

The box often referred to as the computer actually contains the central processing unit (CPU) together with the power supply, disk drives, and sockets (ports) for the various peripheral devices to be connected to it. Some machines, such as the iMac, have the monitor integral with the computer, but it is usually best to have the monitor separate from this box to allow for different-sized monitors to be connected.

Most PCs have Pentium processors, running at various speeds, from 400 to 750 MHz at the time of writing. Current Macintosh's use G3 or G4 processors, again running at a variety of speeds, from around 350 to 500 MHz. Speed by itself is not necessarily a good indication of the 'power' of a computer (even a Ferrari can get stuck in traffic and be limited to 10 mph!). Factors such as the speed of data retrieval from the disk drives and the amount of memory installed will all influence how long certain operations take to perform. As discussed earlier, it is always best to run the applications you intend using with typically sized images, and perform certain 'benchmark' tests on different machines.

Operating systems

The operating system of a computer is basically a series of computer programs which enable other programs to run on the computer. It creates an environment enabling different programs to perform functions such as saving, displaying lists of stored files and deleting. Without an operating system, each program would need to have these functions built-in. The ability to 'cut and paste' items between programs is an integral part of the operating system of the computer, as are the colour management tools ColorSync and ICM. The Windows operating system is actually a 'front end' to Microsoft DOS, making it much more user-friendly. The Macintosh OS, currently OS9, was designed right from the start to be highly intuitive and easy to use.

It is important to take care when transferring files between the two platforms. Macintosh's can 'read' disks and files from PCs automatically. In general, PCs cannot recognize disks formatted for Macs, and can only recognize files if they have the three-letter extension denoting the file type, such as .jpg, .tif or .txt. When used on a Macintosh, Adobe Photoshop has the capability of automatically adding this extension when saving image files (File > Preferences > Saving files > Always add file extension), so that they can be recognized by PCs. It is well worth setting this as a preference in the 'saving' preferences menu, even if you do not foresee putting the files onto a PC. Similarly, it is well worth using PC-formatted disks such as floppies and Zips, as these can be read by both platforms. When writing CDs, write 'hybrid' Mac/PC ISO 9660 format whenever possible.

RAM (random access memory)

Programs and other data such as digital images are stored on disks, such as the internal hard disk of the computer. Before the computer can carry out any functions, the program must be transferred into the computer's memory, the RAM, together with the data required to be viewed or manipulated. RAM is temporary storage – when the computer is switched off, everything stored in RAM is lost. Anything that you wish to keep must therefore be saved either to the hard disk or another form of storage such as a floppy disk.

In general, the larger the effective RAM, the more easily and quickly tasks such as image manipulation can be carried out. Adobe recommend a minimum of 64 Mb of RAM to run Photoshop 5, and 96 Mb if Image Ready is to be run at the same time! As a general rule, an image requires at least three times as much free RAM as it is large (this is because the program maintains a record of the image prior to manipulation to enable that operation to be 'undone'. In some cases it also reserves another block of memory to enable it to carry out

sophisticated operations). Adobe recommend three to five times the amount for some operations! Thus a 4 Mb image (this would be a relatively low quality colour image) needs at least 12 Mb RAM. We would recommend most strongly that for serious imaging purposes, 128 Mb RAM is the absolute minimum required, but preferably a figure higher than this. As new programs become available, the amount of memory they require seems to increase! Many photographers routinely use machines with 256 Mb RAM or more, and this will obviously have a cost implication when budgeting the system, although the price of RAM has fallen dramatically over the last couple of years.

When buying a machine it is essential to check that it has the capability of being upgraded to the amount required. It is a relatively easy job to upgrade (increase) the RAM of the computer yourself by inserting extra memory chips into slots on the main circuit board, though beware – many manufacturers say that doing this yourself will invalidate the guarantee. If you do decide to do it yourself, make sure that you earth yourself to a suitable earthing point with a suitable wrist strap, often provided for the purpose when the RAM is purchased. If you have any doubts at all about doing this, get a qualified technician to do it for you!

Monitors

An often neglected component of the imaging system is the computer monitor. Photographers are used to looking at sharp transparencies or prints with good colour saturation and brightness range. A computer monitor that is even slightly soft will cause eye strain, particularly as you will be sitting quite close to it, often for long periods. Computer monitors use cathode ray tube (CRT) displays. Three electron guns (one for each of the three colours, red, green and blue) scan the screen and fire a stream of electrons at the screen in proportion to the intensity of the signal received from the digital to analogue adapter in the computer. This device compares the digital values sent by the computer to a Look Up Table (LUT) which contains the matching voltage levels needed to create the colour of a single pixel. With a VGA (Variable Graphics Array) monitor for example, 256 values are stored in the adapter's memory. As the electrons strike the phosphors coated on the inside of the screen light is emitted. Three different phosphor materials are used for red, green and blue. If a group of RGB phosphors is struck by equally intense beams of electrons, then the result will be a dot of white light. Various colours are created when the intensity of the beam for a particular colour is different from the others.

Important considerations for imaging are the size of the monitor, the number of colours which can be displayed on a monitor (bit depth), and the sharpness of the image (spatial resolution). When running imaging programs such as

Adobe Photoshop it is assumed that 'photo-realistic' images are required. Photo-realism is a qualitative term which is used to describe how closely a digital image matches the photographic original.

With bit depth, for photo-realistic display, a minimum of 16 bits (32 768 colours) per pixel ('bit depth') is required, and preferably 24 bits (16.7 million colours) to give photographic quality images, although, if the budget is limited, 16-bit displays are almost indistinguishable from 24-bit with most images. (The 'bit depth' of an image refers to the number of grey shades or colours which a monitor can display. An 8-bit system can display 2^8 (256) greys or colours. A 16-bit system can display 2^{16} colours (32 000) whilst a 24-bit system can display 2^{24} colours or 16.7 million.) Strictly, the monitor cannot display this number of colours at one time, but it is the number of colours stored in the LUT. It is really those images with areas of graduating intensity (e.g. graduated backgrounds on still-life pack shots) that the difference between 16-bit and 24-bit becomes important. It is generally reckoned that at least 160 levels for each of the three colour channels is required to show a continuous gradation without a banding effect (i.e. a 24-bit display). The correct combination of computer, monitor and graphics card is required to give this facility, and must be checked when selecting a machine.

Spatial resolution is the number of pixels which can be displayed both vertically and horizontally. With low spatial resolution, edges of objects, particularly curves and diagonal lines, will exhibit a staircasing effect known as 'aliasing' (see Chapter 2). The effect becomes less, the higher the resolution, i.e. the higher the number of pixels per inch.

Monitor resolutions are quoted in pixels (e.g. 800 horizontally \times 600 vertically). A single pixel is created by several adjoining points of light on the display. The fewer the dots of light used to create the pixel, the better the resolution. Most monitors have a resolution of 72 or 75 pixels per inch.

Some typical monitor resolutions

VGA	640 \times 480
SVGA	800 \times 600
XGA	1024 \times 768
SXGA	1280 \times 1024
UXGA	1600 \times 1200

New video cards and improved monitors offer higher resolutions, for example 1024 \times 768 pixels, and even 1800 \times 1440 pixels is now available.

The size of a monitor is quoted in inches, and is measured diagonally from corner to corner. This may be misleading, however, as this figure will probably not be the actual image size and manufacturers seem to use different criteria for measurement! A 19-inch monitor is 11.5 \times 15.25 inches (292 \times 388 mm),

but many only have an image area of 10.75 × 13⅝ inches (273 × 344 mm). It is easy to calculate the usable image area of a screen knowing the vertical and horizontal pixel count and the screen resolution. In the example above:

 19-inch screen (483 mm):
 horizontal pixel resolution of 1024 pixels
 vertical pixel resolution 808
 resolution 75 dots per inch

This gives an image area of 10.75 × 13.63 inches (273 × 344 mm).

Other specifications to examine when choosing a display monitor are the vertical scan rate (or screen refresh rate) and dot pitch.

Vertical scan rate

Television pictures are transmitted as interlaced signals. The electron beam first scans the screen once, to give half of the picture or field, then does so again, with the second scan interlacing with the first to give a complete picture or frame. This is known as the vertical scan rate. In the UK, the PAL system of television is used, working at 50 Hz – the screen is 'redrawn' 50 times per second. However, with interlacing, only half of the image is redrawn at each pass, so that we end up with a framing rate of 25 frames per second. Computer monitors work at figures between 50 and 80 Hz, and are generally non-interlaced, so that the screen is redrawn at a rate of between 50 and 80 frames per second – i.e. each pixel is scanned at this rate. If the rate were too low, a flicker effect would result which, as we generally sit quite close to computer monitors, would become very uncomfortable to look at after a time. The image on a computer monitor is therefore much more stable than a domestic television. The Video Electronics Standards Association (VESA) established 75 Hz as a flicker-free refresh rate. Monitors with higher resolutions, such as 1600 × 1200 or 1800 × 1440 require higher refresh rates. Generally, a scan rate of 70 Hz and over should give a flicker-free display. Some flickering may become apparent if the brightness level is high, or may occasionally result from a strobing effect with fluorescent lighting.

It is possible to buy non-interlaced displays to give static images, but these are usually more expensive than interlaced ones, and may be no better than a good-quality monitor with high refresh rate and resolution.

Dot pitch

Dot pitch refers to the distance between the holes on the shadow mask, a thin metal plate with holes through which the electron beams pass before striking the phosphors coated inside the face of the cathode ray tube. Good screen displays have a small dot pitch (e.g. 0.26 mm), high dot pitches give coarse,

grainy images. In Sony Trinitron-based monitors (which tend to give sharper and brighter images than those with a shadow mask), the shadow mask is replaced by an aperture grill (or tension mask) made of thin parallel wires. The specification in this system is referred to as a 'stripe pitch' rather than dot pitch.

TFT technology

Recently, new technologies using thin film transistor (TFT) active matrix liquid crystal displays (LCD) have been developed, allowing flat screen monitors of remarkably high definition. Whilst still more expensive than conventional monitors, a major practical advantage is the smaller amount of space ('footprint') they take up on a desk!

Whilst any size of high-resolution monitor capable of displaying 16 or 24 bits per pixel is acceptable for imaging purposes, a reasonably large one is to be recommended – 17-inch or 19-inch are excellent. This allows an image to be displayed along with other palettes for showing brushes, layers, history and the like. You will probably also want, at times, to display several images at the same time – the larger the monitor, the more information it can display. One possibility used by many photographers when running Photoshop, for example, is to use two monitors, one for displaying the image/s, the other displaying the various tools and menus.

When using monitors, especially with work intended for colour output, it is important to arrange a constant light source for viewing. Just as photographic colour printers use a standard fluorescent tube and neutral background for assessing colour prints, so a computer monitor should be viewed in standard conditions. Variable natural lighting should not be allowed to fall on the screen, and ambient room lighting should be as consistent as possible. Black viewing hoods can be purchased for the purpose or easily constructed. Once set up, they prevent other people from altering the controls of the monitor as this will affect the final output – some operators remove the knobs from their monitors for this purpose! Also, remember that monitors generate heat, and that as they warm up the shadow mask or aperture grill expands. If the monitor is to be used for accurate colour calibration, wait for at least 20 minutes until it has reached its optimum condition. It is very important too that the desktop pattern of the monitor is a neutral grey colour and not patterned! This can be changed in the monitor's control panel of the operating system.

Mice and graphics tablets

The mouse supplied with most computers is fine for most purposes but not very good for drawing precise outlines. An alternative to the mouse is the

digitizer or graphics tablet, a flat plate, usually A5 or A4 in size. Drawing and pointing is carried out with a stylus which looks and acts very much like a pen. Much finer control over drawing or making selections is possible with the stylus, which is usually pressure-sensitive. When using programs such as MetaCreation's Painter, the more pressure that is applied to the stylus, the more 'paint' is applied. Unlike the mouse, which can be raised and moved to another part of the mat without altering the position of the cursor on the screen, the positioning of the stylus on the tablet dictates the position of the cursor. When selecting a graphics tablet, do not be tempted by the adage that 'biggest is best'. For many applications, an A5- or even A6-sized tablet is excellent, as they can be used on the knee rather like a notepad. A4 and larger tablets are useful, but are not so manoeuvrable on a desk and are more expensive!

Laptop computers

A laptop or portable computer is merely a physically small computer which folds up into the size of a small attaché case, and can be operated by battery. They can be as powerful as desktop machines, having fast processors, with the capability of large amounts of RAM, and can run programs such as Adobe Photoshop with ease. The main difference is the screen, which is difficult, if not impossible to calibrate for colour. However, conventional monitors can be attached to them, as can devices such as data projectors. Different disk drives can be inserted, such as floppy disk, CD or Zip.

Many press photographers working on location use laptops to download their images, process them and then transmit them via modems. Most laptops have PCMCIA card readers, so that cards from digital cameras can be inserted directly and the images from them loaded into an application such as Photoshop. These slots can also be used for modem or network cards.

CD-ROM drive

CD-ROMs have become an almost universal way of storing and distributing images and software, and most programs are now supplied on CD-ROM (Adobe Photoshop is supplied on two). Buy the fastest one you can, although, as noted elsewhere, a twelve-speed drive does not necessarily operate at twice the speed of a six-speed. Consider too the possibility of an integral CD writer and reader. These now cost relatively little, and with discs costing under a pound make a very good investment.

Digitizer (frame-grabber) board

If the image required is to be obtained from an analogue video or still video source, then, as discussed in Chapter 2, it needs to be digitized. Several 'frame-grabber' boards are available from a variety of suppliers for PCs and Apple computers for converting an analogue video signal into a still digital one. Depending on the board, they will generally take a variety of input signals, e.g. Composite video, SVHS, etc. and convert it into a still frame. Many newspapers regularly 'grab' individual frames from transmitted television pictures with a frame-grabber board. For multimedia applications, boards are also available for digitizing moving video sequences.

Connecting other devices to the computer

When connecting peripheral devices such as scanners, external disk drives and printers to computers, the information needs to be sent quickly through the cable system used. On modern computers, there are several types of socket, or 'port' used including serial, parallel, SCSI, USB and FireWire ports. A major current development is in the use of wireless communication using infrared or radio signals.

Serial port

The serial port (often referred to as the RS-232 port) on a PC is an industry standard, though even with this standard the variety of connectors can be confusing. It is a multi-purpose port for connecting mice, modems and other devices to the computer. The basic principle of the serial port is to have one line to send data, another to receive data, and several others to regulate the flow of that data. The data is sent in series, i.e. one bit at a time. This is somewhat inefficient but no problem for communicating with devices like mice, which don't require speed and for modems connected to standard telephone lines which can handle only one signal at a time.

Parallel port

The parallel port is often referred to as the Centronics port. It is most often used for connecting to printers. The parallel port has eight parallel wires which send eight bits (1 byte) of information simultaneously in the same amount of time which it takes the serial port to send one. One drawback with the system

is that of 'crosstalk' where voltages leak from one line to another, causing inter-
ference of the signal. For this reason, the length of parallel cables is limited to
approximately 10 feet (3 metres). Most PCs have both serial and parallel ports.
The Macintosh computer generally has one or two serial ports, one for the
printer, one for a modem, and another called a SCSI connection.

SCSI connections (Small Computer Systems Interface, pronounced 'scuzzy')

This port permits relatively high-speed communication between the computer
and peripheral device, such as a scanner, external hard disk, CD-ROM drive or
even a digital camera.

Up to six extra SCSI devices can be connected to the computer. They are
linked or daisy-chained together with each device being assigned a specific
identity number. This ID number can be set on each device using switches on
the back. By convention, the internal hard disk of the CPU is ID no. 0, and the
computer itself is no. 7, which means that six other devices can be connected.
SCSI is a form of 'bus' – a common pathway for the relaying of data, shared by
several devices. A terminator (terminating resistor) must be used at the start
and end of the chain to identify the limits of the bus and prevent signals reflect-
ing back on the bus after reaching the last device.

When using SCSI devices, always ensure that the devices are switched on
before the computer. Generic software such as 'SCSI Probe' is available, often
through shareware and public domain software suppliers enabling you to check
that all the SCSI devices in a chain are connected ('mounted') properly.

The majority of the IBM PC machines lack SCSI connection, although
inexpensive SCSI cards can be fitted inside the computer.

SCSI is a rather outdated connection, having largely been replaced by USB.
However, a large number of SCSI devices are still in daily use. USB to SCSI
converters are available.

USB (Universal Serial Bus)

This is a relatively recently introduced technology for connecting Macs and PCs
to devices such as scanners, digital cameras and printers. It is a very fast method,
and also extremely expandable, capable of handling up to 127 devices, connected
by a series of USB hubs. The devices are 'hot swappable' meaning that, unlike
SCSI, they can be connected and disconnected without switching off the
computer. Most modern PCs and Macs have two USB ports, but older machines
can have cards fitted giving them USB capability.

FireWire (IEEE1394)

FireWire or the High Performance Serial Bus (sometimes referred to as 'DV In/Out') has been adopted as the standard interface for digital video products. This relatively new interface, developed by Apple to replace SCSI, was designed to handle the large amounts of data generated by the new generation of digital video cameras as well as professional-level digital still cameras.

Accelerator boards

A major problem found when using desktop computers for image manipulation is that of speed. Even with the fastest possible processor, many operations such as applying filters or rotating the image can take an appreciable amount of time to carry out. Many companies manufacture accelerator boards, often specifically designed to work with applications like Adobe Photoshop. These may contain Digital Signal Processors (DSPs) which help speed up mathematically intensive operations. DSPs are now being built into some new computers, although they may have no effect until software is written to take advantage of the facility. Accelerators can speed up many operations by as much as twenty-three times! They are generally expensive, but if the computer is to be used primarily for dealing with large images, they are well worth considering.

Data storage

Floppy disks

The 3.5-inch disk is familiar to anyone using a computer for word processing and the like. Whilst the outer casing is rigid plastic, the magnetic disk inside is flexible, hence the term 'floppy'. A shutter opens when the disk is placed in the disk drive to allow the reading and writing heads of the disk drive to access the disk. There are basically two types: double-density and high-density disks. The double-density disk can store approximately 700 kilobytes of information, the high-density disk approximately 1.4 megabytes. Before use, the disls must be 'formatted' (Apple refer to this as 'initializing') where the disk is divided into tracks and sectors by the disk drive. This enables it to receive the information to be stored on it. The disks can be locked in much the same way as audio cassette tapes, preventing accidental addition or erasure of information stored on them.

 Most digital images will be too large to fit onto floppy disks unless they are compressed, though some software offers the option of saving to multiple disks if no other medium is available.

Hard disks

All computers nowadays are fitted with an internal hard disk. Typical sizes are 4, 8 and 12 Gigabyte. Hard disks are used to store not only documents and images but also the various programs used. For the storage of images obviously the larger the better, and prospective purchasers would be well advised to get an 8 Gb if possible. Additional disks can be fitted internally or external versions are available which connect to the computer usually via SCSI or USB cables.

Like any type of disk, hard disks can become corrupted or 'crash' causing the loss of some or all data on them. It is essential to keep a 'back-up' copy of that data on another disk or other media.

Removable hard disks

Several companies, in particular Iomega with its Zip and Jaz drives, manufacture high-capacity removable disks which can be used in a similar fashion to floppies. Zip disks are similar in size to 3.5-inch floppies, and are available in 100 Mb and 250 Mb capacities. They are remarkably inexpensive and are widely used, though it is worth asking your publisher, client or intended bureau if they have the facilities to read from your particular disk system. Because the disks are removable, they are an ideal way of transferring large image files from one computer to another, perhaps to take an image to a bureau for output. The Zip cartridge has become an industry standard, and most bureaus will have facilities for accessing the information from them.

Magneto-optical drives

This drive utilizes a laser beam which is focused down onto a minute area of a disk composed of crystalline metal alloy just a few atoms thick. The laser beam heats the spot on the alloy past a critical temperature, at which the crystals within the alloy can be rearranged by a magnetic field. Read and write heads similar to conventional disk drives align the crystals according to the signal being sent. Two different sizes of disk are available, 5.25 inch and 3.5 inch, in various capacities including 128 Mb, 230 Mb, 640 Mb, 1.2 Gb and 2.6 Gb. These devices take about twice as long as conventional disk drives to record or read data but the disks are relatively cheap.

DAT (Digital Audio Tape) drives

These drives allow the storage of large amounts of information on small, cheap tape cartridges. They work on a similar principle to video tape recorders except that the data recorded is digital rather than analogue. A recording drum with

two heads spins at high speed. Tape is moved past the heads at a slight angle to them so that data is written to the tape as narrow diagonal tracks rather than a continuous track along the length of the tape. This increases the usable area of the tape allowing more information to be stored. The format of the data on the tape conforms to the DDS (Digital Data Storage) standard. As well as the raw data, indexing information is included to speed up retrieval of the data. Also, most drives have built-in hardware compression. This is much faster than software compression. Two types of tape are available – DDS and DDS-2. DDS tapes are 60 or 90 m long – the 90 m storing approximately 2 Gb of uncompressed data. DDS-2 tapes are 120 m long, can store up to 4 Gb of uncompressed data, and have faster drive mechanisms. DDS-2 tapes cannot be used in DDS drives.

Several sizes are available, such as a single 4 mm wide tape capable of holding 2 Gb of data. One problem with all tape systems is that if the information required is in the middle of the tape, the tape must be wound physically to that point. This makes them relatively slow for jumping backwards and forwards between files, but excellent when recording large amounts of information in a sequential fashion. Whilst the tapes are very cheap and the system very reliable, the drive units themselves are quite expensive.

RAID (Redundant Array of Independent Disks)

This is a generally expensive and complex system for data storage, more useful for the large user such as a large image library or archive rather than an individual user. The basic idea is to use two or more drives which are combined into a single logical drive. Data is written onto the drives in sequence. Various levels of RAID exist, and in its most sophisticated form, the data is error checked as it is written. The system offers very fast writing and retrieval. In some cases, one of the drives can fail yet be replaced without loss of data and without shutting down the system. Several major picture libraries use the system for the archival storage of their huge collections of images.

CD-ROM, writable, and re-writable CD

Audio compact discs have been available for over ten years now and vinyl records have become virtually extinct, with many new music releases only being available on tape or CD. The technology of storing digital information on compact disc has within the last few years become available to photographers, librarians, and others involved in publishing. CD-ROMs are now available containing encyclopedias and dictionaries, multimedia presentations, and collections of images. Many publishers are investing heavily in 'electronic publishing'.

CD-ROMs can store up to 650 Mb of digital information on a single disc but differ from other forms of storage in that the information is 'read only' (ROM stands for 'read only memory'), and cannot be altered. The discs are etched, or inscribed, with a laser, and CD writers are now a common item for many computer users. Many photographers put their folios onto CD for distribution to clients. Concern has been expressed in the media about the life expectancy of CDs. Estimates vary, but it is generally thought that undamaged discs could last up to 100 years.

Audio CD players spin the discs at a speed of around 200 rpm, taking around 72 minutes to read a whole disc. This speed originally became the 'standard' speed drive. Because computers can process information at much faster rates, faster drives are now appearing on the market. The speeds of these drives are normally quoted in multiples of the 'standard drive speed'. There are now double-speed, six-speed and twelve- and twenty-four-speed drives. However, the increase in speed of a double-speed drive does not necessarily mean a halving in the time taken to transfer data, as factors such as memory buffers, method of connection and even software will limit the transfer process.

All CDs have several layers – a polycarbonate substrate which provides rigidity and keeps any scratches and blemishes on the surface out of the focal plane of the laser, a layer of metal acting as a reflective surface for the laser beam, and an acrylic layer on which the label is printed, and which protects the metallic surface. Data is stored on the metallic layer as a pattern of reflective and non-reflective areas known as 'lands' and 'pits'. Lands are flat surface areas whilst the pits are minute bumps on the surface. These patterns are originally etched into the CD by means of a minutely small focused laser beam. When reading the disc the laser penetrates the polycarbonate layer and strikes the reflective metallic layer. Laser light striking a pit is scattered, whilst light striking a land is reflected directly back to a detector, from where it passes through a prism which directs the light to a light-sensing diode. Each pulse of light striking the diode produces a small electrical voltage. These voltages are converted into a stream of 0s and 1s, binary data which the computer can recognize.

The data is recorded along an extremely thin spiral track (approximately 1/100th the thickness of a human hair) which, if straightened, would be about 3 miles long. This track spirals from the centre of the disc outwards, and is divided into sectors, each of which is the same physical size. The motor which spins the disc employs a technique known as 'constant linear velocity', whereby the disc drive motor constantly varies the speed of spin so that as the detector moves towards the centre of the disc, the rate of spin slows down (see Figure 4.1).

The writable CD-R (Recordable) discs are made in a similar fashion except that the laser is made to heat a minute spot in a layer of dye. This heat is transferred to the adjacent area of the substrate which is physically altered so that it disperses light. In areas left untouched by the laser, the substrate remains clear

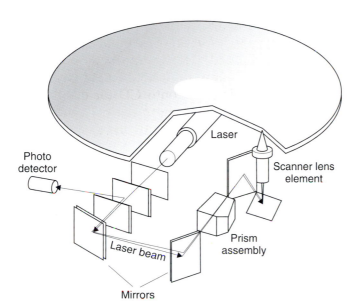

Fig. 4.1 CD driver assembly.

Photo detector

Laser

Scanner lens element

Laser beam

Prism assembly

Mirrors

allowing the laser light reflected from the metallic layer through so that it can be read by the detector.

A rewritable CD (CD-RW) was launched in 1997 by Ricoh, enabling users to erase discs and record more than once. This facility is now found in most CD recorders. Rewritable discs are slightly more expensive than ordinary writable ones.

The major advantages of the CD disc are the size of the disc and the cost per unit. The CD writable disc allows the storage of 650 Mb of information at a cost of between less than £1 per disc. This cost is far less than 1p per megabyte, one of the cheapest forms of digital data storage available. A novel form of CD is credit-card sized and shaped, and has been used as an advertising medium.

Improvements to the storage capacity of disks are likely over the next few years. One new format, DVD (originally Digital Video Disc, but now better known as Digital Versatile Disc), uses a dual layer to greatly increase the capacity of CDs. Two formats are planned – 2.6 Gb and 4.7 Gb. DVD players are already in widespread use in the home for the viewing of feature films, replacing VHS tapes, and recordable DVD will become available in the near future. The software controlling the writer, such as Toast Pro for the Macintosh, allows the user to choose the form in which the data is stored. This can be either specific to the platform on which the disk was created, Mac or PC, or, in the case of ISO 9660, independent of the platform and readable by other types of computer. When producing these 'hybrid' disks, do remember to maintain file naming conventions. For example, images must have the file name followed by the three-letter extension (e.g. .tif, .jpg) to enable the PC platform to recognize them.

Computer software

All software piracy is theft and a crime. The FAST (Federation Against Software Theft) organization is dedicated to tracking down software copying and fining offenders. Software can be an expensive investment and most software companies offer demonstration software with the 'save' option disabled to enable a customer to test it before buying. These are often distributed on 'try and buy' CD discs on which the full version of the package can be unlocked by payment to a phone number with a credit card.

Computer viruses

A virus is a computer program deliberately written to disrupt the normal operation of a computer. They may 'crash' the computer, display messages, delete files or cause other strange things to happen on the screen. They can cause a great amount of damage within a computer, perhaps erasing whole hard disks. Many are designed to come into force on particular days, or are transmitted via e-mail attachments such as the notorious Love Bug virus which struck thousands of the world's computers in May 2000. To minimize the risk of viruses getting into your computer system it is essential to take certain precautions:

- Install a virus checker (sometimes known as 'disinfectants') on your computer. A good example is Sophos Sweep for PCs. Many others are freely available from public domain and shareware suppliers, and come into action the instant the computer is switched on, checking all files for viruses.
- Do not use floppy disks given to you by other people (particularly with games!) unless you have a virus checker on your machine.
- By their very nature, virus-checking programs are always one step behind the authors of viruses, so cannot be relied upon to identify all current viruses.

Health and safety considerations

Working with computers can give rise to certain health problems, such as eye strain or injury to wrist joints caused by the position of the hands when using computers. A few simple guidelines will help ro prevent these problems:

1 Sit comfortably, preferably in a chair with a good backrest, and adjustable height. You should try to sit upright, and at a height where your forearms are in a horizontal position when using the keyboard. Use a wrist support wherever possible.

2 Adjust the monitor height and angle to minimize head and neck movement (European laws now insist that all computer monitors are on tilt-swivel stands). If possible, try to have it at such an angle that you are looking down at the monitor slightly. Do not sit too close to the monitor.
3 Place the monitor sideways to windows, thus avoiding reflections on the screen.
4 Take frequent breaks from the computer. Walk away from the computer to get some exercise and rest your eyes as much as possible.

Where to buy

Look for a reputable dealer (preferably one who knows about digital imaging!) who is local to your area. This may not appear to be the cheapest option in the short term but if you encounter any problems it will rapidly become an investment. Purchase from a dealer who offers the appropriate level of support to your needs, and who will let you see the machine in operation before purchase. Some dealers may offer a more expensive deal but this may include training for customers who are not conversant with computers. Clarify the service offered at the time of the initial quote and get it put in writing. This should include the terms of guarantee, the scope of service if included and the details of what will be supplied and installed.

In any imaging system the final result is only as good as the weakest link. It therefore makes no sense to connect a scanner costing several thousand pounds to an £800 computer and expect the results to be anything but poor. No photographer would use cheap lenses on their Hassleblad camera, and the same philosophy should apply to computing!

5 File size, storage and image compression

It will be apparent by now that bitmapped digital images take up large amounts of storage space, and that one of the main problems encountered in digital imaging is that of storing and accessing the images. This is a major problem for picture libraries and archives faced with the problem of digitizing thousands or even millions of images.

Table 5.1 gives some examples of file sizes from different resolution scans of a range of print/transparency sizes.

Table 5.1 Tables of sizes for uncompressed files

Resolution (ppi)	Colour	Monochrome
35 mm transparency		
500	1.1 Mb	0.4 Mb
1000	4.5 Mb	1.5 Mb
2000	18 Mb	6 Mb
6 × 6 cm transparency		
150	373 K	124 K
300	1.46 Mb	497 K
600	5.83 Mb	1.94 Mb
1200	23.32 Mb	7.76 Mb
5 × 4 inch transparency		
150	1.29 Mb	440 K
300	5.16 Mb	1.72 Mb
600	20.63 Mb	6.88 Mb
1200	82.52 Mb	27.51 Mb
10 × 8 inch print		
150	5.3 Mb	1.7 Mb
300	21.3 Mb	7.03 Mb
600	85.5 Mb	28.1 Mb

File formats

A file format is the method used to store digital data, be it text, graphics, sound or movie. Many different image file formats exist for storing images, and it is

essential to have at least a working knowledge of the main ones to ensure that an image can be transferred to other programs such as a desktop publishing or a presentation graphics program, or sent in the correct form to a printer or other form of output medium. Some formats are used extensively for publishing on the Internet. Some imaging programs will only open specific file formats, whereas others such as Photoshop will open a wide range. Programs such as DeBabelizer and Graphic Converter are available whose primary function is to convert files from one format to another. Examples of file format used for both Macintosh and PC type computers include TIFF, EPS and Photoshop. Most formats are compatible with both platforms, but do remember to include the three-letter extension (.tif, .jpg, .eps, etc.) if the images are to be transferred from Mac to PC.

Whatever the format, image file formats generally consist of two parts, a file header and the image data. The header will contain information such as:

Horizontal and vertical dimensions in pixels
Type of image data (greyscale, colour, etc.)
Bit depth of the image
Compression technique used (if appropriate).

This header information must provide all necessary information to reconstruct the original data and its organization from the stored data. After the header information is the image data. This data might have been compressed or stored in a variety of ways. The header information will allow it to be recreated perfectly.

An 8-bit greyscale image, 600 pixel × 800 lines in size could be described as follows:

Header
width = 600
height = 800
format = greyscale
no. bits/pixel = 8
compression = none

Image data
480 000 bytes of image brightness data

This format typically assumes that the data is organized in lines from the top-left to the bottom-right of the image.

Some computers (such as mainframes) and some scientific imaging programs save images in formats which cannot be read by programs such as Photoshop. However, Photoshop can open 'Raw files'. These are streams of numbers which describe the colour information in an image. The colour value for each pixel is

described in binary format – one code for each of the RGB or CMYK channels. Different file formats may compress the image data by differing amounts, and again, a knowledge of file size, and method of compression is essential if quality is to be maintained.

Table 5.2 gives the size of the *stored* file of a 4 Mb image saved in a number of file formats:

Table 5.2

Photoshop 5.5	4 Mb
TIFF with LZW compression	2.84 Mb
JPEG: 'maximum' setting	286 Kb
JPEG: 'medium' setting	59 Kb
JPEG: 'low' setting	46 Kb
EPS	5.5 Mb

Note: these figures will vary according to the type of image, in particular, the amount of detail or area of flat tone it contains.

Diagrammatic composition of three file formats

Major image file formats

TIFF (Tagged Image Format File) .tif

This file format was developed jointly in 1986 by Aldus and Microsoft in an attempt to standardize on the growing number of images being produced by scanners and other digital devices, and needing to be imported into desktop publishing programs. It was specifically designed to be portable across computer platforms, and to be flexible to allow for development over time. Blocks of data within the file are interpreted by the use of tags which identify them. Even so, there are several versions of TIFF currently available, though these generally pose few problems. It is a very widely used file format for bitmapped images for both the Apple and PC platforms, and is the best format to use for transferring

images from one system to another or supplying images to a bureau. It is used extensively when making colour separations. Whilst most file formats contain a small number of 'headers' which describe the properties of an image, TIFF images can include up to 60 tags, each defining a specific property such as size, resolution, etc.

Within TIFF a lossless compression routine known as LZW is available (see the section on image compression later in this chapter). This reduces the size of the stored file by around 50 per cent, without perceptible loss in quality. Adobe Photoshop is able to read and save captions in TIFF files, particularly useful when used with the Associated Press Picture Desk, which uses the same caption fields (see Figure 5.1).

Figure 5.1 TIFF dialog box showing Mac/PC options and LZW compression facility.

EPS (Encapsulated PostScript) .eps

EPS uses the PostScript page description language to describe images and is used to export files (particularly those in colour) to page layout programs such as Quark Xpress or InDesign. It can be used for storing object-oriented graphics as well as bitmapped images, though these may give very large file sizes. The way in which images are described by the PostScript language, using vectors, means that the resolution of the image is dependent on the resolution of the output device. EPS files can also include halftoning information such as screen ruling and angle and dot shape. EPS files are used to store data related to 'clipping paths' enabling 'cutouts' for use in desktop publishing programs.

A variation of EPS, developed by Quark for its QuarkXpress desktop publishing program is called DCS (Desktop Colour Separation). This format enables users to print colour separations of imported artwork and photographic images. When saved in DCS format, five files are created: yellow, magenta, cyan and black, and a preview of the image which can be viewed and positioned within

page layouts. The DCS-2 format is used with files containing more than four component colours. These can be used to define spot colours, for example.

PhotoCD .pcd

PCD is the format used to store PhotoCD images which have been encoded in the YCC colour model (a variant of the CIE colour space) and compressed. By opening PhotoCD images directly, the YCC images can be converted into Photoshop's Lab colour mode, ensuring no colour loss. As discussed in Chapter 3, there are several different PhotoCD formats (e.g. PhotoCD Master, Pro PhotoCD). A technical limitation of the scanner used to produce PhotoCDs is that the maximum density it can read is only approximately 2.8, resulting possibly in loss of shadow detail from transparencies which may have densities well above 2.8 (no such detail is lost when scanning negatives which have a maximum density of 2.0). Photographers cannot make their own PhotoCDs – they must be written on a PhotoCD workstation, which scans the images, compresses the data and stores it in a standard format, as well as producing an index print of the images for the CD case.

Photoshop .psd

This is the native file format within Adobe Photoshop, and has the capability of retaining information relating to layers, masking channels, etc. which will be lost when saving in another file format. Photoshop 5.5 has a lossless compression routine built into it. The format is recognized by many other programs which can open images stored as Photoshop format directly. As is the case with most software when it is upgraded, Photoshop v.5+ will open Photoshop v.4 files, but not the other way round.

JPEG .jpg

This is a lossy compression routine, capable of compressing images to a ratio of 20:1. It has rapidly become an industry standard. Users can set their own quality settings on a sliding scale within the software (see the section on image compression). Photoshop 5.5 incorporates a preview when saving JPEG images, so that users can determine the optimum amount of compression whilst retaining image quality. Speed of transmission with different speeds of modem is also shown. The options box also offers various settings when preparing images for Web pages, such as how many passes it takes before the image finally appears on screen (Figure 5.2).

Several variants of JPEG exist, and a new JPEG standard, JPEG2000, is currently being developed. This will provide better quality from compressed

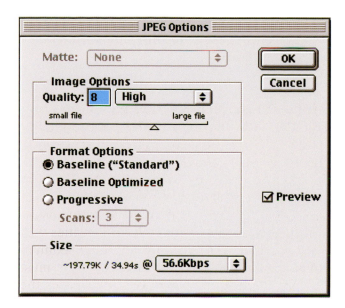

Figure 5.2 JPEG dialog box, showing level of compression, compressed size, and transmission time with 56.6 Kbps modem. Original image was 4.5 Mb.

images and allow compression of different regions of the image to different degrees.

Other formats

Whilst the above are perhaps the commonest and most familiar formats, a wide range of others is available, a selection of which is given below.

Amiga IFF (Interchange File Format) .iff
This is Amiga's all-purpose graphics file format, similar to PICT on a Macintosh.

PICT .pct
This is the native graphics format for the Macintosh platform, and works equally well with both bitmapped and object-oriented artwork. The current version is PICT 2, which supports images in any bit depth size or resolution. It is particularly effective at compressing images containing large, flat areas of colour. If you have Quicktime installed on the Macintosh, then PICT images can be JPEG compressed. Such files can be opened up into word processor packages such as Microsoft Word, and Apple's own TeachText. It should not be used for desktop publishing applications.

 If you capture screen images on a Macintosh (Apple > Shift > 3), then these are automatically saved as PICT files on the hard disk when they are created.

PCX .pcx
This is the file format used with one of the oldest paint programs for DOS, PC Paintbrush. A number of versions are available.

PIXAR .pxr
This format is used for transferring files to high-end PIXAR workstations. These are generally used within the film industry for 3D and animation applications.

Window's Paint BMP .bmp
This format is native to Windows and can be used to save monochrome and colour images up to 24-bit.

Targa .tga
This is a bitmap graphics file format, used to store images up to 32-bit in RGB mode, used particularly for overlaying graphics and video.

PDF (Portable Document Format) .pdf
This is the format used by Adobe Acrobat, its electronic publishing software. Many documents such as instruction manuals, technical data sheets, and desktop published layouts can be 'published' as PDF documents using Acrobat Distiller, and will appear exactly as they were created on Macs, PCs or Unix computers. They are independent of the computer platform, and the computer does not need to have the fonts contained in the document. The documents are relatively small in size, having been compressed, so can be used to download information from the Internet.

 Photoshop's PDF format supports RGB, indexed colour, greyscale, bitmap and Lab modes, but does not support alpha channels. Either JPEG or Zip compression can be used when saving files. Zip is a lossless compression routine similar to LZW.

IVUE
This is Live Picture's own pixel-based image format. To edit images in Live Picture they must be in IVUE format. An IVUE file must be converted back into its original format for printing. Live Picture is no longer available, but still has a number of dedicated users.

FIF (Fractal Image Format) .fif
An uncommon format as yet, but one which uses fractal mathematics for compressing images. It may become increasingly important for storing large single images, or for video sequences. The thousands of images on the multi-media encyclopedia 'Encarta', for example, are fractally compressed.

(*Note*: Fractal mathematics is also used by some programs for interpolating new image data.)

FlashPix .fpx

This image file format was developed by Kodak, Live Picture, Microsoft and Hewlett-Packard in 1996. It is a multi-resolution image file format in which the image is stored as a series of independent arrays, each representing the image at a different spatial resolution. For example, if the original image is 1280×960 pixels, then the format would have versions measuring 640×480, 320×240, 160×120, 80×60 and 40×30. This allows the image to be displayed on different output devices at different resolutions with minimal resizing of the image. Each version is divided into tiles, 64 pixels square. As the operator zooms in and out of the image, the software selects the appropriate resolution for the screen display. Any changes made to the image are recorded in a script, which is a part of the file. Any information here can be applied to any of the resolutions of image.

A FlashPix file generally requires 33 per cent more disk space than an uncompressed TIFF file for example, because of the extra resolutions contained within it. However, it requires about 20 per cent less RAM for viewing than a comparable TIFF file and takes less time to modify it and store the revision. A Photoshop plug-in for opening and saving images in FlashPix format is available from Kodak.

File formats for Web publishing

The tremendous growth in the use of the Internet has led to a huge demand for images for Web sites. Many photographers use the Web as a vehicle for marketing their images, and compromises have to be made between speed of download and image quality.

Several file formats are available specifically for Web use, and Photoshop 5.5 has several utilities for optimizing images for the Web.

CompuServe GIF (Graphic Interchange Format) .gif

GIF is used primarily for placing images on Web pages. It can handle only 8-bit images, so images need to be converted to indexed colour. The compression used is similar to the TIFF LZW. There are basically two types of GIF file: the 87a, and the GIF 89a. In the 87a, all the pixels are opaque, but in the 89a, some of the pixels may be made transparent, so that viewers can see through portions of the image to the Web page background. GIF images can be viewed on all Web browsers. Simple animation is possible with a sequence of images.

PNG (Portable Network Graphics) .png

This is the newest image format for Web pages, and supports 24-bit and 32-bit images. It was designed to outperform and eventually replace GIF. (In 1995, Unisys, the developers of GIF, started to charge royalties on the use of GIF. PNG, on the other hand, is not patented.) Various levels of compression are built into the format, as well as interlacing – the ability to draw the image on-screen in seven passes (Adam 7).

Save for Web

Photoshop 5.5 has a Save for Web command (File > Save for Web . . .) where images can be previewed in a number of different formats such as GIF, PNG and JPEG before saving. Information is given about transmission times with various speeds of modem, and choices can be made about gamma and colour, for viewing on different platforms (Figure 5.3).

Image ready

Photoshop 5.5 comes bundled with another program – Image Ready, designed specifically for preparing images for the Web. It can display various versions of an image at various compression levels, but also has tools for producing Web page features such as roll-overs (Figure 5.4).

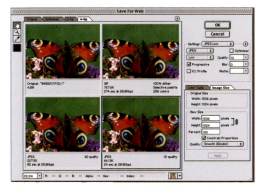

Figure 5.3 Photoshop 5.5's Save for Web dialog box, showing original, and three compressed versions (GIF, JPEG), with relevant image sizes and transmission times. It is possible to specify a final file size, and the software will compress to that size.

Figure 5.4 Image Ready is a program bundled with Photoshop 5.5 designed specifically for optimizing images for Web pages. It includes a range of features and tools.

Image compression

There are various methods of compressing digital information depending on the type of data – text, graphic, photographic, audio or video, for example. This will save disk space, and enable faster transmission when sending data via telephone or e-mail, for example. When compressing images, consideration must be given to image quality and reaching a compromise between quality and file size.

There are three basic types of compression method for digital images: 'lossless' where no information is lost during the compression and decompression process, and the reconstructed image is mathematically and visually identical to the original; 'lossy', where some information is lost during the process; and 'visually lossless', where the image data is sorted into 'important' and 'unimportant data' – the system then discarding the unimportant data. PhotoCD uses this method. A very important consideration here is whether the lost information is noticeable in the final output. Huge savings in file size can be achieved, and if the result is good enough for the intended purpose then its use can be justified. Bear in mind that if the final image is to be analysed for scientific purposes, then the compression techniques used, whilst not visible to the human eye, may affect the analysis. The amount of compression achieved will be dependent upon the software and hardware in use, the amount of detail within an image, and the quality requirement of the final image.

Compression relies on the fact that any digital data generally contains redundant information. With images, this might be repeated patterns, or areas of common brightness between multiple pixels within the image.

Lossless compression

This type of compression looks for patterns in strings of bits, and then expresses them more concisely. For example, when giving directions to someone you might say 'turn right at the traffic lights, drive past one road on the left, then another, then another, then another, then turn left'. Instead, it is much easier to say: 'turn right at the traffic lights and take the fifth road on the left'. This is an example of a process known as '*Run Length Encoding*', where a repeated series of items is replaced by one item, together with the count for the number of times which that item appears. The system depends on a continuous series of data that is the same. It is illustrated diagrammatically in Figures 5.5–5.7.

An example of run length encoding is used by *Huffman compression*. This assigns a code to a particular pattern – the most frequently used patterns are assigned the shortest code. (This is similar to Morse code where the commonest letters are assigned the shortest codes, and the least common the longest, e.g. E = dot, Z = dash, dash, dot, dot.) However, because digital documents

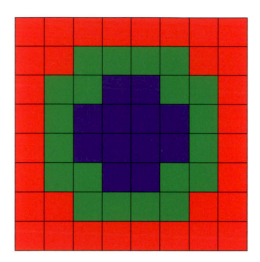

Figure 5.5 Simplified diagrams of compression concept. The original colour image is a cross made up from three colours.

R	R	R	R	R	R	R	R
R	R	G	G	G	G	R	R
R	G	G	B	B	G	G	R
R	G	B	B	B	B	G	R
R	G	B	B	B	B	G	R
R	G	G	B	B	G	G	R
R	R	G	G	G	G	R	R
R	R	R	R	R	R	R	R

Figure 5.6 Each pixel is recorded.

8	R						
2	R	4	G	2	R		
R	2	G	2	B	2	G	R
R	G	4	B	G	R		
R	G	4	B	G	R		
R	2	G	2	B	2	G	R
2	R	4	G	2	R		
8	R						

Figure 5.7 Rather than recording each pixel, strings of similar values are coded to reduce the amount of data needing to be stored.

vary in their type, so the Huffman code must create a new set of codes for each document.

As an example, the words **DIGITAL IMAGE** can be processed as follows:

Character	Frequency
D	1
I	3
G	2
T	1
A	2
L	1
M	1
E	1

This can then be coded as follows:

Character	Frequency	Huffman code
I	3	0
A	2	00
G	2	01
D	1	110
E	1	111
L	1	000
M	1	001
T	1	101

Huffman works best with text files, and variants of it are used in certain fax machines. Whilst it does work with images, it requires two passes of the data, the first to analyse the data and build the table, the second to compress the data according to the table. This table must always be stored along with the compressed file. Because of the way Huffman encoding analyses the data the process is known as a 'statistical compression method'. A refined version of it, which uses a 'dictionary method of compression', is called **LZW compression**.

This method, which was developed in the late 1970s, is named after the three men who developed it – Abraham Lempel, Jacob Ziv and Terry Welch. It is an integral part of the TIFF file format. At the beginning of the file, LZW starts to build a small table, like Huffman compression. It then adds to this table every new pattern it finds. The more patterns it finds, the more codes can be substituted for those patterns, resulting in greater compression. It does this in one pass resulting in greater speed. LZW can compress images up to 10:1. Another format which uses LZW compression is GIF, used for displaying 8-bit images on the World Wide Web.

Lossy compression

The most common form of lossy compression, and one which has become virtually the industry standard for greyscale and colour images, is JPEG (Joint Photographic Experts Group) which was developed during the 1980s and first became available in 1991. This group was created to define a standard for compressing photographic images, and is a joint effort by the Consultative Committee on International Telegraphy and Telephony (CCITT) and the International Standards Organization (ISO). It relies on the fact that the human eye is much more sensitive to changes in brightness (luminance) in an image than to colour (chrominance). The image data is thus separated into luminance and chrominance, and lossy compression algorithms are then applied to the chrominance data. (This is similar to television, where a medium-resolution monochrome signal is overlaid with a low-resolution colour signal.)

It is a three-stage process. The system divides the image into blocks of 8×8 pixels, to which a mathematical transform known as 'adaptive discrete cosine transform' (ADCT) is applied, transforming the image from the spatial domain into the frequency domain. This has its basis in Fourier transforms used by engineers for analysing the frequency components of signals. The data in each 8×8 block is converted into an output block representing the frequency components. The process averages the 24-bit value (or 8-bit value if a greyscale image) of every pixel in the block. This value is stored in the pixel in the top left-hand corner of the block. The other 63 pixels are assigned values relative to the average. This step produces an 11-bit per colour file, with values ranging from -1024 to $+1023$. This is actually larger than the original file, but prepares the data for the compression process to follow.

The next step is **quantization**. Here, the values produced by the ADCT process are divided by values in a quantization matrix. The ADCT process produces matrices which tend to diminish sharply from the top-left to the bottom-right corner. When a quantization matrix with sufficiently high quantizing values is used, then many of the values are reduced to zero. This can mean that, when a file is decompressed, the 8×8 blocks representing low spatial frequency parts of an image (e.g. blue sky) are made up of 64 pixels of the same value, i.e. the zero values indicate that there is no difference from the average value stored in the top left-hand corner of the block. A practical result of this is that when compressing images heavily, a 'blocky' appearance may result.

In areas of high spatial frequency (i.e. detail) only values further towards the bottom right-hand corner of the block are reduced to zero.

The third stage in the JPEG process is **entropy encoding**. The 8×8 pixel block is now represented by a stream of quantized figures, many of which are zero. JPEG uses a combination of Huffman encoding and run length encoding to produce the most effective compression for a wide range of image types.

During the reordering of the data, most zero values will occur in one part of a 'run' through the data in the 8 × 8 blocks, which can be represented by a very short piece of computer code.

Practically, when saving images using the JPEG option in Photoshop 5.5, you are presented with a range of settings relating compression to image quality. 'Small' files give 'low' image quality and vice versa. Information is also given about transmission times with various speeds of modem. Image Ready, a program supplied with Photoshop, gives a visual indication of the quality of various JPEG (and GIF) settings.

JPEG works best with continuous-tone images, where there is a gradual transition in tone between neighbouring pixels. Areas of flat tone may give a 'blocky' appearance when compressed heavily. JPEG is a cumulative compression process. Photoshop recompresses the image every time it is saved in JPEG format. So there is no problem with repeatedly 'saving' an image during processing because JPEG always works on the screen version of the image. Data is lost, however, every time the image is closed, re-opened and saved again.

Obviously, the determination of whether image quality has been lost or not is subjective, and is dependent upon the viewer and the quality of output device being used. Various tests have been carried out using different types of image, viewed by groups of individuals. Most of these tests concur that with a compression setting of 'medium' and above, there is, to all intents and purposes, no perceptible loss in image quality, though it must be restated that there is always a loss of data with the system.

Images that have had unsharp masking applied will, by definition, contain more detail and will not compress to the same degree as those without. If you require a high degree of compression therefore, do not apply the unsharp mask before compression.

The JPEG compression routine is found in most imaging programs like Adobe Photoshop. It is also available as a standalone package from companies like Storm who produce a program called PicturePress. This has a much wider range of options, including the ability to compress selected portions of an image only. This can be coupled with a digital signal processor (DSP) board to speed up the process enormously. Other companies such as Colour Highway have modified the JPEG algorithm to produce higher-quality compression with standard images and a range of compression facilities with EPS and DCS files (see Figures 5.8–5.10).

Compression with PhotoCD

As discussed in Chapter 3, a standard PhotoCD Master disk can hold up to 100 colour images. Each image is stored at five resolutions in an 'image pac' yielding

Figure 5.9 File saved as TIFF
with LZW compression. File size
920 Kb. The amount of
compression will vary according
to the detail content of the
image. Images with larger areas
of flat tone will compress more
than images with lots of fine
detail. Compression of up to 50
per cent is possible.

Figure 5.8 Original PhotoCD image showing
cropped area. Original image was Base × 4
version (4.5 Mb) from PhotoCD showing cropped
area, with levels adjustment, and unsharp mask
settings of 200 per cent, 1.0, 1.

uncompressed file sizes of 18 Mb, 4.5 Mb, 1.25 Mb, 312 K and 78 K. As compact
discs can only hold 640 Mb of information, it will be seen that in order to put 100
image pacs on the disc some form of compression must be used. In fact, the
average size of an image pac for 35 mm images is 4.5 Mb, though this will vary
according to the type of image.

The compression method used is a proprietary system which utilizes 'chroma
(colour) subsampling'. This relies on the limitations of human vision, whereby
colour information is not so important as detail. (Try the following experiment.
Convert an RGB image into Lab mode in Photoshop, and apply a Gaussian blur
filter with a radius of 3 pixels to the a and b channels. When the full image is
viewed, it will appear almost exactly the same as the original, even though the

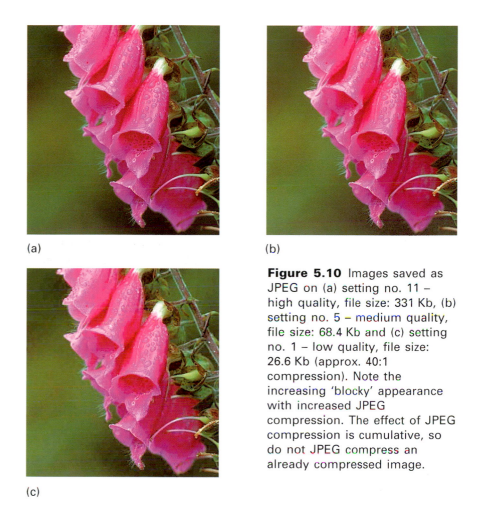

(a)

(b)

(c)

Figure 5.10 Images saved as JPEG on (a) setting no. 11 – high quality, file size: 331 Kb, (b) setting no. 5 – medium quality, file size: 68.4 Kb and (c) setting no. 1 – low quality, file size: 26.6 Kb (approx. 40:1 compression). Note the increasing 'blocky' appearance with increased JPEG compression. The effect of JPEG compression is cumulative, so do not JPEG compress an already compressed image.

colour information has been blurred. This is a useful technique for noise reduction in digital images.) Colour information can therefore be discarded more readily than detail before it is perceived. In the case of PhotoCD the loss is referred to as being 'visually lossless'.

The scanner used in the PhotoCD Workstation for 35 mm film utilizes a three-element moving array to scan the film to give a 12-bit, 2000 dpi (base × 16) scan of the film giving a 24 Mb size file. This is transferred to the 'data manager', a powerful high-speed computer dedicated to converting the 12-bit RGB image file created by the scanner into an 8-bit 'Photo YCC' format reducing the file size to 18 Mb.

The PhotoYCC format used by PhotoCD is Kodak's proprietary image compression system, where the RGB values of an image are converted to PhotoYCC. This is similar to a television system, which uses a luminance signal

and a chrominance (colour) signal). In PhotoYCC, 'Y' (equating to the luminance, or brightness values within an image) is calculated using values for red, green and blue. This accounts for most of the image detail. 'CC' are colour difference signals representing the colour information of the image:

C (Chroma 1) = Blue – Y
C (Chroma 2) = Red – Y

Since the values of the red and blue components of the image are recorded along with the greyscale (luminance) value, the green can be calculated.

This file format has three main advantages. First, the signal can be read and displayed on a standard television set, and second, it allows the use of visually lossless compression using image deconstruction. The last and the most important reason is that the YCC format can contain all the information from the 12-bit RGB scan. This means that the file can contain virtually all the contrast and colour information from the film original.

As each pixel in the original scanned image is converted from RGB to YCC a process known as chroma decimation is applied.

Chroma decimation

The image is formed of rows of pixel elements each made up of the three channels Luminance, chroma 1 and chroma 2. The decimation process removes the chroma channels in each alternate pixel in the odd rows of pixels and all the chroma channels in the even rows of pixels (Figure 5.11).

The reduction in file size is derived from the following:

Original file size = 6 Mb luminance + 6 Mb C1 + 6 Mb C2 =18 Mb

In the new file each pixel with a chroma value is surrounded by three pixels without chroma values:

New file size = 6 Mb luminance + (1/4 × 6 Mb C1) + (1/4 × 6 Mb C2) = 9 Mb

Image decomposition

This 9 Mb file is then reduced by a two-step colour-averaging and subsampling process. This removes every alternative pixel and creates a new pixel which is the average of adjacent colour and luminance values, to give a file half the width and half the height of the original, one quarter of its size.

The data manager of the PhotoCD system now contains, in its memory, a 9 Mb file and the new subsampled file reduced to 2. 25 Mb. It expands the smaller file by interpolation to create a virtual copy of the 9 Mb file. The differences between the original and the virtual copy are stored as 'Residuals'. These residual values then undergo quantization. Using a form of Huffman encoding a

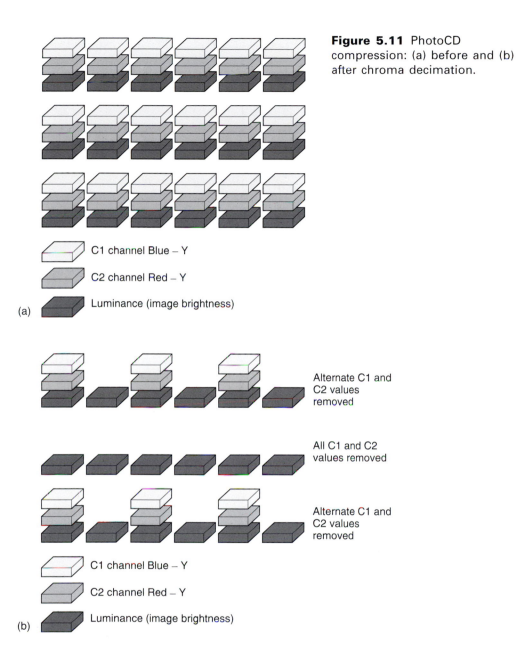

Figure 5.11 PhotoCD compression: (a) before and (b) after chroma decimation.

C1 channel Blue – Y

C2 channel Red – Y

Luminance (image brightness)

(a)

Alternate C1 and C2 values removed

All C1 and C2 values removed

Alternate C1 and C2 values removed

C1 channel Blue – Y

C2 channel Red – Y

Luminance (image brightness)

(b)

short code is allocated to common elements which reduces the actual number of bytes required to store the information.

This procedure is carried out twice to give a 9 Mb file consisting of residual values and a 2.25 Mb file consisting of residual values. The halving process continues three more times, but as only relatively small files are created here they are stored in their original form.

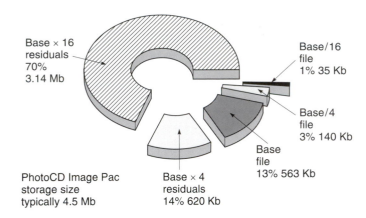

Figure 5.12 PhotoCD Image Pac.

Base × 16 residuals 70% 3.14 Mb

Base/16 file 1% 35 Kb

Base/4 file 3% 140 Kb

Base file 13% 563 Kb

PhotoCD Image Pac storage size typically 4.5 Mb

Base × 4 residuals 14% 620 Kb

The YCC PhotoCD Image Pac is now assembled and written to the disc (Figure 5.12). The Image Pac now contains the information in Table 5.3.

The technique used for the two largest files in the five-file Image Pac is termed 'lossy plus lossless residual encoding'. Using this method, all losses occurring during the compression process are offset by the addition of information from the residual files.

Table 5.3

Name	Contents	File size when expanded
Base x 16 image	Residual values	18 Mb, 2048 × 3078 pixels
Base x 4 image	Residual values	4.5 Mb, 1024 × 1536 pixels
Base	563 Kb YCC file	1.25 Mb, 512 × 768 pixels
Base/4	140 Kb YCC file	313 Kb, 256 × 384 pixels
Base/16	35 Kb YCC file	78 Kb, 128 × 192 pixels

YCC colour space

The YCC colour space records information in three channels, one for Luminance (brightness) and two for Chrominance (colour). The principal advantages of this system are:

- It allows high levels of visually lossless compression of the image.
- It provides a system that provides consistent representation of images from negative or positive originals.
- It provides the widest gamut of colour space in which to store colour information.

6 Digital image processing

Digital image processing is the general term used to describe a wide range of operations carried out to digital images. Strictly speaking, any digital image that is modified in any way by a computer has been processed, and the applications are widespread. Much of the current technology has resulted from the work of NASA, who have been enhancing and analysing images transmitted back from spacecraft for over 30 years. The most famous example is perhaps that of the Hubble space telescope, whose distorted images were partially corrected by digital image processing before it could be physically repaired in space. Other major applications include medical imaging and machine vision (where cameras monitor production lines, and can be programmed to automatically reject faulty components).

Image manipulation is a highly contentious area, and there have been several high-profile examples of digitally manipulated or created images being used to illustrate news stories. A recent example, from 1999, is one of the wedding photographs of Prince Edward and Sophie Rhys-Jones. In the image of the main group, Prince William had a rather sullen expression. A picture of him smiling was pasted over the original image. The story made front-page headlines in many UK national newspapers!

This chapter will discuss some of the basic principles of image processing, illustrated with examples from Adobe Photoshop v.5.5, and a 'public domain' image analysis program, 'NIH Image 1.6'. It will also discuss a few selected techniques aimed at showing photographers the potential of the software. It is not intended as a substitute for a good training manual, nor as a textbook on digital image processing!

Digital image processing can perform a huge range of functions to images, including:

- enhancement of brightness and contrast
- alteration of colour balance
- addition or subtraction of colour or grey tones either for scientific or creative use
- sharpening of images
- reduction of noise in digital images
- removal of parts of images to aid analysis

- modification of images to extract information
- distortion of the image, usually for creative effect.

In addition to the above, a wide range of 'special effects filters', generally for creative use, are available for image-processing programs to add textures, simulate a lighting effect and even add the effect of lens flare to an image!

There are very many different image-processing programs available, varying in both their capabilities and price. Many of the less expensive programs (such as MGI PhotoSuite and Adobe PhotoDeluxe) will still carry out a wide range of image enhancement and retouching procedures, and it is worth examining these carefully to see if they are adequate for the purpose required. They often have very different interfaces, often enabling you to follow step-by-step instructions to perform operations such as removing the effects of red eye, for example, or sepia tone an image. They are excellent for the beginner, and are usually much cheaper than Adobe Photoshop (see Figure 6.1).

Image-processing programs are known as 'paint' programs, where the image is composed of a rectangular grid of pixels known as a 'bitmap'. Each pixel is assigned a value, from one bit (black or white) to 24 bits per pixel for-full colour images (some programs work with 32 bits, where a fourth 8-bit 'alpha channel' stores information relating to masks and layers etc.). Because bitmapped images contain a fixed number of pixels, the resolution (pixels per inch) is dependent upon the size at which the image is printed.

Other programs used primarily for drawing and graphical illustration are known as 'object-oriented' or 'vector-based' programs, and include Adobe

Figure 6.1 Screen shot of MGI PhotoSuite III, showing controls for brightness and contrast. Such software often has an extensive range of tools and filters, but these will not be as controllable as with software such as Photoshop.

Illustrator and Macromedia Freehand. These use mathematical formulae to define lines and shapes (for example, a circle can be described by the formula $x^2 + y^2 = z^2$). The artwork is built up from a series of separate components, or objects, each of which is independently editable. Vector images are stored as a display list describing the location and properties of the objects within the image. Objects can include the letter 'A', in Helvetica font, italic style, 12 point, a square, with sides 50 mm, and line width 0.5 mm, and a raster image scaled to 5 cm \times 8 cm. Because an image composed with an object-oriented program is made up of mathematical data, the resolution is dependent upon the output device, be it a laser printer or a high-resolution imagesetter. Also, images stored as bitmaps tend to be much larger than vector-based images as the computer needs to have information about every pixel within the image.

When desktop computers suitable for imaging first became available, many of the programs were written for the Apple Macintosh computer platform, but now most programs, including Adobe Photoshop, are available for PCs and other computer platforms as well. Images can be easily transferred between platforms using standard file formats such as TIFF or JPEG. Programs are updated at regular intervals by the authors, and it is very important to register your software immediately with the manufacturer to ensure that you receive the latest versions, upgrades and 'bug fixes'. The potential of the programs is huge, and here we can look only briefly at the operations possible. It is essential to spend time reading the manual supplied with the software, and carry out the suggested tutorial exercises. It will take a long time to become proficient in all areas of the program, but the basic operations will become familiar relatively quickly. Photoshop 5.5 is supplied on two CD-ROMs, one with the program and all the accompanying software, whilst the other contains a wealth of tutorial material relating to its use as well as some sample images to use. It is important to develop a good working practice to ensure that you use the software in the most efficient manner to get the best results. Another important factor to remember is that there are usually several different ways of achieving the same result, and very often there is no one 'right way'!

Adobe Photoshop

The following text could relate to the use of Photoshop 5.5 on either a PC or a Macintosh. It works in virtually the same way on both platforms, except for some of the key combinations and mouse clicks.

Adobe Photoshop has become, in recent years, the industry-standard program for image enhancement and manipulation on desktop computers. It is capable of a huge range of functions including conversion to CMYK for output to printing plate. It also acts as the 'host' for many digital imaging devices such as digital cameras and scanners, which come with small programs called 'plug-ins', or

drivers, which are accessed or 'imported' through Photoshop. Many third-party developers also write extra plug-ins for the program, such as extra filters. Similarly, 'export modules' allow the output of images directly to various printers through Photoshop.

Written primarily for photographers, Photoshop has many tools familiar to photographers such as dodging sticks and burning-in tools from the darkroom. Many of the other cheaper programs will have a range of similar facilities and functions, and many of the remarks made here about Photoshop will be applicable to them also.

Images stored in a large range of file formats such as TIFF, JPEG, GIF, PNG and BMP can be opened and saved, as well as Photoshop's own proprietary format PSD. PhotoCDs can also be accessed directly through Photoshop. Colour management is a major integral feature of the program, with the ability to embed ICC colour profiles into images, for example. Photoshop 5.5 has several features for producing images specifically for Web pages, and comes bundled with another program, Image Ready, which is designed specifically for optimizing images destined for the Web.

Upon opening the program, the screen will be seen to display a menu bar at the top and a toolbox running vertically down the left-hand side (Figure 6.2).

Figure 6.2 Screen shot of Adobe Photoshop 5.5 on an Apple Macintosh computer, showing toolbox and menu bar, open image, brushes palette and channels palette (showing component red, green and blue channels). Also, the unsharp mask dialog box and preview window. The desktop shows two hard disks, Macintosh HD and G3 term (used as Photoshop 'scratch disk') and icons for PhotoCD and PC formatted Zip disk. Note the image size, 18 Mb, at bottom left of the open image.

Various extra windows can be opened to display, for example, the range of brushes available, the various layers associated with the image, or the navigator, which enables you to zoom in and out and pan around the image.

We will begin by looking at the various features of the program and then describe some specific techniques such as adjustment of brightness and contrast, sharpening and reduction of noise. A small selection of Photoshop techniques is included, but a much more detailed account of the use of Photoshop is given in Martin Evening's book *Adobe Photoshop 6.0 for Photographers*, published by Focal Press.

Introduction to the tools

The 'toolbox' contains several items familiar to photographers, such as pencils, paintbrushes and buckets, rubbers and burning and dodging tools, together with others for selecting and moving areas of the image, creating text, cropping images and filling selected backgrounds with a gradient (Figure 6.3).

Tools are selected from the toolbox by clicking the cursor on the required one, then taking it into the image area. When a tool shows a small black arrow in the bottom right-hand corner, it indicates that several other tools of a similar nature will be found. For example, clicking and holding the mouse button down on the 'dodging stick' displays a horizontal sub-menu containing the burn tool and a sponge tool as well. With many of the tools, double clicking the mouse button brings up a range of further options which may be selected (Figure 6.4).

Figure 6.3 Photoshop 5.5. toolbox showing range of selection, drawing, painting and other enhancement tools, as well as two colour palettes and various other options.

Figure 6.4 Brushes palettes, showing different sized brushes with hard and soft edges, brush options including opacity and 'blend mode', and palette for making a new brush to your own specification.

The first set of tools in the toolbox are selection tools, enabling you to select parts of an image for modification or adjustment. The marquee tool enables selections of rectangular and elliptical (they can be constrained to be squares or circles if required) shapes, whilst the lasso tool is used to make freehand selections. The 'magic wand' is used to automatically select parts of the image based upon the colour similarities of adjacent pixels. It can be used to select part of an image such as an even-toned background. Once selected, the required area is outlined by 'marching ants', an animated dotted line. When applying modifications to the image, only the area selected is affected. For more precise selections, the 'QuickMask mode' can be used, where selections can literally be painted (rather like painting photographic lith negatives with red lith paint) (Figure 6.5).

Figure 6.5 Selecting in 'QuickMask' mode, where the selection boundary can be painted with a brush.

The most precise way of selecting a part of an image is the pen tool. The required area is selected by making various points around the item. The selected area can be saved as a Path, which can be edited very precisely, and, if required, exported as a 'clipping path' to a graphics or desktop publishing program.

Selections can be 'feathered' – their edges being softened by varying amounts to make it easier when merging them with other images, for example (see Figure 6.6). The move tool is used to move selections and layers.

Both the pen and lasso tools have a 'magnetic' option, where the line drawn by the tool is attracted to the edge of a defined area. It is particularly useful for selecting objects against a contrasting background.

The cropping tool is used to select a part of an image and discard the remainder, in much the same way as trimming a photographic print. Always crop an image to remove any redundant or unwanted information to obtain the smallest possible size, and thus save on memory. Precise dimensions can be set so that an image can be cropped to a specific size.

Figure 6.6 Feathering can be applied to all selection tools to produce a soft-edged selection.

A major group of tools in the Photoshop toolbox are concerned with painting, drawing and retouching. The pencil, paintbrush and airbrush are all self-explanatory. Their size and characteristics can be altered in the Brushes palette. The colour applied will be the colour displayed in the foreground colour box at the bottom of the toolbox. The pencil is used to paint hard-edged lines or dots, the paintbrush soft-edged strokes, whilst the airbrush lays down a diffused spray of colour. The way in which the colour is applied can be altered in the Brushes palette using one of the various 'blend' options. Adjustments can be made to the opacity, saturation and many other modes of application. The shape of the brush can also be altered. A very important preference to set when setting up Photoshop is to open the 'Display and Cursors' preferences file (File > Preferences > Display and Cursors), and check the 'brush size' button. When a brush or other drawing tool is selected, it will be shown as a circle exactly the diameter of the brush.

The eraser is used to erase parts of an image and will remove the image down to the background colour displayed at the bottom of the toolbox. When working with layers, the colour removed by the eraser is replaced by transparency. The eraser can be converted into the 'magic eraser' which will erase an alteration made to an image back to the previously saved version.

The line tool is used for laying down straight lines, at any angle or length. It has the option to have arrowheads at the start or end, and be drawn in a variety of thicknesses. It is useful for producing annotated photographs. As with the text tool, the line will be bitmapped so that diagonal lines will exhibit aliasing.

The foreground colour in the toolbox can be selected by clicking the eyedropper tool in any part of the image. This colour will now be the one used by the drawing tools until another is selected.

The cloning (or rubber stamp) tool is potentially one of the most useful in the toolbox. It allows you to sample a part of an image and place an exact copy (clone) of it elsewhere in the image or into another image. Extensive options allow the cloning of patterns, or with an 'impressionist' style, for example.

The dodging and burning tools operate in much the same way as dodging and burning-in tools in the darkroom, making areas of an image lighter or darker. The size of the tools can be adjusted in the Toning Tools Options palette, as can the degree of dodging and burning. The sponge option can be used to increase or decrease the colour saturation of part of an image.

The smudge tool smears colour in an image, in much the same way as dragging a finger through wet paint.

The blur/sharpen tool will blur or sharpen small areas of an image without resorting to the blur/sharpen filters from the filter menu. There is not so much control over the process as with user-definable filters such as the Gaussian blur or unsharp mask filters.

The gradient tool can be used to apply gradients of tone or colour to areas of images, such as the background behind an object. A useful technique for simulating the effect of a graduated optical filter for darkening a sky in a landscape image is discussed later.

Text can be entered onto an image using the text tool, in a range of fonts (those installed on the computer), sizes, style and colour. Images can be labelled or captioned. The colour of the text is that of the foreground colour palette, so ensure that this is set before adding the text to an image. Text generated automatically becomes a layer, which can be moved around on an image until it is in the required place. The style of the text can be selected, and it can be filled with a gradient colour, for example. Various effects can be applied to the text, such as drop shadows, which can be found in Layer >Effects. Whilst the text option with Photoshop is useful, it must be remembered that the text will be bitmapped, and will be the same resolution as the rest of the image so that magnification of the image will show 'aliasing' or 'staircasing' on rounded or diagonal parts of letters (Figure 6.7).

Whilst anti-aliasing software (Adobe Type Manager) is supplied with the program, which helps smooth out this effect, it will never match the quality of text generated by a desktop publishing program producing PostScript language type, and if good high-quality type is required it is worth considering taking the

(a) (b) (c)

Figure 6.7 Aliased text: (a) aliased text, (b) anti-aliased text, (c) vector text.

image into another type of program for adding text afterwards. The same applies to the drawing of diagonal and curved lines.

Where an image is larger than the displayed window, the hand tool can be used to drag the image within the frame. Double clicking the hand tool forces the image to fill the monitor screen. The zoom tool allows you to zoom into or out of an image. When first selected, the magnifying glass will display a plus sign, and will enlarge the image when clicked, to a limit of 1600 per cent. If the Option key is held down a minus sign appears, and the tool will now zoom out, or reduce the magnification, to a limit of 6 per cent. Placing the tool on a particular part of the image will enlarge that part. An important feature of Photoshop 5.5 is the 'Navigator' window (Figure 6.8). This allows very precise and rapid zooming in and out, and of navigating around the image.

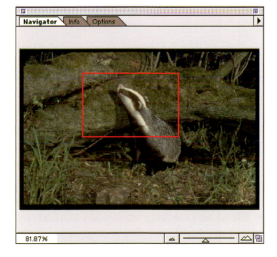

Figure 6.8 The Navigator dialog box, enabling rapid and precise zooming and moving around an image.

Introduction to the menus

The menu bar at the top of the screen contains pull-down menus for such operations as changing the mode of display of the image, adjusting brightness, contrast, and colour balance, applying filters and controls for copying and pasting parts of images together. Only a small selection can be discussed here.

Mode

This menu allows you to convert an image from one mode to another. For example, a greyscale image can be converted to RGB mode. Although it will not look any different on the screen, it now enables the painting of colours selected from the paint palette – rather like hand colouring a monochrome print. One consequence of this conversion is that the file size will increase by a factor of three.

Another conversion for greyscale images is to produce duotones, tritones or quadtones, whereby the image is printed with two three or four inks. In duotoning, for example, an image can be displayed using black and one other colour, perhaps an orange. This will result in a sepia-toned effect. The colours chosen relate to industry-standard printing inks such as the Pantone range. Modifying the curve for the ink enables you to control which areas of the image are coloured. You might tone the shadows one colour and the highlights another colour for example, to simulate a photographic 'split-toned' image.

RGB images can be converted to CMYK, enabling photographers to produce the four colour separations required for four-colour litho printing, including all the necessary registration and calibration bars. Whilst this is an easy operation to carry out in the software, the process itself is rather complicated with many variables and is beyond the scope of this book. It requires calibration of monitors, printers and inks, and photographers regularly requiring this facility are advised to liaise closely with their printer. Many printers and bureaus recommend that photographers supply their digital images as RGB files and have the separations made by the bureau.

Another option within the mode menu is that of 'indexed colour'. In this mode, Photoshop builds a Colour Look Up Table (CLUT) based on a uniform sampling of colours from the RGB spectrum. Indexed colour images can only hold 256 colours. If a particular RGB colour is not present in the colour table, the program matches the colour to the closest one in the table, or simulates the colour using those that are present. You can edit this CLUT very precisely to improve the colour rendition of the image. An 8-bit indexed colour image can be almost as good as a true 24-bit image, yet occupy only one third of the disk space (though it is worth noting that indexed colour images cannot be compressed using JPEG). For this reason, many multimedia programs, which include large numbers of high-quality still images, often use indexed colours.

Indexed colour can also be used to produce graphic effects such as colour posterizations from monochrome images, where a range of grey tones can be allocated specific colours.

The 'Lab' mode consists of three channels: L is the lightness (a better term is luminance), or brightness channel, containing the detail part of the image. The 'a' (green to red) and 'b' (blue to yellow) are colour or chroma channels. Using this mode allows adjustment of the detail component of an image without affecting

the colour component. When filtering is performed on three-colour channel images each channel may have a slightly different degree of detail contrast, and effects cannot be controlled with complete accuracy. There is the risk of colour casts, particularly on subjects with neutral colours. More details of the use of this mode are given in the later section on sharpening images.

Brightness and contrast controls

When printing monochrome negatives in the darkroom, photographers can control the brightness (density) of the print by varying the exposure and its contrast, through the use of different grades of paper. In digital imaging, the same controls are available, but to a much higher degree. The simplest form of control found in the program is a simple slider bar (Image > Adjust > Brightness/contrast), allowing the brightness and contrast of the whole image or selected part of the image to be controlled. This can work well, but very often a much tighter control is required, perhaps of just one area of the image such as the shadow or highlight. Two much better controls which should be mastered are the 'levels' (Image > Adjust > Levels) and 'curves' (Image > Adjust > Curves) controls. These allow very precise control over the overall density and brightness of images as well as colour.

Levels

The 'levels' control is often referred to as a histogram (Figure 6.9). It is a graphical representation of the distribution of pixel values within an image. Being able to interpret an image histogram is very important. It can give important information relating to exposure, and brightness range of the image. Several digital

(a)

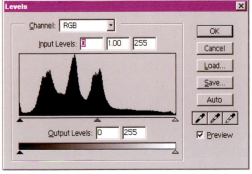

(b)

Figure 6.9 This histogram shows a good distribution of pixels across the tonal range, with detail in both highlight and shadow regions.

(a)

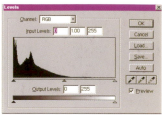

(b)

Figure 6.10 (a) This rather flat image is a 'raw' PhotoCD image without any enhancement. (b) The histogram shows the pixels distributed towards the shadow end of the tonal range.

cameras now have the facility of viewing the image histogram on the screen on the rear of the camera, enabling the photographer to tell immediately if the image has been correctly exposed, for example. The horizontal axis of the histogram represents the 'brightness' of pixels, from 0–255 for 8-bit greyscale images. For RGB colour images, histograms for each of the three colours are available. The vertical axis is the number of pixels which fall into that brightness value (Figure 6.10).

Sliders at the base of the histogram allow you to set the 'black point' and 'white point' of the image, i.e. the point at which tones start to record as black

(d)

(c)

Figure 6.10 (*continued*) Dragging the right-hand input levels slider to the point where the pixels begin, the whole image is brightened (c) and (d).

and white. Dropper tools allow you to sample points within the image, enabling you to choose which points record as black or white.

Histograms can show the experienced viewer whether an image is generally too light or too dark, or high or low contrast, and how much of the available dynamic range of the image is being used. Many image-processing programs offer the ability to manipulate the histogram to alter the image quality. The two commonest forms of histogram manipulation are *histogram stretching*, and *histogram sliding* (Figure 6.11). Both of these operations redistribute the levels of brightness within an image to enhance its contrast characteristics. If the image

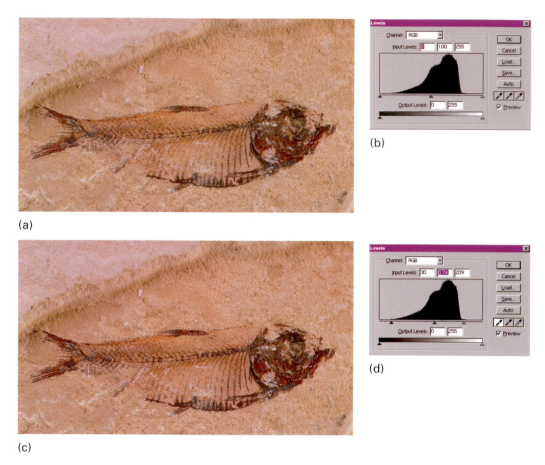

(b)

(a)

(d)

(c)

Figure 6.11 This fossil fish has pixels distributed in the centre of the tonal range. By sliding the input levels sliders to the start of the tones, the image is given a better range of tones.

data is 'stretched out' to fill the histogram, gaps appear in the histogram. This absence of pixels in certain areas can lead to 'posterization' effects or tonal banding. This may not be noticeable, or may only become obvious when other corrections or enhancements are made to the image.

There is an 'Auto' function within the dialog box. This automatically selects the darkest part of the image and makes it black and the lightest part of the image and makes it white. By default, this automatic feature 'clips' the white and black pixels by 0.5 per cent – i.e. the first 5 per cent of each end of the scale is ignored. This value can be altered if required. Having defined a black and white point, the midtone pixel values can be adjusted by using the grey slider in the centre of the levels box.

(a)

(b)

Figure 6.12 Use the 'Auto Levels' command with care. Whilst it will work well with a 'standard' image, it can badly distort images which do not have a full range of tones, as shown in this illustration of skin.

Whilst Auto Levels will give good results in many 'average' situations, use it with care! There will be many instances when the image does not have, and should not have, a white or black tone! A pronounced colour shift might well result, as shown in Figure 6.12.

Curves

Another important adjustment feature available within programs such as Photo-shop is the 'Curves' control. This is similar to the characteristic curve of a film emulsion, but can be adjusted to almost any degree on screen, either for image enhancement or for special effects such as solarization. When used with colour images, each channel of an RGB or CMYK image can be adjusted independently, allowing fine control of colour balance and contrast.

The *x*-axis of the graph represents the original brightness values of the pixels in an image, whilst the *y*-axis represents the new output values. Upon opening the

(b)

(a)

Figure 6.13 (a) The original image from a PhotoCD is rather flat. (b) The default curve shows a straight line at 45°, indicating that input and output values are the same.

dialog box, the default display shows a straight line at 45°, i.e. every pixel has the same input and output value (Figure 6.13). This curve can now be adjusted, by altering either the slope of the whole curve or part of it. As with a photographic characteristic curve, the steeper the angle the higher the contrast of the original. Tones on the curve can be pegged, and the rest of the curve made to pivot around that point. The grid indicates the quarter, three-quarters and mid-point within the image. Figure 6.14 shows a low-contrast scanned image enhanced to give good highlight and shadow detail by applying an 'S' shape to the curve. An 'auto' setting automatically

(b)

(a)

Figure 6.14 To increase contrast, two anchor points (pegs) have been placed on the curve, and the shape adjusted to give a steep S shape. Like photographic sensitometry, increasing the gradient of the curve leads to an increase in contrast.

maps the darkest pixel in the image to black, and the lightest to white. As with the levels control, use this facility with caution! An 'arbitrary curve' can be drawn with the pencil tool to give special effects such as solarization (Figure 6.15).

Control of colour balance

Digital photographic colour images are generally displayed as either RGB or CMYK images. The overall colour balance can be altered, or the image

(a)

(b)

(c)

Figure 6.15 Major changes to the curve can give interesting graphical effects, such as these images which show the effect of solarization, where part of the curve has been reversed, giving negative tones.

separated into its component channels, and each channel modified independently. In Photoshop, a colour balance dialog box can be displayed whereby slider controls can be used to add or subtract red, green or blue, or yellow, magenta and cyan. This can be applied to the whole image or just areas such as the shadows or highlights of the image. One instance where this could prove extremely useful is with a poorly processed negative, with 'crossed curves', where the image has, for example, green highlights and magenta shadows, and it is impossible when printing it to remove the cast. A 'variations' facility is available (Figure 6.16), which is similar to the 'colour ring-around' used in photographic colour printing. A range of variants of the image are displayed, showing the effect of adding or subtracting various colours. Again this can be applied to highlights, shadows or mid-tones only. Finally, the hue, saturation and brightness of each colour can be altered, again enabling fine control over the final image.

Photoshop is capable of displaying 'out-of-gamut' colours. As discussed elsewhere, the gamut of a colour system is the range of colours which can be displayed or printed in that system. It may not be possible to print a colour displayed on a monitor in RGB when converted to CMYK. Whilst Photoshop automatically brings all out-of-gamut colours into gamut, you may wish to see them so that modifications can be made manually. Photoshop will display an exclamation mark (!) in the appropriate dialog box for out-of-gamut colours. Colour management issues are discussed elsewhere in this book, but Photoshop does have a number of features aimed at helping photographers achieve the correct colour for images. In particular, the 'show info' dialog box (Window > Show info) acts like a densitometer in taking colour and density readings from

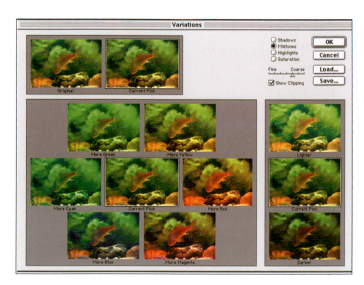

Figure 6.16 The Variations dialog box, where variations in overall colour balance can be easily seen. The effects can be 'fine' or 'coarse', and applied to midtone, shadow or highlight regions of an image. The 'clipping' box will show colours that are out of gamut, and unlikely to print successfully.

pixels. If a part of the image is known to be a neutral grey (if possible, incorporate an 18 per cent grey card, or Macbeth colour checker into part of the image), or white, then the values of the RGB readings should be the same. A second dropper tool (the colour sampler tool) is available in the toolbox, enabling you to take up to four readings from different parts of an image to help colour adjustment. When using the sampler tools to evaluate colour, double click on the tool, and select the 3 × 3 or 5 × 5 pixel option in the options box. An image of an 18 per cent grey card will often be made up of a range of different pixel values, and if only one single pixel is sampled this could lead to false readings.

Image size

Images can be resized, and the resolution changed (resampled). Resizing can be carried out by percentage or by specific dimensions. If the image size is to be increased, then it may be necessary to increase the resolution. This, however, does not necessarily produce a higher quality image, as in order to increase resolution, the software has to create new pixels through a process called *interpolation*. This process is also used by the software when images are rotated by anything other than 90° increments or distorted. Photoshop has three methods of interpolation for image resizing: bicubic, nearest neighbour and bilinear (Figure 6.17).

The 'nearest neighbour' option copies or replicates the adjacent pixel when creating the new one. This is the fastest option, but least effective. The 'bilinear' option smoothes the transitions between adjacent pixels by creating intermediate shades between them. It creates a softened effect. The third option, 'bicubic', increases the contrast between pixels following the bilinear option, offsetting the softening effect. This takes time, but offers the best quality of image.

A more detailed discussion of the practical uses of the image size box will be found in Chapter 8.

The 'canvas' size of the image can also be altered, perhaps for adding white space to the bottom of an image to provide an area for captioning the image or for printing two or more images on the same sheet of paper.

Filters

Image-processing filters are the electronic equivalent of the glass or acrylic filters which photographers place over lenses, but are capable of a vastly more comprehensive range of effects than their photographic equivalents. In general, try to use those filters that allow you some control over the effect, such as the Unsharp Mask or Gaussian blur.

Digital filters can be generally divided into two basic types: corrective or enhancement, and destructive. In very simple terms, a filter is a mathematical

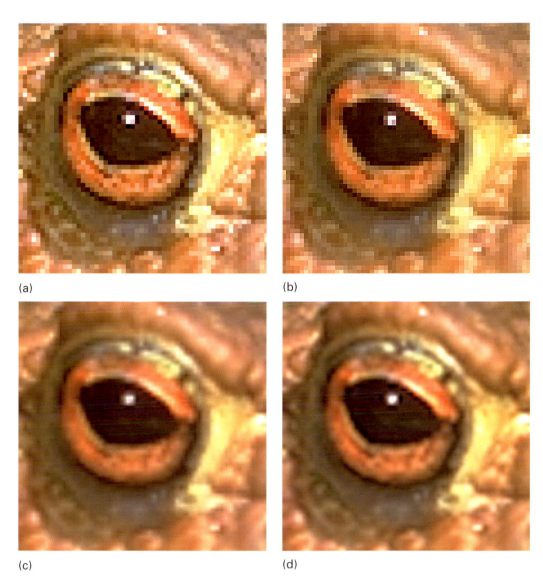

(a)

(b)

(c)

(d)

Figure 6.17 Interpolation examples. (a) 72 dpi image resampled to 300 dpi using three interpolation methods available in Photoshop 5.5. The nearest neighbour option (b) copies or replicates the adjacent pixel when creating the new one. This is the fastest but least effective option. The bilinear option (c) smooths the transitions between adjacent pixels by creating intermediate shades between them. It creates a softened effect. The bicubic option (d) increases the contrast between pixels, offsetting the softening effect. This takes a longer time, but offers the highest quality.

weighting which can be applied to the whole image or selected part of the image. The formula can exaggerate the differences between adjoining pixels, remap those pixels, or make them become different values. The filters are made up of 'kernels' or blocks of pixels, usually 3×3, 5×5 or 7×7. The 'convolution mask' contains coefficient or multiplication factors which are applied to the values of the pixels within the kernel and then summed to calculate each new pixel value.

For example, a 3×3 kernel consists of 9 pixels, 8 pixels surrounding the central one being processed. The central pixel has a value of 100, and its eight neighbours all have a value of 60. The sum total of the neighbouring pixels is therefore 480, which, added to the 100 of the central pixel, gives a total value of 580 for the whole kernel. This is divided by 9, giving 64. The central pixel is given this value, which is less than the original, making it therefore darker (or lighter if the image-processing program used, e.g. Image 1.6 has a LUT (Look Up Table) where white is given the lowest value).

The filter described above will be applied to all the pixels within the image (or selected area of the image) and has the effect of 'smoothing' (blurring or softening) the image, and is known as a 'low-pass' filter. This type of image filtering is known as spatial filtering which affects the rapidity of change of grey levels (or colour) over a certain spatial distance. Low-pass filters accentuate low-frequency details leaving high-frequency details attenuated, or reduced, as a result.

Processing time will obviously depend on the size of the image and power of the computer. Applying such a kernel to a 640×480 greyscale image means that the process has to be applied $640 \times 480 = 307\,200$ times. As each pixel will require nine multiplications and nine additions, this means that the whole image will require nearly 3 million calculations!

You can construct your own filters in Photoshop in the 'Custom' filter part of the filter menu (Figure 6.18). Experiment by typing in various figures into the grid.

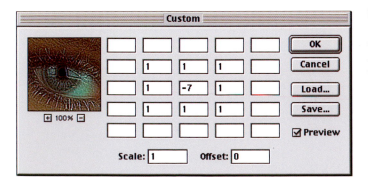

Figure 6.18 Custom filter box in Photoshop 5.5, enabling users to create and preview their own filters.

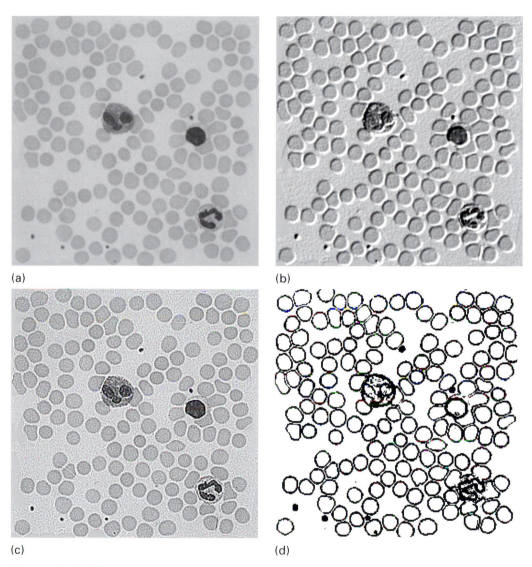

(a) (b)

(c) (d)

Figure 6.19 Filter examples to enhance a scientific image. (a) Original photomicrograph of blood cells. (b) Using shadow effect to enhance filter. (c) Using sharpen filter. (d) Using 'trace edges' filter. Unsharp masking.

Examples of filters are given in Figure 6.19 and below.

Sharpen

-1	-1	-1
-1	9	-1
-1	-1	-1

This is just one of many types of sharpening filter.

Smoothing

1	1	1
1	1	1
1	1	1

This filter blurs (softens) an image, and can also reduce 'noise'.

Shadow

−2	−1	0
−1	1	1
0	1	2

This produces a shadow effect with the light appearing to come from lower right.

Trace edges

1	1	1		−1	0	1
0	0	0		−1	0	1
−1	−1	−1		−1	0	1

Traces horizontal edges Traces vertical edges

Sharpen filters

Probably the most used (and possibly abused) filter within image-processing programs is the sharpen filter. Most digital images require sharpening. PhotoCD, for example, relies on the softness of the scanned image to enable the compression required to fit the disk, and several digital cameras, such as the DCS 620, have an 'anti-aliasing' filter which effectively softens the image in order to reduce aliasing. Adobe Photoshop has four sharpen filters (Filter > Sharpen), 'sharpen', 'sharpen more', 'sharpen edges', and the 'unsharp mask' (USM). The main problem with the first three is that they do not allow the photographer any element of control – they merely sharpen to an amount determined by the author of the program. The best advice therefore is to ignore them, and use only the unsharp mask filter for sharpening images. The rather unfortunate name comes from an old technique used in the printing industry for sharpening images, whereby a slightly unsharp version of an image is sandwiched with the original during printing. High contrast areas such as edges are effectively sharpened, whilst areas of continuous tone remain largely unaffected.

Another major reason for photographers having control over the sharpening process is that different types of image, from highly detailed technical images to soft focus portraits' images, will require different amounts of sharpening. Also, the resolution of the image, the printing technology to be used, and of course the photographers' or their clients' subjective assessment of what is sharp all have to be taken into account!

The subject therefore is not precise, but guidelines can be given derived from the experience of photographers and printers over many years. Do take great care not to oversharpen your images – the result is very noticeable!

To illustrate how unsharp masking works, two grey boxes were created in Photoshop, a light grey and a dark grey (Figure 6.20). Part of the image was selected and an unsharp mask applied of 500 per cent, 1.0, 1. As can be seen, an exaggerated boundary between the two grey tones has been created. The original pixel values of the two boxes were:

116 177

The USM process has put four intermediate tones at the boundary, so the pixel values now run as follows from left to right:

116 97 34 255 212 177

Different amounts, radius and threshold settings will give different effects, but it is a useful exercise to see how the USM process works.

Unless the images are destined for on-screen viewing, such as for Web pages or multimedia productions, don't rely on the screen image to judge the effect of the filter. An amount of around 50 per cent may be appropriate for screen-based publishing, but printed output will usually require more, often in the region of 100–200 per cent. You will need to do some tests, with a typical image, and using the print technology which you will be using.

(a) (b)

Figure 6.20

The unsharp mask filter consists of three parts:

1 **The amount** – This is the degree of contrast change between adjacent pixels. A relatively low figure produces little effect, whilst high figures cause large differences. The percentage figures given do not actually mean anything, so just treat them as a simple scale. Figures in the region of 100–200 per cent are most often used, particularly when the images are designed for reproduction in books or magazines.

2 **The radius** figure determines the range of pixels on either side of the edge boundary where sharpening will occur. Generally, you will only ever need single figures here, just 1 or 2 will usually suffice.

An often-quoted rule of thumb is to divide the output resolution in dpi by 200, to give the required radius in pixels. For example, an output resolution of 300 dpi, when divided by 200, gives a radius setting of 1.5. Figures greater than 2 will result in exaggerated edge contrast, and thickening of fine detail such as hair, but may be used to make part of an image 'stand out' from its background.

Of course, the resolution of a print is dependent on the resolution of the human eye, and the viewing distance of the print. The 'correct' viewing distance for a print is around 1.5 times the length of the diagonal (around 20 inches for a 10-inch × 8-inch print). The resolution of the human eye is difficult to define, but a multiplying factor of 0.0004 is derived from the size of acceptable 'circle of confusion'. A formula which can be used to derive the radius setting is:

$$\text{Radius} = 1.5 \times \text{image diagonal (inches)} \times \text{resolution (dots per inch)} \times 0.0004$$

This can be simplified as:

$$\text{Radius} = \text{image diagonal} \times \text{dpi} \times 0.0006$$

For example:

A 10-inch × 8-inch print (diagonal 13.5 inches) at 300 dpi would require a radius of:

$$13.5 \times 300 \times 0.0006 = 2.4 \text{ pixels}$$

If the same image is enlarged to 72 × 48 inches (diagonal 86 inches) at a resolution of 150 dpi, then the radius should be increased to:

$$86 \times 150 \times 0.0006 = 7.7 \text{ pixels.}$$

3 **The threshold** – this setting controls the number of pixels to which sharpening is applied, based on the brightness difference of neighbouring pixels, i.e. how different pixels have to be before they are treated as edge pixels. A

setting of 0 will result in all different pixels being altered, which can ruin areas of subtle tonal gradation such as skies. If the sharpening process causes noise to appear in continuous-toned areas, this is because the threshold is set too low, and needs to be increased.

Applying the unsharp mask to an RGB image sharpens each channel by the same amount, which may introduce colour aliasing effects or increase the amount of noise in an image. It is possible to sharpen one or more of the individual colour channels. As the blue channel is the one which generally exhibits most 'noise', then select the red and green channels to sharpen, and not the blue. A refinement of this is a technique used by many professional photographers, particularly with digital cameras, whereby the image is converted to Lab mode, and the USM filter applied to the Lightness (luminance) channel only. This sharpens the detail part of the image without affecting the colour.

Another way of doing this is to apply the filter to the RGB or CMYK image, and to apply the fade filter command in 'luminosity' blend mode.

There is some debate as to whether it is best to apply the filter in one go, for example 200 per cent, or to apply 50 per cent four times. It is worth testing this on your own images to see which suits you best.

A very important factor to remember is that unsharp masking must be the very last operation that is carried out to an image prior to output, in particular following any resizing of the image. Also, if you are supplying images to printers, for reproduction using four-colour litho for example, make sure you tell the printer that you have applied a sharpening filter. Most printers will automatically apply their own sharpen filter, and may prefer images supplied to them unsharpened. It is worth checking before sending in images to clients. Again, if you are supplying digital files to picture libraries, check first to see if they want sharpened images or would prefer them unsharpened (see Figures 6.21 and 6.22).

Other filters for image enhancement

Blur
Like the sharpen filters, there are several blur filters, but probably only one will be of use – the Gaussian blur, which, like the USM, can be adjusted to suit the effect required. It gives a very good 'photographic' blur, like an out-of-focus image, and can be used to enhance depth of field effects.

Noise reduction
As discussed in Chapter 3, most digital images exhibit an element of 'noise' – a spurious signal which exhibits itself as a random scattering of coloured pixels in areas which should be black. The 'noise' menu has again several filters, including despeckle and median. The despeckle filter blurs an image but retains edge

(a)

(b)

(c)

(d)

(e)

(f)

(g) (h)

(i) (j)

Figure 6.21 Unsharp masking
examples. (a) Raw.

1 Amount 100 (b), 150 (c), 200 (d)
 Radius: 1.0
 Threshold: 1

2 Amount: 100
 Radius: 1.0 (e), 2.0 (f), 3.0 (g)
 Threshold: 1

3 Amount: 100
 Radius: 1.0
 Threshold: 0 (h), 10 (i), 100 (j)

Figure 6.22
USM dialog
box showing
amount, radius
and threshold
settings, and
preview box.

detail – assuming that noise is most apparent in areas of continuous tone. Noise will probably be most apparent in the blue and red channels and least noticeable in the green channel. Try applying a small amount of Gaussian blur to the 'a' and 'b' channels of a Lab colour image but leave the lightness channel untouched. This should minimize the noise considerably. This is possible due to the fact that the human eye needs more information about the detail component of an image rather than colour. The colour component of images can be blurred to quite a degree before any loss in quality is perceived.

Perhaps the most useful noise-reduction filter is the 'median' filter, where each pixel is replaced with the median, or average value of neighbouring pixels within a 3×3 cluster, and falling within a specified tolerance (Radius). Any pixels outside the pre-set radius, i.e. noise, are ignored. This is a relatively slow operating filter because, for each pixel in the selection, the nine pixels must be sorted and the central pixel replaced with the value of the median/fifth. This is a useful filter for removing any extraneous noise generated by CCDs in digital cameras.

Other filters

Photoshop comes with a large range of other filters, and several manufacturers produce extra sets which can be added as Photoshop 'plug-ins'. They have a wide variety of uses, from creating textures for use as backgrounds, distorting images, applying the effect of artistic brushes, through to applying various lighting effects (Figure 6.23). They are really beyond the scope of this book, but are well worth experimenting with. One particularly well-known series are the KPT (Kai's Power Tools) filters, which include texture and fractal generators, and a whole range of effects like the greatly overused 'page curl'! Another is the Quantum Mechanics filter, from Camera Bits, specifically designed to improve the quality of images from digital cameras (see Chapter 3).

Working with layers

Layers are an important feature of Photoshop. When an item is copied and pasted into an image it automatically generates a layer, as does any text generated in Photoshop. Individual layers can be edited, and can be thought of as a stack of sheets of glass, some with images, others with areas of transparency. Layers can be made visible or invisible, have their opacity altered, and have changes made in the way they relate to other layers by using different blend modes. Layers can be rotated, their shape distorted and even have perspective corrections applied. Images of buildings displaying 'converging verticals' when photographed on small- or medium-format cameras can be corrected here, for example. A layer can be dragged from one image and dropped onto another. Several layers can be grouped or merged together.

Figure 6.23 Filter examples: Sunflower by Adrian Davies, an image demonstrating just three of the dozens of creative effect filters found in Photoshop. Top right: 'solarize' filter; bottom right: 'find edges' filter; bottom left: 'emboss filter'.

One particularly important type of layer is the adjustment layer. These store information about any adjustments made to such things as brightness, contrast and colour without affecting the original. These 'adjustment layers' can be switched on or off to show their effect and, by double clicking on the layer, the amount of adjustment can be altered. The important feature here is that the original image remains untouched. Any changes are stored as layers, which can be accessed afterwards and re-edited if required.

When saving images, if the layers are required for future use, then the file format used will automatically be Photoshop's own proprietary format (PSD), which is the only one that will retain the layers information.

One effect of creating layers is that the file size increases. A 4 Mb image with perhaps four layers may reach 10 Mb or more in size. The exact figures will be found in the bottom left-hand corner of the image window. The left-hand figure is the size of the original image, the right-hand figure the size of the image plus the various layers) (Figure 6.24). When the image processing has been completed, and the layers will no longer be required, the image can be 'flattened' so that all adjustments will be applied to the image. It must be stressed, though, that all the information stored as layers will be lost permanently.

Figure 6.24 The 'layers' facility within Photoshop. The image is composed of three layers – the owl itself, the moon with an associated mask, enabling the moon to be placed behind the owl, and a text layer. Note the file sizes (bottom left of screen) – the original size is the left-hand figure 4 Mb. The right-hand figure is the total for all three layers.

The history palette

A major advance with version 5 of Photoshop over previous versions is the history palette. This records all the operations which have been carried out to an image since it was opened. It is possible to view an image at any stage in the

history list, and remove or delete historical states. The history brush in the toolbox allows you to paint through from one historical state to another. This in effect gives the user the option of multiplc 'undo' states, a serious drawback with previous versions.

Automating photoshop

Built into Photoshop is an actions palette, allowing you to record a series of actions which can be 'replayed' to other images. Such a sequence might be adjust levels, adjust colour balance, apply unsharp mask. Photoshop comes supplied with a whole range of pre-recorded actions for performing operations such as making frames and vignettes, drop shadows or conversion to other modes. Two potentially useful actions for photographers supplied with Photoshop are found in the automate menu (File > Automate). These are Contact Sheet, and Picture Package. The Contact Sheet will produce a sheet of all the images in a folder, together with their file names if required. This is very useful for sending to clients to accompany a CD-ROM, for example. The other feature, the Picture Package, will place a number of different-sized versions of the same image on a canvas for printing. This is very useful for school and wedding photographers selling print packages to clients, giving perhaps one large, one medium-sized and four small prints on the same sheet of paper, for example.

Scientific image analysis programs

Scientific image analysis programs such as MATLAB have been available for PCs for a few years and several are now available for the Macintosh platform as well. Like the retouching and manipulation programs, there is a wide variety, many with very specific uses. They are often used by biomedical photographers, for example, for analysing microscope images or electrophoresis gels, by forensic units of police forces for taking measurements from scene of crime pictures, and remote sensing units for analysing data from satellites. At least one is available for analysing sporting motion, being able to calculate velocity, plot trajectories of throws, etc.

For this book we will use the example of a public-domain software program known as NIH Image (for the Macintosh), which has recently become available for the PC where it is known as Scion Image. It can be downloaded from the sites listed at the end of the book. It is capable of many of the functions of other programs and is highly recommended.

In many respects, at first sight, an image analysis package such as Image 1.6 is similar to a program like Photoshop, with a toolbox containing selection tools, pencils and brushes, and a menu bar with menus for adjusting modes of display.

Figure 6.25 Screen shot of Image 1.6, showing image, 'histogram', 'info' and 'map' windows.

Also like Photoshop, various filters are available for increasing sharpness and reducing noise.

The main purpose of the program, however, is to analyse images and gather data from them. The programs can count particles, measure areas, lengths or perimeters, measure densities and produce density plots from a line drawn across an image. This is commonly used, for example, in the analysis of electrophoresis gels in biology laboratories (a scanner can, in effect, be converted into a densitometer for various photographic purposes). Density slices can be made from an image, highlighting all parts of an image having equal density. Several examples are shown in Figure 6.26.

Filters

Image analysis programs have a similar range of filters to Photoshop (Image 1.6 can also support several of Photoshop's plug-in filters such as digital camera acquire software), such as the sharpening filter, but also include many others to enable photographers and scientists to extract information from images. Specialist filters with names like Laplacian, Sobel and 'Mexican Hat' can, for example, isolate vertical or horizontal lines, sharpen or reduce 'noise' in images. Filters can be written in word-processing programs by typing a grid of numbers, saving it as a 'text' file, and applied to images through the 'convolve' command.

Image can support a number of frame-grabber cards, and can be used for simple animation techniques. A number of separate images, perhaps from a time lapse sequence, can be stacked together and animated. The software will cycle through the stacked frames and play them like a cine projector. Areas

Figure 6.26 (a) Photomicrograph of blood cells; (b) 'surface plot' command; (c) blood cells with 'density trace' along dotted line; (d) blood cells with histogram; (e) original blood cell image; (f) using 'threshold command'; (g) using 'analyse particles' command to count and measure cells; (h) time-lapse sequence of images, which can be animated if required.

of the images which have not changed will remain static, whilst areas that have changed, perhaps a plant growing for example, will show as movement. If the interval between the images is known, then growth rates can be calculated.

A fundamental feature of Image is the ability to write one's own 'macros' (small programs deigned to automate complex or repetitive tasks) in the Pascal-like programming language used by the software. Consideration of this is beyond the scope of this book, but many readers will find this program very useful for this type of work. Image is supported with an excellent Web site, with downloadable images and macros, manuals for various techniques, and several user groups.

Other programs

Whilst Photoshop and similar programs are the ones most likely to be used by photographers for the bulk of their work, a number of other image-processing programs are available which tend to perform a smaller range of functions, often of a very specific nature. For example, 'Goo' from Metatools allows users to distort images to produce often bizarre effects, and even link several together to produce animated sequences (Figure 6.27)!

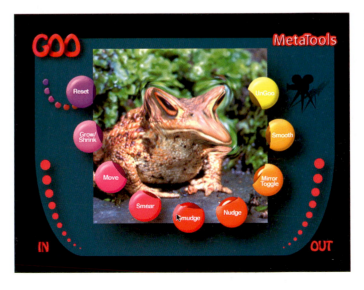

Figure 6.27 Screen shot of 'Goo' for producing bizarre distortions.

Another type of program, for example PhotoVista, is one that can 'stitch together' a continuous series of landscape images to produce 360° panoramic images. These can produce remarkably good results, making seamless joints.

Training packages

Recently, a number of multimedia training packages on CD-ROM have become available for teaching the use of programs like Adobe Photoshop. These usually have video sequences of various operations being carried out, including commentary by the operator. They are an excellent way of learning a program and are to be recommended.

Other types of software for digital imaging

Image databases

One major sector of the photographic industry eager to utilize the technologies of digital imaging are picture libraries and archives. Some libraries are looking to the technology to store digital copies of their images, whilst others are thinking of replacing their printed catalogues with CDs, which can also contain keyword search databases. Obviously, for a library consisting of perhaps several million images, huge databases are required. However, for the individual photographer with perhaps several thousand images, smaller programs are available which are nonetheless very powerful in their search and retrieval capabilities. Examples are Extensis Portfolio, Canto Cumulus, and Digital Catalogue. Photographs can be given a number of keywords to describe them, which can be compiled into a database. The user can sort through images of different file types using low-resolution thumbnails on the screen and keyword search databases. Most of the programs available can handle several thousand images, whilst Digital Catalogue can theoretically handle 13 million. Each of these images can have up to 14 pages of text associated with it, each word of which can be used as a 'keyword' for search purposes. With many image libraries now digitizing their collections, it is becoming increasingly important to provide captions suitable for 'keywording'. An image of a Badger, for example, might have the following keywords associated with it:

Badger, *Meles meles* (Latin name), **Nocturnal** animal, **Woodland mammal**

Optical character recognition (OCR) for scanners

Whilst not strictly an imaging program, many photographers will find this software very useful. Pages of text, either typed or printed, can be scanned on a flatbed desktop scanner and the text read and converted into a format readable and editable by a word-processing package. Most of the software available nowadays, for example Omnipage and TextBridge, is very good and will

recognize pages of typed and dot matrix printed text as well as good-quality laser printing. It works best with plain typefaces such as Times or Helvetica, in sizes from 9 to 12 point. It is not so efficient with type that is too large, or printed on poor paper where the ink has spread.

Desktop publishing

With the ability to design and lay out brochures, magazines and books on the computer screen, desktop publishing revolutionized the publishing industry in the 1980s. A basic grid layout is designed, as a master page, onto which text, graphics and photographic elements can be imported. The text can be 'flowed' around the graphical elements, including 'clipping paths' imported from Photoshop, whilst boxes can be drawn and filled with greys, colours or textures. Many desktop publishing programs have powerful imaging facilities within them, particularly for separating the image into its CMYK components (although most bureaus and printers would recommend that they are sent 'RGB TIFF' files, and perform the separations themselves, as they know the characteristics of their output device and the requirements of the separations). Probably the best known of these programs are QuarkXpress and Adobe PageMaker (now superseded by InDesign), both of which are available for both Macintosh and PC platforms. Generally, images need to be imported as TIFF or EPS files, usually at low resolution to act as guides for the designer (known as an FPO – 'For Position Only'). When sending material to a printer or bureau for output, it is necessary to leave the FPO in the document, and also include the original picture files so that they can be output correctly by the imagesetter. For example, if you are sending a photographic TIFF file and a piece of artwork saved as an EPS file created in a drawing program, both the original TIFF and EPS files must accompany the document file to the printer. Both programs can import images directly from PhotoCDs.

As well as page layouts, desktop publishing programs are excellent for producing photographers' letterheads and invoices and the like. The letterhead can be saved as a master page onto which letters and other documents are added. This can then all be printed as one document, reducing the need to have large quantities of stationery printed at one time. This can be done relatively cheaply now in colour, on small desktop colour ink jet and other types of printer.

Electronic publishing software

Many documents, such as instruction manuals, or technical papers, are now published in electronic form, available either on CD-ROM or from the

Internet. It is very important that such documents appear the same irrespective of the computer platform they are viewed on. Any diagrams, fonts or digital images must appear the same whether viewed on a PC or Mac, for example. One way of achieving this is to produce a PDF (Portable Document Format) file, using Adobe Acrobat. There are several different components to Acrobat. Distiller is used to create the PDF files, whilst Adobe Acrobat Reader is used to view them. The Reader software is freely available on the Adobe Web site.

Painting programs

Several programs such as Fractal Design Painter are available where photographic images can be painted over to give the effect of oil paint or various other textures and effects. These are best used in conjunction with a digitizer tablet and pressure-sensitive stylus, enabling various amounts of 'paint' to be applied.

Presentation and multimedia programs

Whilst 35 mm slide projectors will survive for a good few years yet, many computer programs are now available enabling photographers and others to produce high-class presentations for conferences and seminars and the like. They are much more versatile than the conventional multi-projector presentation as all types of elements from single photographic and graphic images to animations and even video clips can be incorporated into the same presentation. This can be easily edited on screen, without the need for producing new 35 mm slides, although the information can be output to slide via slidewriters if required.

Video or data projectors are now extremely high quality (and although expensive, the price is falling rapidly), and remove the need for several slide projectors to be aligned together. Probably the commonest example is Microsoft Power Point. With these programs, a 'master' slide or template can be made consisting of such items as a background, logo or frames, into which the various elements can be placed. The prepared slides can be viewed as a set, on a 'lightbox', and their order changed by dragging them into new positions. Various transitions such as wipes and fades can be set when the slides change. When preparing images for these presentation programs, it is important to remember that they will only be viewed on a computer monitor at 72 dpi for example, so resize the image for this resolution.

True multimedia presentations are now relatively easy to produce using programs such as Macromedia Director and Macromedia Authorware. Here,

graphics, animation, video, high-fidelity sound (including musical instruments via MIDI – musical instrument digital interface) can all be combined into highly complex presentations. Multimedia 'authoring' requires all the skills of the film director, with scripting and storyboarding, with the added dimension of possible interactivity with the viewer.

Video editing

Over the last couple of years, huge advances have been made with the handling of video on small desktop computers. Video digitizers are available for most desktop computers which will digitize video sequences (and their associated sound in some cases) from a variety of sources such as video tape and camcorder. This can be edited on screen using programs such as Adobe Premiere which can link sequences together with a huge variety of wipes, fades and other transitions, and mix sound with the video. Some computers and various video boards will convert the digital video to analogue and output it back onto video tape. Video requires huge amounts of storage space. As an example, a high-resolution 13-inch monitor has 307 200 pixels (640 × 480 pixels). In 24-bit colour mode, each pixel must represent 24 bits of information (8 bits for each component of the RGB signal). With 8 bits to one byte, 24 bits is equal to 3 bytes. Thus each frame of digitized video is 307 200 × 3 = 921 600 bytes. At 30 frames per second, 2 seconds of digital NTSC video will take up more than 54 megabytes!

A typical 10-second sequence captured from a colour video camera will take up around 8 Mb of disk space. As with still images, a number of compression routines are available, for example MPEG, which reduce the storage space required.

All Macintosh computers and PCs with Windows 98 have 'QuickTime' software, which is an extension to the system software. It allows the user to play and record dynamic time-based data as opposed to static data such as text and still images. QuickTime incorporates two types of compression – 'temporal' and 'spatial'. Spatial compression reduces information within a single frame by looking for areas of even tone. In an image with a black background, rather than identifying pixel 1 as black, and 2 as black and 3 as black etc., it identifies the groupings of black pixels. Temporal compression works by describing changes between frames – a process known as 'frame differencing'. QuickTime 'movies' can be copied and pasted into other documents, and are being used increasingly for teaching and training applications, where instructions in the form of text can be supplemented with a video clip showing the actual operation of a piece of equipment, for example. On PCs, Video for Windows has recently become available, which performs a very similar task.

Photoshop techniques

The following examples, aimed specifically at photographers, demonstrate just a few of the myriad effects capable with Adobe Photoshop. It is not intended as a comprehensive listing, but merely to demonstrate the potential of Photoshop for photographers. A feature of digital image processing is that there are usually several different ways of achieving an effect, so the techniques illustrated here may often be achieved by other methods.

Retouching an old photograph (Figure 6.28)

This sepia-toned and faded photograph from the 1940s was scanned at high resolution on a flatbed scanner in RGB mode. It was converted to greyscale mode (Image > Mode > Greyscale). The density and contrast of the image were adjusted using the levels control and paintbrush.

A number of blemishes were removed using the cloning tool and paint-brushes. When using the cloning tool, try using either the lighten or darken blend modes. In lighten mode, for example, only pixels darker than the blend colour are replaced.

Two final versions were created. First, the image was duotoned (Image > Mode > Duotone). Various combinations of black and orange colours were tried until an appropriate colour was discovered. (Photoshop is supplied with a number of pre-set duotone colours: load these from the 'Duotones pre-sets' folder found in the Goodies folder created on the hard disk when Photoshop is installed.)

Second, the image was hand coloured. It must first be converted to RGB mode (Image > Mode > RGB), when it will now take the colour painted with brushes or pencils. Use the 'color' blend mode when painting so that the colour is applied in proportion to the underlying pixels, thus retaining all the underlying detail. The actual colours used here were determined by the author, and probably bear no resemblance to the original clothes! Skin tones in particular are very difficult to make so that they look natural.

Painting with a sharpening filter (Figure 6.29)

Whilst it is possible to select an area of an image and apply a filter to that area, one interesting technique is to effectively paint with a filter, such as an unsharp mask or Gaussian blur. The technique relies on the use of the layer mask facility in Photoshop. The technique is as follows:

1 Open the layers palette (Window > Show Layers), and rename the background by double clicking on it.

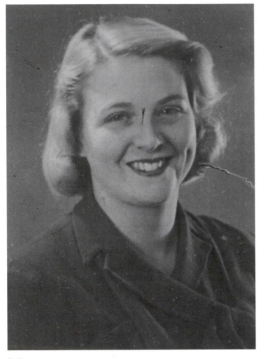

(a)

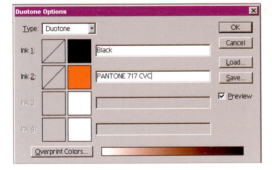

(b)

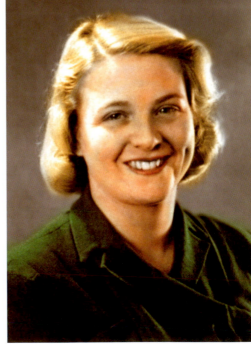

(c)

(d)

Figure 6.28 Retouching an old photograph. (a) Original; (b) sepia box; (c) sepia tones; (d) hand colours.

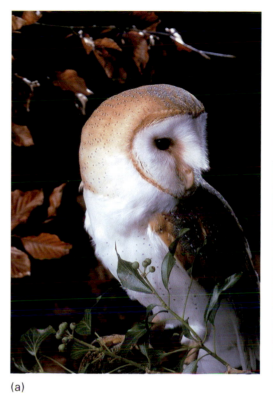

(a)

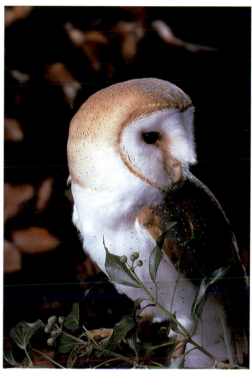

(c)

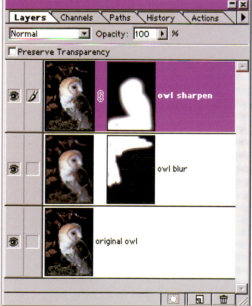

(b)

Figure 6.29 Painting with a sharpening filter. (a) Original; (b) layers; (c) final.

(a)

(b)

(c)

Figure 6.30 Simulating the effect of a graduated filter. (a) Original; (b) gradient; (c) layers; (d) final.

(d)

2 Duplicate the layer by dragging it to the 'new layer' icon at the base of the palette.

3 Apply an unsharp mask filter to the copy layer (try using a large amount, even 500 per cent – the effect can be reduced at a later stage).

4 Create a layer mask by clicking on the layer mask icon.

5 Fill the layer mask with black, at 100 per cent opacity in normal mode (Edit > Fill > Black). This will effectively place a mask over the filter.

6 Set the foreground palette to white.

7 Select an appropriate brush and paint the image in those areas that you want the filter to affect. The white paint is basically making a hole in the black mask and will appear in the mask icon in the layers palette. Try reducing the opacity of the paintbrush. This will paint a grey hole rather than a clear hole in the mask and thus change the effect of the filter.

8 Go through the above sequence and make another layer, this time with a Gaussian blur filter. Now different areas of the image can be selectively sharpened or blurred to different degrees.

Simulating the effect of a graduated filter (Figure 6.30)

Many photographers, particularly landscape photographers, use graduated filters to darken or colour a sky. The effect of such a filter can be reproduced using the gradient tool and the layers features of Adobe Photoshop. The basic idea is to create a window the same size as the image and put a gradient into this window which will be laid over the image and blended into it as appropriate.

1 Use the command 'select all' and copy the image into the memory of the computer.

2 Make a new window (File > New). The dimensions shown in the dialog box are those of the image held in the memory of the computer.

3 Select a colour in the foreground pallette of the toolbox. This might be a neutral grey or a colour such as blue. Double click on the linear gradient tool and select the gradient 'foreground to background'. Use the edit command to adjust the amount of foreground to background colour. In this case, the colour is limited to a very small area.

4 Drag the gradient tool from top to bottom of the new blank window. This will produce a gradient from colour to white in the window. (A note here about printing gradients – if you experience banding when printing gradients, try applying a small amount of 'noise' to it.)

5 Use the 'select all' command and copy the gradient 'filter' into the computer memory.

6 Go back to the image window and 'paste' the filter over the image. This will disappear.

7 Open the layers palette and notice the original background image, and layer 1 on top of it. Use the blend command, select the mode 'multiply'. This mode multiplies the underlying pixels by the values on the layer. So pixels at the bottom of the image are multiplied by nothing, whilst those towards the top of the image are multiplied by an increasing amount.

The effect can be further controlled by altering the opacity of layer one to make the effect more subtle if required.

Sharpening in Lab mode (Figure 6.31)

When applying a sharpen filter in RGM mode, all three colours are affected, possibly leading to colour artefacts, as shown in Figure 6.31(b). A much better

(a)

(c)

(b)

(d)

Figure 6.31 Sharpening in Lab mode. (a) RGB raw; (b) RGB USM; (c) Lab Channels; (d) USM Lab.

(a)

(b)

(c)

Figure 6.32 Simulated false colour infrared images. (a) Visible; (b) infrared; (c) false colour.

method is to convert the image to Lab mode and apply the sharpen filter to just the lightness (luminance) channel. This sharpens the detail part of the image without affecting the two chroma (colour) channels. This works particularly well with fine detail, as shown here, or perhaps images of people with fine hair detail.

Simulated false colour infrared images (Figure 6.32)

To produce a false colour image, similar to that produced by Infrared Ektachrome film, two images are required, an ordinary RGB image of the subject and an infrared version. Infrared colour film is sensitive to green, red, and infrared light. During the process of dye formation during colour processing, yellow dye is formed in the green layer, magenta dye in the red layer, and cyan dye in the infrared layer. The result is a false colour image, with subjects given different colours according to how much infrared they reflect. To simulate the effect the following technique can be used:

1 Capture the same scene in both RGB and infrared using the Wratten 87 filter. It is essential that there is no movement between the two images, so a tripod will be required.
2 The infrared image is coloured cyan. Open the foreground palette and set the G value to 255 and the B value to 255. Convert the image to RGB and use the commands edit > fill > foreground colour, 100 per cent, SCREEN mode.
3 Open the RGB image and in the SHOW CHANNELS menu go to the split channels option. Delete the blue channels, then colour the green channel yellow (R – 255, G – 255), and the red channel magenta (R – 255, B – 255), as in stage 2.
4 Combine the three images together by dragging the layers on top of each other, and using the MULTIPLY mode in the layers palette.

It is likely that the infrared image will be a slightly different size due to the focus shift which occurs with infrared wavelengths. This will make perfect registration of the three images almost impossible.

'Creative imaging' with Photoshop (Figure 6.33)

Photoshop and other similar programs are giving artists and photographers new opportunities for creative imaging. The example shown here is by the photographer Luzette Donohue. Rather than a step-by-step guide to its production we have shown the component images and the final result. The components are a scanned image of a page of poetry, a scanned leaf, a photograph of a horse statue, and a blue texture, again scanned. The final image relies heavily on the use of layers, and the various blend modes including darken, soft light and overlay modes.

(a) (b)

Figure 6.33 Creative imaging with Photoshop. (a) Components; (b) final image. (Image by Luzette Donohue.)

7 Image output

Digital image files can be printed either directly as bitmapped images or as part of a desktop published page layout with text and possibly other graphics. In this case the page will be saved as a PostScript file and the images saved as bitmaps within the Postscript file.

Graphic file formats for printers

There are two common methods of representing images in the computer – bitmapped files and PostScript descriptions. Most printing devices are designed to print one or the other type of image.

Bitmapped images

These include file formats such as TIFF, PICT, JPEG, etc. In a bitmapped image the elements of the picture are mapped as individual screen display pixels. The image is stored in an array of binary information. Each pixel of the picture is represented by one bit or binary piece of information (in the case of a greyscale bitmap each pixel requires 8 bits which can represent 256 levels of grey).

Magnification of a bitmapped image will show the individual pixel elements in its construction.

PostScript files

'PostScript' is an interpreter between the computer and the output device. The PostScript file translates the picture into a series of PostScript graphic drawing routines with a degree of resolution much finer than can be represented on the screen of the computer. The image of a house could, for example, be represented by a square with a triangle on top. In the PostScript system, enlarging this image would only create a larger square and triangle. The bitmapped image would break down into the dots forming the lines of the square and triangle.

PostScript cannot record photographic images but it can handle text and graphic elements with great effectiveness. In a PostScript file photographic elements are saved as bitmaps. The system is slower to print these pictures than

a dedicated bitmap printer. Bitmap printers will print photographic elements faster and better than a PostScript printer but the quality of text and graphic elements will not be as high. The main reason why PostScript has become the industry standard for sending desktop published pages to printers is that it is device independent. In other words, the graphical objects are defined mathematically, and it is not until the page is output onto paper that it takes on the resolution of the printer being used. The PostScript version of a printing system will normally cost more due to a licence fee payable to Adobe, the authors of the technology.

Printing 'photographic' images

The printing of digital, continuous-tone (photographic) images varies enormously, and the quality of the output will be dependent on the type of output device and the technology used. In order to understand the shortcomings or advantages of the various methods, an explanation of the various methods used to emulate continuous tone is necessary. We first need to examine the two commonest forms of colour image, photographic images, and images on a printed page.

Photography

In colour photographs the colour is generated by having three layers of dye, each layer corresponding to one of the primary colours, red, blue and green. Dyes are formed of a complementary colour to the layer in which they are formed, i.e. yellow dye is formed in the blue-sensitive layer, magenta dye in the green layer and cyan dye in the red layer. The silver halides in these layers are converted into microscopic dye clouds, and due to the fact that each layer is transparent, a full, continuous spectrum of colours can be reproduced. The colour is controlled by increasing the density of the dye to increase the saturation of the colour. Examination of the photographic image under a magnifying glass will show a seamless graduation of colour and shade. This type of image is termed 'continuous tone'.

The printed page

Photographic images are printed (using either lithography or photogravure) in books, magazines and newspapers by a process known as halftoning. This is a method of representing the images as groups of differing size dots from the four inks used, cyan, magenta, yellow and black. The system produces all other

Figure 7.1 Magnified view of halftoned image showing structure of the halftone dot image. (Original photograph courtesy Kodak/Bob Clemens.)

colours by printing mixtures of these inks and by altering the size of the dots to visually emulate the new colour. When viewed from a distance, the impression is given of a full-coloured image. For example, a chequered pattern of cyan and yellow will appear green to the viewer at a distance. Close examination of any published image with a magnifying glass will show the individual dots. The size of the smallest dot is dependent on the quality of paper. Cheaper paper such as newsprint is more absorbent and the size of the dot will spread (dot gain) into the fibres of the paper. The higher the quality of the paper the smaller the size of printable dots (see Figure 7.1).

In the digital publishing environment neither of these technologies lends itself to the production of a unit either affordable or small enough to be suitable for a desktop unit. Several different technologies are available, but first, the decision has to be made as to the purpose of the output and the quality required.

Output devices for digital images fall into two main categories: printers and proofers. Printers are designed to produce prints on paper which can be used in display albums or for exhibition purposes, for example. Proofing devices are designed to produce an emulation of how an image will appear when it appears on a printed page. The following types of printer are currently available.

Laser printers

Primarily designed as black and white printing devices, good-quality colour lasers are becoming increasingly common. Their price has fallen substantially over the last couple of years and the quality of colour reproduction has increased greatly.

Operation

The printer contains a rotating metal drum coated with a fine layer of photo-sensitive material. An electrostatic charge is applied to the whole drum. This charge on the drum can be removed by applying a light to its surface. The image to be printed is applied to the drum via a laser beam or row of LEDs (light-emitting diodes). A negative image of the subject to be printed is projected onto the surface of the drum The result of this is to 'undraw' the image on the drum as it rotates. The process is similar to producing a statue by chipping away all pieces of stone until the statue is complete. The end result of the operation is to leave an 'image' of the original as an electrostatic charge on the drum. The drum rotates past a toner dispenser containing ink. The ink used has an electrical charge and is attracted to the charged image on the drum. This can then be transferred onto paper by giving the paper the opposite electrical charge. The ink is then attracted from the drum onto the paper, the paper giving a black ink

image on the paper. The light source scans across the surface of the drum forming the image by a series of overlapping individual dots. The minimum size of the dot is the width of the light beam as it is focused on the drum. This means that all images are formed by multiples of a single dot. Note that the size of this dot does not change – larger dots can be formed by groups of overlapping dots. Colour laser printers use four drums, and store image colours in cyan, magenta, yellow and black elements (see Figure 7.2).

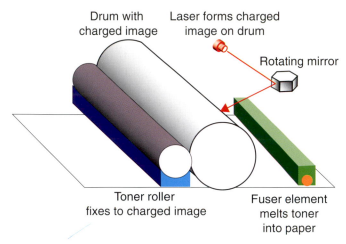

Figure 7.2 Laser drum.

Photocopiers uses the same laser technology in constructing their copies, the only difference being the method of inputting the data to be recorded onto the drum. Several models are available of large colour photocopiers working in a dual mode, either scanning the flat copy in a similar method as the flatbed scanner system or via a computer linked directly to the printer with the information being fed to the laser drums via a dedicated computer running a Raster Imaging Program (RIP). Units such as this can provide up to A3 size output.

Thermal wax transfer

This printing method works by heating a coloured wax sheet and melting it onto a paper surface. The wax is transferred or 'ironed' onto the paper by thousands of individually controlled heating elements each heated to 70–80°C which will melt a tiny pinpoint of colour. Colour is created by a four-pass system, cyan, magenta, yellow and black. These units tend to be relatively inexpensive, but do not produce true photographic quality prints.

Ink jet

The cheapest yet possibly most improved form of computer printer is the ink jet printer (although 'high-end' ink jet printers, such as the Iris range, producing 'photographic quality' prints in large sizes, are available). They generally use four ink cartridges each filled with cyan, magenta, yellow and black ink, though an increasing number of 'photo' models have been introduced specifically for the printing of 'photographic quality' images. These use five coloured inks: cyan magenta, yellow, light cyan and light magenta plus black. The addition of the pastel inks allows much finer tonal gradations on areas such as skin tones and graduated backgrounds.

The cartridge contains liquid ink which is forced into a tiny nozzle by the application of heat or pressure. Several manufacturers, such as Canon and Hewlett-Packard, use a thermal technology whereby the specially formulated ink is heated rapidly in a tiny chamber in the print head, where it forms a tiny bubble at the end of the nozzle, hence the common name of 'bubble jet' printers. The size of the droplets can be many times smaller than the width of a human hair. For example, the size of ink droplets with some Epson printers varies between 3 and 6 picolitres (1 picolitre = 0.000 000 000 001 litre!). The ink is ejected through microscopic nozzles onto the paper.

The other major system adopted by Epson printers uses 'piezoelectric technology' instead of the heat process. Piezo crystals control tiny pumps which can fire the ink droplets at the paper with high speed and great accuracy. (Piezo crystals oscillate, and change their shape when a voltage is applied – this piezoelectric effect is used in various devices such as crystal microphones and strain gauges.) The shape, size and sharpness of each dot can be determined with great accuracy – some Epson models can produce up to six different droplet sizes (Figure 7.3).

Inks too have improved enormously recently, with new versions being quick drying, meaning less spreading as they hit the surface of the paper, leading to sharper images.

All ink jet printers work best with dedicated paper types, as the absorbency of the paper controls the brightness and definition of the image. It is worth testing several different paper types and surfaces, as surprising differences in quality will be found even between two 'photo quality glossy papers', for example. Even the base white may vary from one manufacturer to another, leading to colour changes in the images. It is important to read the recommendations supplied with the paper regarding printer settings, as these will govern the amount of ink put onto the paper. Too much ink will lead to 'bronzing', for example, where shadow areas may exhibit a metallic sheen where the ink has not been absorbed by the paper. Ink jet papers are made in a wide range of

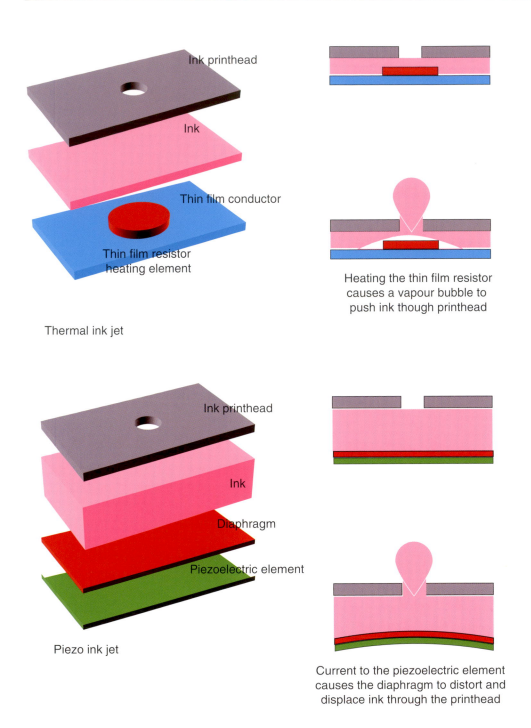

Figure 7.3 Diagram of ink jet delivery system.

surfaces such as watercolour, canvas and satin, and several are available as double-sided papers. It is possible to use good-quality 'art' paper for exhibition purposes and experimentation is worth while.

Recently, there has been much controversy surrounding the permanence of ink jet prints, with many tests indicating that ordinary ink jet prints may start to fade within weeks of being produced. The problem is twofold – the inks fade, but the situation is aggravated if the paper has a high acid content. Several companies, including Lyson, have produced a range of archival quality inks and papers, claiming a life span of up to 60 years. New models of the Epson printer now use archival inks too.

In June 2000, Epson announced a new system using pigments rather than inks. The pigments adhere to the surface of the paper rather than penetrating it. Epson claim a possible life of 100 years when used with suitable papers. No further details were available at the time of writing, but one reviewer who had seen prints from the new system said they were easily as good as conventional photographic prints.

Although the printing process is slow, the technology has the advantage of working at any size and by a process of scaling up the transport mechanism and the size of the nozzles, printers can be made to output prints A0 size and larger.

Resolution

The resolution of laser, thermal wax and ink jet printers is normally quoted in dots per inch, typically 300–600 dpi, although several recent ink jet models quote 720 and 1440 dpi. This measurement is somewhat deceptive, however, as it refers to the number of overlapping dots that can be printed in a line length of one inch. The actual number of visually separate dots is much lower than this. For example, a 720 dpi printer will give optimum results when printing an image with a resolution of around 240 dpi, whilst a 1440 dpi printer requires images at around 360 dpi. These figures should be used as the starting point for experimentation, and will vary according to paper type etc. However, it is important to note that there is no point in having images of higher resolution as any extra information is 'wasted', and in some cases resampled down by the printer software.

Laser, ink jet and thermal wax printers all use opaque colours to produce their images, so the photographic technique of dye formation to simulate colours is not applicable. The solution to the problem is to introduce simulated halftone representation or 'dithering'. This should not be confused with halftoning in its more established form. In its simplest form, representative halftone is a method of representing greyscale.

The representative or simulated halftone

The complexity of the halftone system will depend on the number of different shades that the image will show. Different tones are produced by creating larger groups of dots in different patterns to represent the different shades of tone or colour in the image.

In the simplest example a matrix of two by two dots can represent five separate tones (see Figure 7.4):

1 No dots yields white.
2 A single dot yields 25 per cent grey.
3 Two dots yield 50 per cent grey.
4 Three dots yield 75 per cent grey.
5 Four dots yield 100 per cent black.

The above could equally apply to shades of a colour. By increasing the size of the matrix the number of tones will increase. By increasing the matrix to four

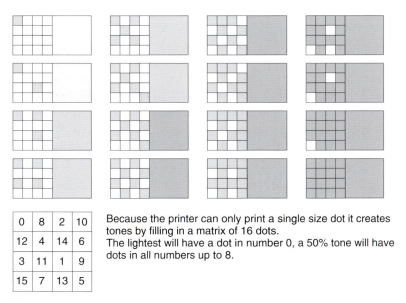

0	8	2	10
12	4	14	6
3	11	1	9
15	7	13	5

Because the printer can only print a single size dot it creates tones by filling in a matrix of 16 dots.
The lightest will have a dot in number 0, a 50% tone will have dots in all numbers up to 8.

Figure 7.4 Illustration of a 4 × 4 cell to represent 17 tones.

by four the system is capable of printing the 17 tones from 0–16. With a similar colour dithering pattern, using the cyan, magenta and yellow colours, a representation of all other colours can be achieved. Ink jets use different methods of creating the illusion of colour, different manufacturers often giving them different names.

File size for simulated halftone devices

The effect of the simulated halftone is to reduce the effective resolution of the printer from the quoted lines per inch to a figure derived from the lines per inch divided by the size of one side of the matrix. Therefore in a black and white laser capable of 600 dpi which claims to print 256 shades of grey, the effective resolution is: 600 divided by 16 = 37.5 dpi.

Therefore, to print a 4-inch × 4-inch image the required file would only be recording the difference between each group of 16 × 16 at 37.5 dpi = 22 Kb as opposed to sampling at 600 dpi = 5.5 Mb.

Although other factors have been introduced to improve the quality of the simulated halftone system, it is worth testing any printer by producing a series of sample files and printing them until quality becomes affected in order to establish the optimum size versus quality.

The other drawback of the simulated halftone is the effect of banding where the dots form patterns within the image. To improve the quality of simulated halftoning laser printer manufacturers have introduced the capacity to produce two sizes of dots to give smoother edges to the dot groups.

In the ink jet field, developments in paper technology, the ability to produce varying dot sizes, and the use of transparent inks allow output approaching continuous tone. Generally, two methods are available for halftoning, either 'dithering' or 'error diffusion'. Dithering aligns dots of different colours uniformly to create the appearance of colour. This method is appropriate only for 'graphic' type images such as charts and graphs. Error diffusion, on the other hand, places individual dots in a random pattern to create colour. Using this method, the printer can achieve much better gradation of tone and colour, and produces excellent 'photographic-quality' images when used with the right paper.

Continuous-tone printers

These devices use the photographic principle of laying down transparent dyes on top of each other to create the colour. The technique also utilizes a slight blurring of the individual elements of dye to allow blending between adjacent elements of image to give the appearance of continuous tone.

Thermal dye sublimation printer

This type of printer has become very popular in recent years, with improvements in both speed and quality of the image produced. The printer uses a system of

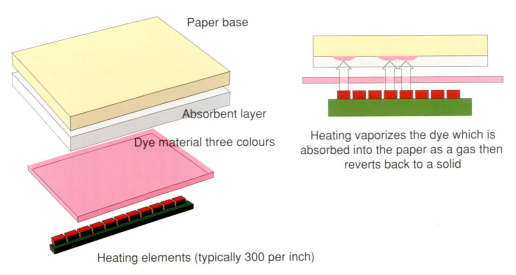

Paper base

Absorbent layer

Dye material three colours

Heating elements (typically 300 per inch)

Heating vaporizes the dye which is absorbed into the paper as a gas then reverts back to a solid

Figure 7.5 Thermal dye sublimation printer.

transferring a dye from magenta, yellow, cyan and, in some machines, black ribbon onto a paper surface (Figure 7.5). A heating element the width of the paper vaporizes (the word 'sublimation' means passing from a solid to a gas without becoming a liquid first) the dye on the donor ribbon surface which is then absorbed into the surface of the paper. The image is generated by applying three or four passes of the donor ribbon to a single sheet of paper. The registration of the paper is crucial to the quality of the final image. As the dye is transparent, each pixel on the page can represent any colour by varying the amount of the three or four colours. The action of the dye in being absorbed into the paper also means that the individual pixels join together to form a seamless area of colour similar to a true photographic print.

Most models incorporate a fourth element to the ribbon, an ultraviolet laminate, to prevent fading of the prints.

Pictrography

A proprietary system developed by Fuji, Pictrography uses laser technology to beam the image onto a chemically impregnated donor sheet inside the machine. A three-colour laser diode is used to give a one-pass exposure to red, green and blue light to form the image on the surface of the donor material. This is then brought into contact with the paper surface and heated. The activating element in the system is a small amount of distilled water which is removed by the heating process. The donor sheet remains in the body of the printer and, as the

process uses a silver-halide-based system, the silver can be recovered from the donor sheets.

Originally A4 size only, the system can print up to A3 at a resolution of 400 dpi. The machines are relatively expensive when compared with dye sublimation, whilst the cost per print is similar.

These printers will deliver results almost indistinguishable from a photographic print, although they all require the use of special dedicated papers to print the image. Prints from early dye sublimation models suffered from fading, but later models have lamination layers with incorporated ultraviolet filters. Also, they should not be stored in PVC wallets, as the gases in PVC will bleach out the dyes.

Colour proofing

The process of creating a colour facsimile for approval by the client before the print run goes ahead has long been an established practice in the publishing world. This requirement is necessary because a print run may number tens of thousands of copies, and any mistakes or changes in the colour, images or text must be corrected before the print run is started. There are several classifications of proof and various methods of production: positionals, position proof, composite, for position only (FPO), and black and white comps. These are representations of the various elements that make up the page. They show the structure only, and make no attempt at colour accuracy.

Soft proof or on-screen preview

These are the pages as seen on a computer monitor. The colour, contrast and resolution are limited by the calibration and construction of the monitor, and bear no relation as to how the images will appear on paper. Always bear in mind that the monitor display is composed of glowing phosphorescent dots, whilst the printed output will be composed of ink or dye on paper. Standard viewing conditions for the monitor are essential, excluding the effects of variable daylight or artificial lighting.

Typical 'position proof' devices include: thermal wax printers, low-cost ink jets, laser printers and colour photocopiers.

Digital proof or colour comp

This is an attempt to represent the page content and colour using a technology other than the ink on paper process. The danger here is that the gamut of the two output devices may differ substantially. The process can give a

good result if the image is modified by a colour space system to represent the limitations of the CMYK colour space of the final published result. This manipulation of the image requires a skilled operator who is aware of the input and output profiles of the input device and target device, as well as the intervening processes that will affect colour. The major drawback of this type of proof is that the actual structure of the image will differ from the printed page.

Typical 'digital proof' devices include: high-end ink jets (e.g. Iris printer) and thermal dye sublimation printers.

Contact proof or separation-based proof

This attempts to simulate the actual dot structure, dot gain and colour of the final printed page. This is more accurate but expensive. The four separations (CMYK) are created as four separate sheets on clear film and viewed together in a register termed an 'overlay proof', or alternatively the four colours are created on layer material and laminated onto a single sheet termed a 'laminated proof'.

Typical 'contact proof' systems

Matchprint
This is a system devised by 3M which uses a system of creating four colour CMYK separations using the same data that will generate the final printing plate. Each separation is placed on the relevant coloured laminate and the resulting sandwich exposed to ultraviolet light. The coloured laminate softens when exposed to the light, and a process is then applied to remove the softened areas, leaving a positive image of each layer constructed of the same dots as the printed page. The process is applied to the four layers of coloured laminate which are then bound in register and sealed.

Cromalin
A solution produced by the Dupont Company uses the same technique of generating the four separations, CMYK. However, the separations have a laminate applied to the backing of each film. The action of exposing the film to ultraviolet light hardens the exposed areas and leaves the unexposed areas with a sticky surface. After each exposure the laminate is passed through a processor containing finely powdered pigment of the appropriate colour which adheres to the surface. After all four layers are assembled the surface is covered with a protective film and the composite layers hardened.

Although expensive to produce, these proofs do use the same dot structure and colour gamut as the final printed page.

Kodak approval system

This is a thermal dye sublimation system that uses the same dot structure to print the four colours onto the page. The dye ribbons in the printer are calibrated to the output inks, and the system has the great advantage of being able to print the image onto the same paper stock as the final printed page.

Press proof or press check

The final and most expensive form of proof is a page printed using ink from the actual plates that will print the page. The process of making the page is complete and this is the final opportunity for checking that everything is acceptable. Any correction done after this stage will be very expensive as the plates will have to be remade.

Printing to film

Many designers, picture researchers and art buyers are happiest when dealing with transparencies rather than proof prints. Several ways of outputting digital information to film exist.

Presentation graphics

Most printing devices, such as thermal dye sublimation and ink jet, offer the option of printing onto film (acetate) rather than paper. The quality of the output will be directly proportional to the paper output quality, but will usually be good enough for projection on overhead projectors, but not generally for reprographic purposes. To output an image onto silver-halide-based film requires a large amount of data.

Analogue film recorders

These use a cathode ray tube onto which the image is projected. The film is exposed three times, through red, green and blue filters. The size of the electron beam is in the region of 20 microns, but will vary according to the size of the film format being imaged, being around 3 microns for 35 mm, 6 microns for 6 cm × 6 cm, and around 12 microns for 5-inch × 4-inch film. The electron beam scans the image area exposing each individual pixel in turn, successively through red, green and blue filters (Figure 7.6).

Film recorders depart from convention by expressing their resolution in 'K' rather than dots per inch. K refers to the number 1024, meaning the 'address-ability' of the system. Typical values are 2 K, 4 K, 8 K and 16 K. Addressability is the maximum number of pixels recorded across the length of the film output. For example, a 2 K film recorder will expose 2048 pixels in the 1.5-inch (35 mm) length of 35 mm film. The writing time will be dependent upon the resolution set and film format. It is most important to scan the original

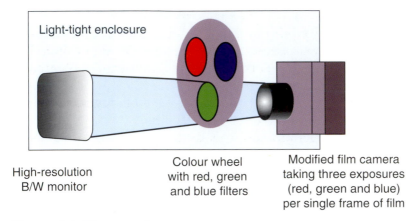

Figure 7.6 Film recorder.

image at a resolution to match the intended output. For example, a 6 cm \times 8 cm transparency can be written by a film recorder to a resolution of 3000 \times 4000. If the original is scanned at the same resolution this will mean a scan resolution of 1350 dpi. Film itself, of course, has a resolution limit, and there is no point in writing 8000 pixels to 35 mm film as it cannot resolve that much detail. Maximum figures would be in the region of 4500 pixels (4 K) for 35 mm and 8500 pixels (8 K) for 6 cm \times 8 cm. Typical outputs of film recorders are given in Table 7.1.

Table 7.1 Typical output resolutions of film recorders, showing file sizes and suggested uses

Resolution	No. of pixels	Approx. file size	Suggested use
2 K	2048 \times 1366	10 Mb	35 mm presentation slides, low/medium quality repro.
4 K	4096 \times 2732	35 Mb	Up to 4-inch \times 5-inch transparencies, 'photographic quality'
8 K	8192 \times 5464	150 Mb	10-inch \times 8-inch transparency, superb quality

Digital film recorders
This system uses a laser or light-emitting diodes (LEDs) to 'draw' the image onto the surface of the film. The resolution can be increased by controlling the dot forming the image and the number of pixels it draws to form the image. The

system is designed to recreate 10-inch × 8-inch transparencies from images retouched on high-end systems. The size of files needed to generate a film image is very large. A 5 × 4 transparency would typically require 60 Mb of data. It is also possible to produce negatives, which can then be printed onto photographic paper.

A system has recently been introduced for output onto photographic paper. Aimed primarily at those requiring large print runs, such as estate agents or wedding photographers, two units are currently available, one exposing single sheets of paper, the other having both the exposure and washless processing unit in one machine. The system uses a CRT on the end of a fibre-optic bundle which actually comes into contact with the paper, so that no relay lenses are required. The digital information is converted into a scanning beam which exposes the paper in a single scan. The first print takes approximately 5 minutes, whilst subsequent prints of the same image are produced at the rate of 100 per hour. A full 10-inch × 8-inch print requires 21.6 Mb and can be printed onto any surface of photographic paper. The cost per print is far less than dye sublimation, for example.

Data projection
Although not strictly an 'output' device, many users of digital imaging may need to project images from their computer monitors onto screens in the same way as projecting 35 mm slides. There are various types of 'data projector' available, and the cost has greatly reduced over the last couple of years, whilst quality has improved enormously.

Cathode ray tube
A CRT projector takes either a computer image or a video signal and splits it into red, green and blue elements. These monochrome signals are sent to small, bright cathode ray tubes. These images are then projected through three lenses and made to coincide on the screen. These projectors tend to be bulky and require precise alignment.

Liquid crystal displays
This type uses the property of liquid crystals to go dark or light by the application of an electric charge. The system tracks the red, green and blue components of the signal and projects the image through a lens using an extremely bright halogen bulb. This is probably the commonest type at present.

Digital light processing/digital mirror device
This is a system devised by Texas Instruments using tiny electronically modulated mirrors embedded in the surface of a microprocessor to reflect light. They are able to project very bright, high-quality continuous-tone images.

Many of the projectors on the market are now portable, being similar in size to a traditional slide projector, and capable of projecting both computer displays and video signals, together with any associated sound.

8 Imaging in practice

Throughout this book so far we have looked at technologies associated with image capture and image output, and have dealt with each in turn. This chapter attempts to bring all the various elements together and revisit some of the basic concepts to help produce the very best quality images.

The question of resolution and image size is very important in digital imaging, in the same way that it is to silver-based photography. It is a means of assessing the sharpness of an image, and quantifying the amount of detail present within that image. Various factors govern resolution in conventional photography: film emulsion, development, optics, etc. If the photographs are to be reproduced in books and magazines, then the final resolution will be dependent also upon the printing process, the line screen ruling, size of reproduction, quality of paper, etc. The imaging process is a chain, in which the quality of the final image is only as strong as the weakest link. Obviously, in any imaging system, the final criteria for resolution are set by the human eye. Different people will have different criteria for the 'sharpness' of an image, and this too will depend on various factors such as viewing distance and lighting.

Photographers measure resolution in 'line pairs per millimetre' (lpmm), i.e. the ability of a photographic system to differentiate between two closely spaced lines on a test chart. A typical monochrome film can record around 125–200 lpmm, though this figure will be much reduced when taking into account the degrading effect of the lens (most lenses cannot match the resolution capabilities of film). An overall figure of around 105 lpmm is typical (based on Kodak Tmax 100 black and white film, with the capability of 200 lpmm and a typical lens at 125 lpmm).

Very much the same sort of criteria apply to a digital imaging system. The size of the CCD, and the number of pixels it contains, the processing of the image (sharpening, for example), and the resolution of the output device all need to be taken into account when trying to produce the highest possible quality images. Comparing a digital system with film is difficult, but some useful figures can be given. When looking at the ability to resolve individual lines on a test chart a CCD chip needs to have twice as many pixels as the number of lines required to be resolved. This is because there needs to be a 'white' pixel in between each 'black' pixel recording the lines. In order to achieve a figure of 105 lpmm, therefore, the CCD needs to have 210 pixels per millimetre (ppmm).

This is a very high figure, and most so-called 'high-resolution' CCDs manage only around 80–100 ppmm (for example, the CCD used in the Dicomed Digital camera is 72 mm × 90 mm, containing 6000 × 7520 pixels – around 45 million, which equates to 83 ppmm). This does not take into account any consideration of colour recording, where, as we have seen in a previous chapter, colour information is gained from three filtered pixels. This means that digital cameras are generally no match for film emulsions, though, of course, when film is put onto a printed page, then the image is broken up into a series of dots which will reduce the resolution greatly. It does not mean, also, that digital images are not as 'good' as those from film. It depends on how the image will be printed and at what size. The most important criterion for the evaluation of any input device is '**will the image file provide sufficient data for the required output?**' A small image file does not necessarily mean low quality. Provided that the output image is small enough, then the quality will be adequate.

The fact that the initial capture is just part of the image process means that the digital photographer needs to have a greater understanding of the final output medium than they previously needed and must work much closer with the other operations involved in its creation.

What are pixels?

As we have seen, the pixel is the basic unit of digital images, in the same way that grains of silver are the basic units of photography. In photographic images, the smaller the grains, the more detail can be resolved by the film emulsion, and so with digital images, the more pixels within a given area of the image, the more detail can be recorded. In fact, whilst silver-based photography is usually referred to as being an analogue system, it could equally well be regarded as digital in that the silver halide crystals in the exposed and developed emulsion are either converted to silver or not. In other words, photography can be regarded as a binary system, just like digital imaging. The fundamental difference is that the grains of silver are of a multitude of different sizes within the emulsion, whilst the pixels are all equally sized. In a 'binary emulsion' such as lith or line film, the grains are virtually all the same size, and cannot therefore record shades of grey.

Each individual pixel has an 'address' and a value within the 'bitmap' – the grid containing the pixels. The value of a pixel is concerned with either its greyscale density or colour values. A pixel may have an address of X – 3.6, Y – 1.8, R – 240, G – 200, B – 12. This indicates that the pixel is predominantly yellow in colour. Adobe Photoshop and many other imaging programs have the facility of showing the address and value of each pixel. Photoshop has a 'Show Info' dialog box, showing the bitmap address and colour or greyscale values of each pixel (Figure 8.1).

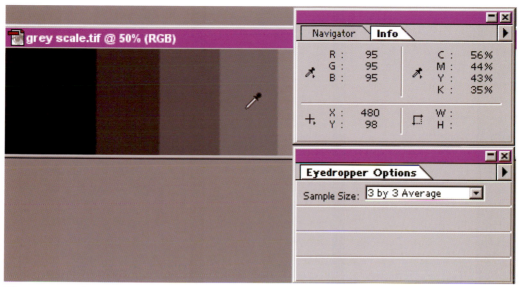

Figure 8.1 'Show Info' dialog box in Photoshop. This gives an indication of the pixel value and address. In this case the eyedropper tool is on a grey patch, and the RGB readings indicate that it is a neutral colour. The size of sampling area can be altered from a single pixel to a 3 × 3 or 5 × 5 sampling area.

Spatial resolution

This is the single most important factor in determining the quality of an image. Undersampling the data in the image will result in pixellation appearing in the final result. Oversampling will result in waste of time, storage space and money.

The term 'spatial image resolution' refers to the number of pixels within an image, and is measured in pixels per inch. An image recorded with a digital camera may, for example, have 2048 × 3072 pixels – 6 291 456 pixels in total. The resolution must be of adequate quality for the intended purpose. The term 'image size' describes the actual physical dimensions of the image. Because the number of pixels within an image is fixed, increasing or decreasing the image size (resizing) will alter the resolution. Increasing the size will cause a decrease in the resolution. Image-processing programs like Photoshop have the facility to both resize and resample (interpolate) the image (see Chapter 6.)

When looking at the resolution of imaging devices, in particular scanners, it is important to distinguish between 'optical resolution', i.e. the actual number of picture elements on the CCD, and higher resolution created by the process of interpolation. A scanner may be advertised as having a resolution of 1200 dpi, where in fact it has an optical resolution of 600 dpi, interpolated to 1200 dpi by the scanning software.

One particular facility available within programs like Photoshop is the ability to match the resolution of the image to the printer, if necessary interpolating the data by resampling the image. In Photoshop this process is controlled in the 'Image Size' dialog box (Image > Image size).

Image size

This dialog box is the part of Photoshop which will control the final reproduction size, and the resolution of that print (Figure 8.2). It is essential that you have complete control over this process in order to produce the very best quality output. The top section of the dialog box shows the pixel dimensions of the image and its size in terms of megabytes.

The next section, the print size area, shows the size of print which the image will give at the resolution shown. With the box 'resample image' **unchecked**, then notice that the height, width and resolution are linked, so that changing one of the dimensions affects the other two. Try doubling the resolution shown from 72 to 144 pixels per inch. Notice that the print size halves, but the overall dimensions and image size remain unaltered. The same number of pixels are squashed into a smaller area leading to higher resolution. Decreasing the resolution spreads the same number of pixels over a larger area, thus reducing the resolution. This is the same as printing a photographic negative, which has a fixed number of grains. The more you enlarge the print size, so the grains become increasingly apparent. (Incidentally, the reason that

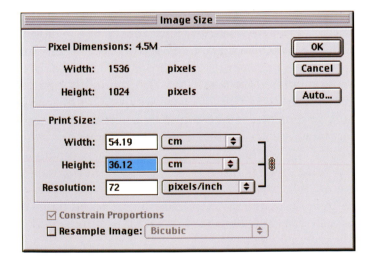

Figure 8.2 Image Size box in Photoshop. This shows the image to be 1536 × 1024 pixels in size – 4.5 Mb.

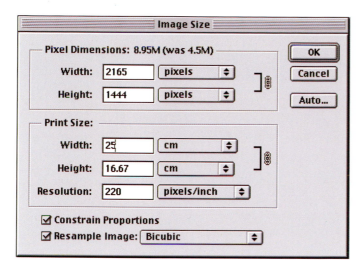

Figure 8.3 The image has been resampled to give a 25 cm × 16 cm print on an ink jet printer at a resolution of 220 dpi. The image size has increased to 21 654 × 1444 pixels – 8.95 Mb.

72 dpi appears when you open the box is that 72 dpi is the resolution of many computer monitors.)

Checking the 'resample image' box allows you to reduce or increase the resolution of the image through the process of 'interpolation' (Figure 8.3). This is the process whereby the software will throw away data, if the image is to be made smaller, or invent (interpolate) new data if the image is to be made larger. Interpolation is also found in scanner software, where the optical resolution can be doubled or even quadrupled. Photoshop uses three methods of interpolation: nearest neighbour, bilinear and bicubic.

The 'nearest neighbour' option copies or replicates the adjacent pixel when creating the new one. This is the fastest option, but the least effective. The 'bilinear' option smooths the transitions between adjacent pixels by creating intermediate shades between them. It creates a softened effect. The third option, 'bicubic', increases the contrast between pixels following the bilinear option, offsetting the softening effect. This takes time, but offers the best quality of image.

If you need to increase the resolution of images then it is probably best to restrict the interpolation to 200 per cent, but is well worth experimenting with other magnifications. If the image needs to be enlarged to a larger print size, then this, of course, would normally be viewed from a greater distance. Use the unsharp mask after the interpolation process.

The 'auto' facility within the image size is interesting in that it allows you to set the resolution of the output device in lines per inch, and the quality of print reproduction (draft, good, best). This relates to the 'Q' factor discussed later in this chapter. A line screen of 133 lines per inch, for example, is automatically sized to give an image of 266 pixels per inch.

Rule of thumb for output

A simple rule of thumb, used by many professionals, can be used to calculate the largest reproduction size of a digital image:

Divide the longest dimension of the image (in pixels) by 300

This will give the largest high-quality reproduction size in inches.

For example: If the image has dimensions of 1500×1000 pixels, dividing the longer dimension of 1500 by 300 gives 5 inches. It may well be possible to enlarge the image beyond this, but it does give a useful indication of the reproduction size possible from a digital image.

Brightness resolution

Often referred to as bit depth or colour depth, this again this must be of adequate quality to supply the output medium with sufficient information. This refers to the number of bits of stored information per pixel. A pixel with 1 bit of information has only two possible values, white or black. A pixel with a bit depth of 8 has a possible 2^8, or 256 values, whilst a pixel with a bit depth of 24 has a possible 2^{24}, or over 16 million possible values.

Computer platform

Although the current trend is for more open interchange between computer platforms, there is a fundamental advantage to working on the same computer platform as the other members of the production process. Conversion from Mac to PC can have detrimental effects on the colour of an image, for example, and may lead to problems in subsequent stages of the process.

The minimum and maximum file sizes required for most output devices are easy to calculate, although the practical working area between these two limits is large, and subject to much discussion! In photography, the question is often asked 'how much can you enlarge a 35 mm negative?' The answer depends on many things, but in particular, how much grain is acceptable in the final print. So with digital imaging, the optimum file size for a particular printed output can only be obtained by running tests on one's own systems to ascertain the quality. However, finding the *optimum* file size for a given use will save time and money in every part of the operation, and is time very well spent! Figure 8.4 demonstrates the effect of different scan resolutions and different screen rulings. It is the sort of test that is well worth doing if possible.

We will now examine various output media in turn, and try to ascertain the appropriate input file size and quality.

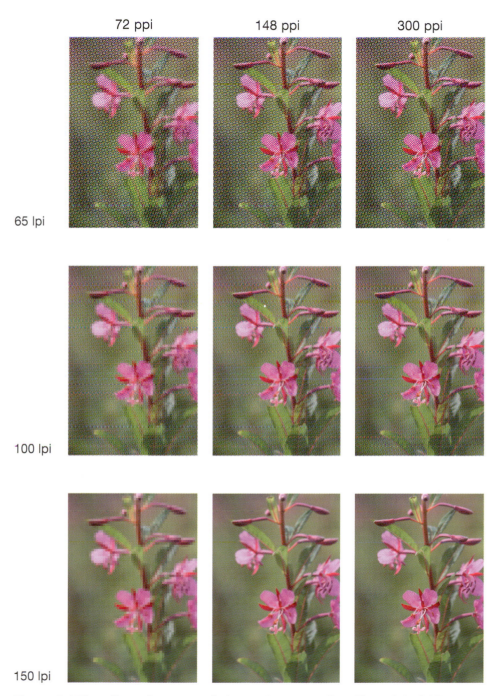

Figure 8.4 The effect of scan resolution and screen ruling. The original 35mm transparency was scanned at 72, 148 and 300 ppi, and is reproduced here at 65, 100 and 150 lpi.

Output media

Soft display

Monitor resolution

This relates specifically to the display on the monitor, and should not be confused with image resolution. It is usually measured in dots per inch (or sometimes pixels per inch). Most monitors have a resolution of 72 dpi (or 75 dpi). An image with a resolution of 144 pixels per inch will be displayed at twice its actual size on a 72 dpi monitor (only 72 of the 144 pixels can be displayed in one inch on the monitor). If the images produced are to be viewed only on a monitor, as in multimedia productions or presentation applications such as Microsoft PowerPoint, then the images should be resized to 72 dpi if necessary.

The images in most multimedia programs have a colour depth of 256 adaptive (indexed) colours (found in the 'mode' menu of Photoshop). This is done for two reasons. First, the file size is one third of a 24-bit image, and second, the majority of users will have monitors capable of displaying this type of image. The use of adaptive palettes means that the file refers the 256 colours to a specific 'Look Up Table' (LUT) biased in favour of the colours in the image. If this LUT is produced well, the image displayed will be very nearly the same quality as a 24-bit image.

The Internet

It is worth noting that delivery over the Internet means that not only do the restrictions mentioned above apply, but also the speed of transmission systems dictates that file sizes must be as small as possible if the delay between receiving images is to be viable. One guideline often used is to use an image with a maximum size of 20 Kb or so following either JPEG or GIF compression. PC and Mac monitors vary in their colour display, and 'Web safe' colours only should be used when putting images onto Web sites. Photoshop and Image Ready have the facility of producing suitable images for cross-platform Web viewing.

Hard copy

As discussed in Chapter 7, the file sizes required for optimum quality are dependent on the output technology used.

Laser printers/ink jet printers

These printers are capable only of printing either black ink only or a combination of coloured ink, usually cyan, yellow, magenta and black. Other colours or shades must be created using groups of dots to represent a single shade or colour. This means that a single pixel of information in the original image is represented by a group of dots on the page. This process means that the 'effective resolution'

of the printed image is lower than the value quoted for graphic or text output. Theoretically, for colour printing on an ink jet printer, for example, each pixel in the image needs to be represented by four dots of ink, so the effective resolution of a 720 dpi printer is 720/4 = 180 dpi. As we have seen, other factors such as paper quality, method of halftoning, and the addition of two extra inks increase this figure, but it is a good starting point.

The formula for minimum file size (effective dpi) when dealing with images is:

output resolution in dpi, divided by the square root of the number of shades that the printer is capable of printing

For example: a printer rated at 600 dpi, capable of printing 256 shades of grey:

Effective dpi = 600/256 = 600/16 = 37.5 dpi

For a greyscale image 4 inches \times 4 inches in size, the file size will be:

37.5^2 (no. of pixels per square inch) \times 16 (no. of square inches) = 22 Kb

For systems using more elaborate methods of printing such as error diffusion halftoning, larger files will produce better results and experimentation is recommended.

Thermal dye sublimation and other continuous-tone printers
Here the 'effective dpi' is the dpi quoted for the printer, as the construction of each pixel dictates its colour or shade. Therefore:

The size of file = resolution per inch2 \times size of image in square inches

For example, using a thermal dye sublimation printer with a resolution of 300 dpi:

For a 10-inch \times 8-inch image the optimum file will be:
$300^2 \times 80 \times 3$ (3 colour channels)
i.e. 90 000 \times 80 \times 3 (for the three 8-bit colour planes) = 21.6 Mb

Again, this figure should be used as the starting point for experimentation, and it will probably be found in practice that it is possible to use smaller file sizes with no perceptible quality loss.

Film output

Film recorders

The size of file will depend on the size of film to be written. A typical file written to 5-inch \times 4-inch film will be in the region of 60 Mb. A formula to determine scanning resolution for output film size is:

$$\text{Scan resolution in ppi} = \frac{\text{film recorder addressability}}{\text{output film length}} \times \text{scale factor}$$

For example, using a 35 mm film recorder with 2 K resolution, a 35 mm slide should be scanned at 1365 ppi, i.e. 2048 divided by 35 (1.5 inches) \times 1.

The printed page

For many photographers, their work will eventually be reproduced in books or magazines, printed 'photomechanically' using a four-colour lith process. This method of printing requires different criteria from desktop printers, and needs to be examined in some detail.

Stage one: Create the required resolution of image

The resolution of printing systems (e.g. offset lithography) when dealing with images is quoted in 'lpi' (lines [of dots] per inch). The quality of the final image is dependent on several factors including the ink and paper quality. Typical values for different paper types used in the print industry are as follows:

Newsprint	80–100 lpi
Books	133 lpi (including this one)
Magazines	150–175 lpi
Quality reports	200–300 lpi

This measurement is a reference to the screening process formerly used to generate the dot images on the page. The process involved sandwiching a finely ruled grid screen with the receiver material in a process camera and exposing a photograph through the grid. The nature of the grid dictated that the image was broken into discrete samples – a quasi-digitization of the image into small samples. The action of the grid meant that the resulting image was formed as single dots in each of the squares forming the grid. The process generated a negative image in which the lighter the tone, the smaller the dot and the darker the tone, the larger the dot. This image composed of dots could then be transferred to a printing plate and used to reproduce the original image with ink dots. The number of dots per inch were dictated by the ruling of the screen, each screen being suitable for a certain paper type and printing press. The only method of changing the number of dots was to use a different screen (see Figure 7.1).

Since the advent of imagesetting equipment the generation of the dots is performed by computer software and the imagesetter equipment writes the image to film. The computer generates a halftone dot in a similar manner to the

laser's simulated halftone. The major difference between the two systems, however, is that the imagesetter is capable of thousands of dots per inch, thus generating patterns far too small to be distinguished from screen-generated dots.

Resolution ratios (Q factor)

Printers use a concept known as a quality factor, or 'Q factor' (sometimes known as a 'halftoning factor') when deciding what resolution is required for a particular output size. The resolution of the original digital file is in pixels per inch, whilst the printing industry uses lines per inch. A fundamental question therefore is: which ratio of pixels to lines gives the optimum result?

Less than 1:1 (ppi<lpi) If less than one pixel per line is used, the image will display pixellation, and the software will have to interpolate (add) pixels to generate extra information. The user has no control over this process and the end result is dependent on the software's interpolation capabilities. If a smaller file has to be used, the best compromise is to interpolate the file size in an imaging software package allowing the user to choose the interpolation method (bicubic, nearest neighbour, etc.) and examine the result prior to printing.

1:1 (ppi = lpi) If the number of pixels matches the number of lines, the resulting image can display artefacts such as aliasing, and colour artefacts introduced by the screening angles used to avoid moiré patterns.

Given therefore that the requirement in the conversion from ppi to lpi requires an oversampling, the next question is 'how much should that oversample be?'

1.25–2.0:1 (dpi >lpi) The standard rule of thumb used by the majority of the print industry is to supply images at a resolution twice that of the output resolution. This figure is worth testing, however, with ratios between 1.25 and 2:1, and it may well be found that there is no perceptible difference between them. Using smaller file sizes will lead to a saving in both time and material cost.

2–2.5:1 (ppi-lpi) The extra information supplied at ratios of 2:1 and greater gives no perceptible addition in quality. In ratios of over 2.5:1 the information is ignored by the PostScript RIP conversion process entirely.

Therefore by experimentation a Q factor can be found within the region of 1.25–2:1. The following guidelines can be given used to start the experimentation process:

> Values of Q from 1.25 to 2.0 work well for halftone dot images
> > Choose a Q value of 2 if screen ruling is 133 lpi and below
> > Choose a Q value of 1.5 if screen ruling is above 133 lpi
> Values of Q over 2 are wasteful, just leading to large file sizes

With the advent of new screening processes such as 'stochastic' (FM – Frequency Modulated) screening and new printing processes such as six-colour Hexachrome and seven-colour 'hi-fi colour', lower pixel resolutions are possible, with the Q factor falling perhaps as low as 1:1. The use of different qualities of paper will also affect the results.

For desktop imaging we have one of three possible scenarios for the conversion of an image:

1 **A device with a set resolution** (digital camera, supplied image file, etc.) The only question here is how large can this image appear on a printed page?

$$\text{Calculation of maximum image size} = \frac{\text{Pixels}}{\text{Q} \times \text{lines per inch}} = \text{inches}$$

For example, a magazine uses a line screen of 133 lpi and a Q factor of 1.5. What is the maximum horizontal print size that can be obtained from a digital camera file with 1024 × 768 pixels?

$$\text{Camera file: maximum image size} = \frac{1024}{1.5 \times 133} = 5.1 \text{ inches}$$

2 To calculate the required number of pixels for a given print size what scan resolution is required for a particular output size?

Provided that the resolution of image and print are in the same units, i.e. inches

Picture size × lpi × Q = number of pixels

or

lpi × Q = required resolution in dpi

It is also possible to calculate the resolution from the magnification of the image, in which case the formula is given by

lpi × Q factor × enlargement factor

or

lpi × Q factor × (size of final image/original image size)

For example, a 5-inch printed image is required from a 2.25-inch negative, using 133 lpi and a Q factor of 1.5:

133 × 1.5 × (5/2.25)
199.5 × 2.22 = 443.33 pixels

3 **Choosing the correct resolution** with a system such as PhotoCD: which resolution is the correct size for a desired printed image size? The formula for the number of pixels will be the same as the required pixel size

No. of pixels = lpi × Q factor × final image size

For example, the printed image is to be 6.5 inches from a portrait image on PhotoCD and printed at 150 lpi with a Q factor of 1.75:

No. of pixels = 150 × 1.75 × 6.5 = 1706 pixels

The choice of five Master PhotoCD Image Pac resolutions is 192, 384, 768, 1536, 3072 pixels. Since the interpolation process in the transfer is not under the user's control, the best option is to choose the next highest value, so the 3072-pixel image is preferable to the 1536. This image could then be resized in Photoshop to give the required 1706 pixels.

Bureaus and printing companies will often have guidelines for their customers, recommending file sizes and resolutions for specific output sizes. An example is given in Table 8.1, but it must be remembered that this relates to one specific company and its own printing press, and should be treated as a guide only.

Table 8.1 Ideal maximum size, in millimetres, for PhotoCD images when used with specific line rulings of screen, with a 'Q' factor of 2

lpi	base	base*4	base*16	base*64
150	43 × 66	86 × 129	172 × 259	348 × 520
175	38 × 55	73 × 111	149 × 223	297 × 447
200	33 × 48	33 × 96	129 × 1965	259 × 391
250	25 × 38	50 × 78	104 × 155	208 × 312

Tonal balance and sharpening

Producing an image at the right size for the intended output is not the only criterion for final quality, however. One important factor is the quality of the print output in terms of ability to print a full range of colours and tones. This is where the calibration of the levels contained in the image becomes very important. Most printers apply a tone in the highlight areas of a printed image and reduce the amount of ink in the shadow areas. Typically, the levels settings for an image may be set to between 10–15 and 240–245 instead of the normal 0–255 (these figures will be seen in the 'levels' dialog box of Photoshop).

The application of the unsharp mask filter, if appropriate, should be the very last operation before printing. Applying the sharpening after tonal balancing and retouching will ensure that any alterations made to the image have the same level of sharpening. Most retouching tools apply anti-aliasing to changes in the image. This can be apparent in a loss of 'grain' in the image when applied over a sharpened area. Be careful not to 'overdo' the unsharp mask. Figure 6.21 shows the effect of various amounts of unsharp masking.

Conversion to CMYK

For many photographers, the conversion of the image from RGB to CMYK will be out of their hands, but it is nonetheless worth giving a brief explanation of the various parameters involved. Much more detailed accounts will be found elsewhere, and the advice must be not to alter these settings unless you know what you are doing!

1 **Choice of ink separation tables** This dictates the type of printing process in terms of paper, ink and press to be used.
2 **Undercolour removal (UCR) or grey component replacement (GCR)** These processes affect how information common to the cyan, magenta and yellow channels is controlled. Liaison with the printer is necessary, as choosing the wrong settings will result in an unprintable image.
3 **Checking of colour gamut** This option, available in image-processing programs such as in Photoshop, allows the user to check if any of the image colours are unprintable, given that the target gamut of the printed image on paper is smaller that the image gamut. Colours outside of the printable area can be desaturated until they fall within the required gamut.
4 **Adjustment of dot gain** This is the correction for the bleeding of the ink dot into the paper surface causing an apparent increase in density to the image. Changes to the dot gain controls compensate for the effect. Adjustment should only be done in consultation with the printer.

There are several software packages that deal specifically with the separation of the RGB image into the required CMYK format and serious users of digital images in publishing should investigate these as they will offer far more control over the process than a general-purpose package.

9 Colour and colour management

There is probably no issue in digital imaging which generates more debate and heated discussion than that of colour management, i.e. the control of the colour of images from capture through to output. Of course, the issue was never straightforward in conventional photography. Different film has its own characteristics, and some subjects are renowned for being difficult to photograph in colour correctly. One major difference between film and digital imaging, though, is that the printed image can be compared with the original transparency – this, of course, is not possible with a digital image on disk!

If you are an individual photographer, sending images to just one or two printing devices, then the issue of colour management is relatively easy – you can calibrate your monitor to the printed output, and provided nobody else touches the monitor or printer then consistent results can be pretty much guaranteed. In technical terms, you have a 'closed loop', where all the components in your system are under your control. If you change your scanner, or the paper in your printer, it is a relatively simple process to run a few tests to achieve a good result.

The problems start when you need to send your images to somebody else to print, or perhaps display them on another monitor. What looks good on your monitor or prints well on your ink jet printer may not look good on another monitor or may not reproduce well when printed in four-colour litho!

Colour management is all about knowing the characteristics of all the components of an imaging chain and relaying this information to all the devices in that chain. The basic idea is to produce a 'profile' for each device, the details of which are embedded in the operating system of the computer.

In order to address the issues that arise in controlling the parameters of digital colour it is useful to establish the aims of the process and the variables which must be controlled.

Colour models

There are several methods of describing the actual colour of an element. For practical purposes there are a number of 'colour models' available, which are used in different applications and analysis:

Perceptual

This is a model that relates all information to the human viewer. The parameters are related to the response of the human visual system. This model uses three elements to describe the colour attributes in a three-dimensional model – hue, saturation and brightness. The two dimensions of the selected colour are recognizable from the colour picker in image-processing software (Figure 9.1).

Figure 9.1 The colour 'picker' in an image-processing program.

Hue (angle)

This is the name of the colour, e.g. red, green or blue or a combination of any two of these forming yellow, magenta or cyan.

Saturation (percentage)

This describes the intensity of the hue, i.e. is the colour a pastel shade (mixed with white) or a highly saturated colour? The scale runs from 1% to 100 per cent.

Although this model works well it shows only two of the colour attributes. The third dimension is represented by the slider which shows the brightness of the colour. If you have a piece of blue card, for example, then the hue and saturation of the colour will remain the same under any lighting conditions. However, the brightness will vary according to how much light is falling on the card. To represent all these elements a three-dimensional shape needs to be created (Figures 9.2 and 9.3).

This shape maps the brightness element of the colour or the amount of black or white in the colour. Note the range decreases as the colour nears either total white or total black, so maximum saturation of colour is achieved only at the halfway stage.

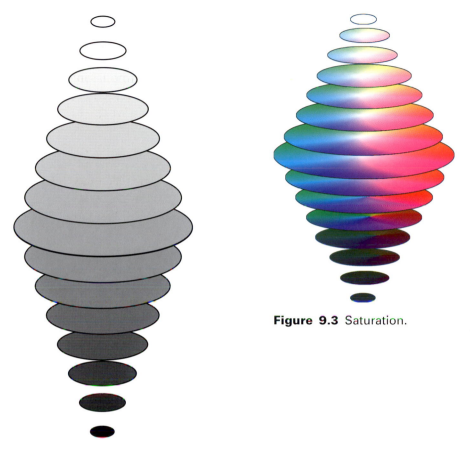

Figure 9.3 Saturation.

Figure 9.2 Tone.

RGB colour space (additive colour theory)

The standard method of image capture in both scanners and digital cameras uses the red, green, blue (RGB) model to represent the entire range of colour (Figure 9.4). In this model the information is stored in the three primary colour channels.

All other colours are formed by a mixture of these three colours. The image itself is formed of three greyscale planes, or channels, one for each colour. The 'colour depth' is determined by the number of shades each channel can hold. For the majority of computer-based colour imagery 24-bit colour is used. This is derived from the fact that each channel uses 8 bits to describe the total number of shades and there are 8 bits of red, eight of green and eight for blue. Since eight binary numbers add up to a total of 256 (255 + 0 as a number) the total spectrum amounts to 256 × 256 × 256 = 16 777 216 or 16 million colours

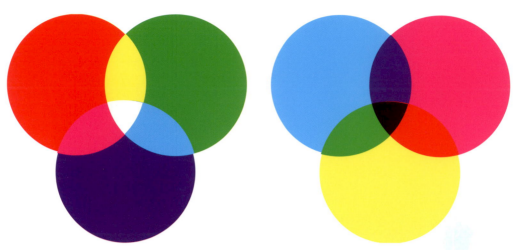

Figure 9.4 RGB model. **Figure 9.5** CMY system.

or 'true colour' as it is sometimes known. Under this scheme zero represents the absence of colour, so 0, 0, 0 represents black and 255, 255, 255 represents white.

CMY colour space (subtractive colour theory)

The reverse of the RGB system uses the complementary colours of cyan, magenta and yellow to produce all other colours (Figure 9.5). Note, however, that in this model all three secondary colours mixed together to produce black.

The CIE colour space YCC

The scientific world has developed an artificial colour space model that can incorporate all the colours that the human eye is capable of perceiving. The Commission Internationale de l'Eclairage created a model known as CIE colour space. Because it shows all the colours it can be used as a reference to plot colours from any device. It works by dividing the colour into 'Lab colour' space, where the colour is represented by two chroma channels (C, C) that hold the colour information, and a third (Y) channel containing the scene brightness, or luminance information. This method also has great potential for sharpening images, where sharpening can be applied to the luminance channel only, thereby having no detrimental effect on colour. This colour space is known as 'device independent' since all devices can be shown within its boundaries. The extent of the range of colours that can fit in this system is termed the 'gamut'.

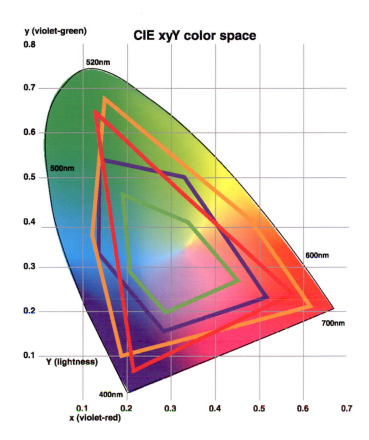

Figure 9.6 CIE colour space model showing the gamut of various media. Orange: typical photographic film (transparency film). Red: typical computer monitor. Blue: typical quality printed material. Green: typical newsprint material.

Gamut reduction

The key to understanding colour control is that the imaging workflow effectively involves the destruction by compression of the colour data in an image. This is due to the fact that the final target colour space is smaller than the original. Therefore, the colours recorded by a colour transparency cannot, in general, be recorded by a desktop film scanner, and the colours and tones from the scanned image cannot, in general, be printed with an ink jet printer. The nature of colour management is to control the process to give the best possible result.

Figure 9.6 represents all the potential colours perceived by the human eye. The boundaries show the restriction of various media when reproducing the colour in various media.

CMYK

A printing press is not able to print all the colours that can be displayed on a computer monitor. It can only print using dots of one of four opaque colours.

In order to simulate the various shades of colour it uses the principle of halftoning. This is a method of simulating colours acceptable to the human eye when viewed at a distance. Close examination of a monochrome printed page will reveal the image as being formed of various sized dots of ink. Shadow areas of images will result in relatively large dots, whilst highlight areas will have relatively smaller dots. Patterns of cyan, yellow, magenta and black dots give the impression of all other colours and tones. (Black ink is needed as the combination of cyan, magenta and yellow ink gives a rather muddy brown colour rather than a true black.)

Proprietary colour models

Designed colour space (graphic design)

This is a colour matching system for the graphic designer. Colours are based on a numbered system and the designer chooses from a book of printed samples. A removable sample swatch of the colour or colours can be attached to the artwork. The printer can then make reference to charts of ink mixing to render the exact colour. The system works on the principle that the samples are printed onto the same type of paper and have the same finishing techniques applied to them as the required colour. Examples of this swatch system include Pantone, Focaltone and Trumatch. The major disadvantage of all these systems is that they all relate to the CMYK colour space. This space has a smaller gamut than the photographic input therefore it works best with graphic images.

Now that we have discussed the methods of describing colour, we can begin to address some of the practical issues of colour management. An image of a typical scene, containing a range of hues, saturation and brightnesses, will be followed through from original transparency to printed page. In this image the key areas will be the highlight and shadow regions.

Visible spectrum

The scene shows the range of colours visible perceived by the human eye (Figure 9.7). It can hold a greater contrast range than is capable of being recorded on either film or CCD. There are also certain colours that the photographic process is incapable of recording. On a bright sunny day with high contrast, the photographer will need to expose the film carefully to give detail in shadow or highlight areas. Some highlight or shadow detail is likely to be lost. The difference between point 1 in the shadow region and point 2 in the highlight can be as much as 12 stops.

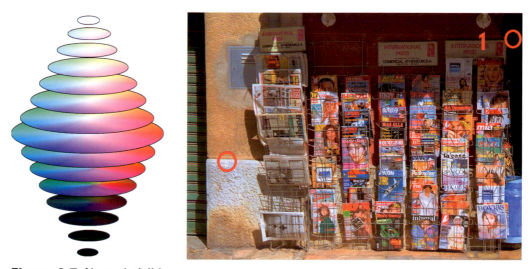

Figure 9.7 Normal visible spectrum.

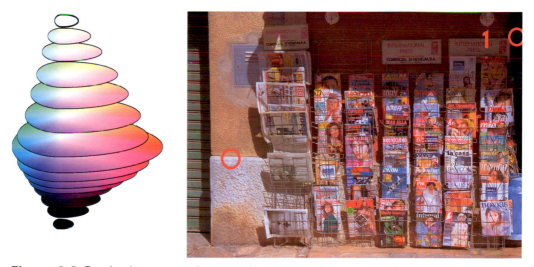

Figure 9.8 Previewing on a colour monitor.

After capturing the image the scene is previewed on a colour monitor (Figure 9.8). The recorded scene is now displayed using the RGB system of the computer monitor. Note the restriction in the green coverage in the colour space of the monitor. There is also compression of the contrast. The maximum black (point 1) that a monitor can display is the dull grey colour that the screen shows when turned off. The maximum white (point 2) is the brightest that the tube or LCD can display. This makes assessment of shadow detail much more difficult

than highlight detail. The calibration of the monitor also becomes a critical factor in the process.

The image on the printed page

When printing the image, each colour is described by a percentage of cyan, magenta, yellow, and black inks (Figure 9.9). Note the massive compression of the tonal range. Here the white point 1 is represented by the white of the paper. The black point is the highest density of the printing ink. The quality of reproduction will depend on the quality of the paper – the whiteness and thickness will all play a part in the final image. It is interesting to note that despite the smaller colour range than the monitor, there is a greater range in the green region.

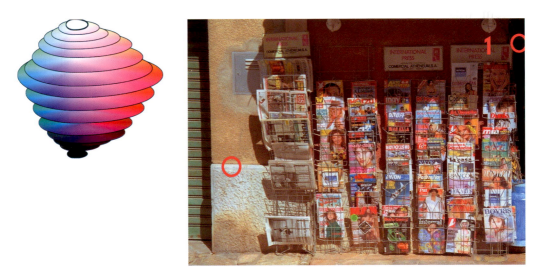

Figure 9.9 On the printed page.

Process control

The purpose of colour management is to provide a system that allows the computer to make the best choices on the compression of colour data.

Colour management with different computer operating systems

PC operating systems
There is no support for colour management within either Windows NT or Windows 3.1 (Figure 9.10). The only solution in these operating systems is if the

Figure 9.10 No colour management with Windows NT or 3.1.

software program handles all the colour control and incorporates its own colour management system. Under these conditions there is no standardization of profile types and each program operates on its own system.

The first implementation of colour management in the Windows operating system was ICM (Image Colour Management). Version 1 was released by Microsoft with Windows 95 (Figure 9.11). The software is supplied to program developers as an API (application programmer's interface). This is a set of computer code that allows connection into the common colour space. This software relies on CMMs (colour management modules) that describe the colour space of the various devices such as scanners, monitors and printers. The software relies on software manufacturers to incorporate the ICM system within their applications, as there is no system-level colour management. The system also relies on the software vendor to incorporate an 'engine' or CMM into their software to control the colour using the common CMM modules. The major disadvantage to the system was it only supported variations of RGB and CMYK colour space related to specific devices so each of these software vendors could decide how their software handled profiling a device. The end result was that the user would have to profile each device for each software package.

Figure 9.11 Windows ICM colour management system with Windows 95.

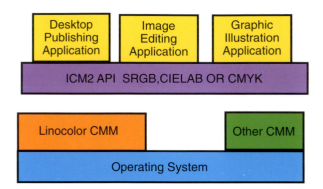

Figure 9.12 Windows ICM2 colour management system (Windows 98, 2000 and NT5).

ICM 2, the second version of the system incorporated into Windows 98 and Windows NT5, was expanded to support independent colour space models such as CIE, and uses the Linotype colour engine Linocolor (Figure 9.12). The software assumes that the application program will embed the correct colour profile into the file and on finding a profile links into the colour management. The 'source' referred to in Table 9.1 could be any input device, and the 'destination' could be any output or monitor.

Table 9.1

	Image has source colour profile	Image has no source colour profile
Destination has colour profile	Use both profiles in the colour mapping	Use sRGB as the source profile and use the destination profile in the colour mapping
Destination has no colour profile	Use the source profile and use sRGB as the destination profile in the colour mapping	Do nothing (assume sRGB is the profile for source and destination)

The Windows solution relies heavily on the adoption of the sRGB colour space as being adopted as the industry standard.

Apple operating system
The Apple operating system uses ColorSync, a system that was produced in conjunction with the International Color Consortium (ICC). The structure of the Apple operating system allows a much greater interaction of data exchange between the application program, the operating system and other applications. This is due to the fact that Apple are suppliers of both the hardware and software, and thus have a much smaller number of variables to deal with.

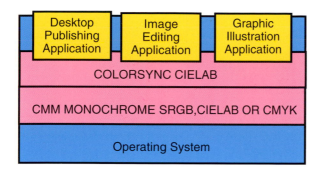

Figure 9.13 Apple ColorSync system (Apple OS 7 or later).

The ColorSync software relies on the use of an independent colour space CIE as the default colour space unless a specific profile is applied to the image file. This enables the system to have a greater colour gamma than that capable by any device. This means that colour compression will not take place unless chosen by the user. The ColourSync software uses the same profile files (CMMs) as the Windows ICM system. The Apple system supplies a colour management engine that software vendors can link to their programs to provide colour management.

Profiling

Now that we have discussed the issues involved, how can the situation be corrected? One of the industry's current preoccupations is with device colour 'profiles'. These offer a partial solution to some of the problems, although there are also practical issues that need to be addressed as well.

Profiles create a universal translation between the different colour spaces of various devices. Accurate colour management ensures that the process of reducing the colour range through the workflow is done in such a way that supplies the best possible resulting image. An analogy is the translation of text from one language into another. To translate between all the languages in the world would require two dictionaries for every combination of two languages, English–German and German–English for example. A simpler and more elegant solution is to create a universal language. Now all that is required are two dictionaries per language, English–Universal, Universal–English. Now we can translate French–Universal–Chinese. The CIELAB colour space provides this universal translation area and we no longer need two translations, just one for each device, an input-CIE for all input devices and CIELAB output for each output device (Figure 9.14).

Creating a profile for an input device

A profile in its simplest form is a description of the characteristics of a device, i.e. how that device is able to reproduce colour. The profile makes no account

Figure 9.14 Comparison diagram. (a) Input profile; (b) CIE colour space; (c) output profile.

of the inability of the device to produce certain colours or restrict contrast, but makes the best transition of information between two devices. The most common question asked concerning colour reproduction is 'Why doesn't the print look like the monitor?' The answer is that unless you print on glass tubes with a light inside the back it won't! A print consists of ink or dye on paper, and is viewed by reflected light. The profile creates a translation from the colour language of a device into the colour space of another device. This is where the use of a device-independent colour space can help in providing a common translation area that can be used to convert between devices. It can also provide a 'holding area' in which to leave images when the final output has yet to be decided. Given that the workflow is a destructive process in terms of image colour content the user must be aware that an image recovered from the final stage of the process, for example a CMYK file, cannot be restored into the RGB file that created it. The image should therefore be stored at some point in the RGB mode in order to maintain its data for future use.

Either device manufacturers supply profiles, or the more intrepid user can create their own using device-generating software.

Output devices

The creation of profiles for an output device requires the following tools:

Profile-generation software
A test target TIFF file of a suitable size, e.g. an IT8 target, or the file supplied with the software. (Note: do not use JPEG compressed files as the JPEG routine may affect the colour balance of the image.)
A spectrophotometer – a device that measures reflected colour.
A huge amount of time and patience!

The simplest device for which to create a profile is a printer. The first stage is to make a print of the test file. This should contain 1000 or so colour swatches which should be within the theoretical colour space of the printer. The resulting print is then analysed by reading each colour with a spectrophotometer and the results entered into a database associated with the profile-generation software. The software then examines the readings against the theoretical values and produces a correction in the form of a profile. This process will only work if all the variables are factored into the profile. For example, in the case of an ink jet printer the profile is only valid for the following criteria:

1 The specific type of media used in the profile generation – variation in manufacturing can affect this result so batch-to-batch consistency is vital
2 The type of ink – different types of ink can react with the media to affect absorbency
3 The speed of the print – different speeds will have different ink 'lay down' values.

It is easy to see that the task of creating and supplying profiles for a product range of media and inks means that all permutations must be profiled. Certainly paper from different manufacturers may have different base white values, for example.

The monitor

A monitor calibrator is effectively a light meter which fits onto the display screen via a suction cup. It measures the values of colours generated by the software and compares the displayed values with their theoretical values recorded in the software. From this information a profile can be generated to compensate, so the user can be sure that any colour bias is inherent in the image rather than in the display.

When calibrating a monitor try to ensure consistent viewing conditions. Block off as much ambient light as possible and make sure that whatever light you have around your workspace is consistent. Many professional monitors are supplied with a deep hood to reduce the ambient light falling on the screen (it is a simple job to make your own). Once calibrated, make sure that no one alters the brightness or contrast controls on the monitor! Also, when calibrating a monitor make sure that it has been running for at least half an hour to ensure that it is at its proper running temperature. Colours will change whilst the monitor is warming up.

Input devices

In general, input devices such as scanners are relatively static in their characteristics, and so are theoretically easy to profile.

The light source in the device has a known colour temperature
The brightness range of the device is a fixed quantity
The device makes no subjective alteration to the image such as a scene
brightness algorithm
The device performs no image compression

Having said this it is worth noting that, in the case of some scanners, altering
the resolution may affect the colour performance, and it may well be worth
performing tests at different resolutions.

Assuming that resolution has no effect, then the only variables left in the
equation are the type of film and paper, so if a profile is created for each type
the profiled system should give consistent results.

Creation of an input profile

The main requirement here is a consistent test target containing a range of
colours, and grey tones. The industry standard is the IT8 available as 35 mm or
5-inch × 4-inch transparency, or as a print (Figure 9.15). They are specially
produced to a very exacting standard, and are thus very expensive. Each target
must be stored carefully, to ensure it does not fade with age.

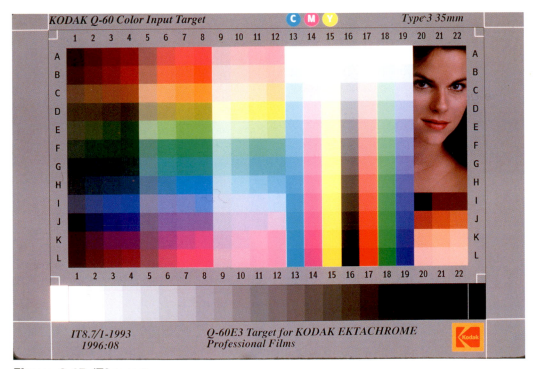

Figure 9.15 IT8 target.

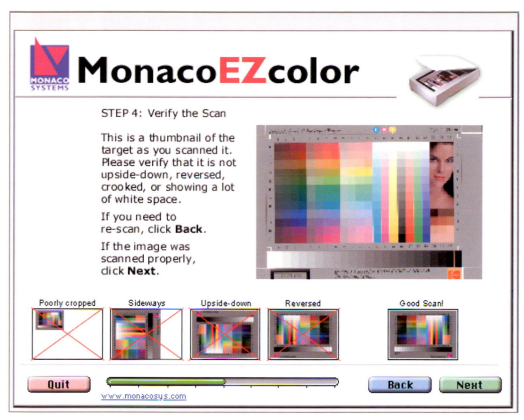

Figure 9.16 Profiling software.

Profile-generating software

The film or paper target is scanned and the software compares the values obtained against the swatch's theoretical values and calibrates a correction profile.

Creating a camera profile

Creating a digital camera profile is more problematic. Even a simple digital camera can have a number of possible variables:

The scene brightness – this can have any value
The colour temperature of the illuminating light
How the camera determines the colour temperature and scene brightness.

This last item may sound like the first two, but the main problem is that most digital cameras have no colour temperature meter built in, so the camera cannot distinguish between tungsten light and daylight, for example. The camera

manufacturers rely on a device known as a 'scene balance algorithm'. In its simplest form this assumes that the image will integrate to an 18 per cent grey and makes adjustments to correct the image if this is not the case. This method can give rise to colour problems with any image having a strong predominant colour as the software in the camera will correct back to a more neutral tone.

The file format can also affect the colour fidelity of the image. In order to give the customer a large pixel count combined with a large number of images on the compact flash disc, many manufacturers build in aggressive JPEG compression to make the file sizes as small as possible. This high level of JPEG compression can destroy much of the colour information from an image.

Camera-to-camera profile

There is potential for camera producers to add a profile into the processing path of the camera to compensate for variations between cameras, so users with

Table 9.2 Matrix of profile use

Device type	Factors affecting profile (*device will require new profile if changed*)	Effect on original colour data
Digital camera	Scene lighting (brightness /contrast) Colour temperature of illumination White balance in camera	None
Film scanners	Illumination device (light source) Scanning speed/resolution Film type	None
Print scanners	Illumination device Scanning speed/resolution Paper type	None
Monitor	Brightness/controls Warm-up time (colour changes over time) Video driver hardware	Restrictive
Ink jet printers	Ink type Paper type Print speed Resolution Dot pattern	Restrictive
CMYK	Type of printing press Type of inks Paper type	Restrictive

multiple models of the same camera can expect consistent results between them all. The alternative is for the user to profile each camera under a common scene and create profiles, which remove any variation.

Camera to scene

So how can profiles be used with a digital camera (see Table 9.2)? The user must use a camera that either has a colour temperature meter or allows the control of colour temperature. The camera must store the image in an unprocessed file format without compression. The user must control the scene lighting contrast and create a profile under the same lighting conditions that they expect to use to photograph normally.

The equipment needed is a colour test target (usually a Macbeth colour checker) and colour profile-generation software. This process measures only 24 separate colours so provides much less data on which to generate an accurate profile.

Setting up Photoshop's colour profiles

The colour profiling and set-up preferences for Photoshop are found in the file menu:

File > Colour settings > profile set up:

Choose Adobe RGB 1998 if you are using an Apple Macintosh. This provides the widest gamut in terms of colour.

On a PC, choose sRGB – this is the Windows standard setting, and restricts the gamut, but is more compatible with Windows-based machines (Figure 9.17).

Figure 9.17 Profile Setup dialog box on a PC, showing sRGB setting.

The CMYK setting will be determined by the gamut of the final printing press. Unless you intend to print the image it is best to keep the image in the RGB colour space as this negates the need to set CMYK settings.

You will also need to configure the RGB settings:

File > Colour settings > RGB setup:

In this dialog box, the RGB setting is the most important one. The monitor settings and gamma value affect only how the image is viewed on a monitor and not the image itself (Figure 9.18).

Figure 9.18 RGB Setup dialog box on a PC.

Appendix A
Glossary

ADC (analogue to digital converter) Any extra circuitry designed to convert analogue signals into digital data. They can be fitted inside a computer to convert analogue video data into digital data. There are two basic types, a 'frame-grabber', capable of isolating single video frames, or 'video-grabbers', for digitizing video sequences. CCD sensors provide analogue data which needs to be digitized through an ADC.

Addressability Addressability is a measure of the resolution of film recorders, and is the maximum number of pixels that can be recorded across the widest dimension of the film output. Film recorders depart from convention by expressing their resolution in 'K' rather than dots per inch. K refers to the number 1024 (kilo . . .), typical values being 2 K, 4 K and 8 K. For example, a 2 K film recorder will expose 2048 pixels in the 1.5-inch (35 mm) length of 35 mm film.

Advanced Photographic System (APS) A photographic format using 24 mm wide cartridge loaded non-sprocketed film. The system allows for three formats on the same roll of film: C (Classic) format: 3:2 aspect ratio; H (HDTV) format 16:9 aspect ratio; and P (Panoramic) format: 3:1 aspect ratio. A basic idea of the system is to transfer photographic data such as date, exposure, use of flash or daylight and the like to the photofinishing equipment by means of digital data recorded onto a transparent magnetic layer coated onto the back surface of the film base and ix information exchange circuitry. APS is thus a hybrid system, using both analogue photographic and digital technologies.

Algorithm A set of rules (program) by which the computer resolves problems.

Aliasing Refers to displays of bitmapped images, where curved lines appear to be jagged due to the way they are composed of square pixels (sometimes referred to as 'staircasing' or 'jaggies').

Alpha channel An 8-bit greyscale representation of an image often used for storing masking information about an image.

Analogue A signal that simulates sound or vision by electrical analogy, e.g. variations in voltage producing corresponding variations in brightness or vice versa.

Anti-aliasing Filter A low-pass glass filter built into the body of some digital cameras to reduce the effects of aliasing.

Artefacts Extraneous digital information in an image resulting from limitations in the device used to create the image. Examples include noise, aliasing, blooming, colour fringing.

Aspect ratio The relationship between the height and width of a displayed image. For television it is 4:3.

Baud rate A measurement of the speed at which information is transmitted by a modem over a telephone line. Baud rates are in terms of bits per second (bps). Typical speeds are 2400, 9600, 36 600 baud and higher. Strictly speaking, at speeds over 1200 bps the terms baud and bits per second are not completely interchangeable.

Bayer array The name given to the pattern of coloured filters in most CCD sensors.

Binary Numbering system using two digits, 0 and 1. In imaging terms, black or white.

Bit Short for binary digit – a single number having the value either zero or one. Eight bits make up one byte.

Bitmap (1) A binary representation of an image, in which each bit is mapped to a point on the output device, where the point will either be on (black) or off (white). (2) An image formed by a rectangular grid of pixels, each one of which is assigned an address (X,Y coordinates) and a value, either greyscale or colour.

Bits per pixel (bit depth) The number of bits used to represent the colour value of each pixel in a digitized image. One bit per pixel displays two colours, 2 bits four colours, 3 bits eight colours, etc. In general, n bits allows 2^n colours. Twenty-four-bit displays have the potential of displaying 16.7 million colours.

Blooming A problem with older CCDs that causes pixel level distortions when the electrical charge created exceeds the pixel's storage capacity, and spills into adjacent pixels. Newer CCDs incorporate anti-blooming circuitry to drain the excess charge.

Brightness range May refer to the range of brightnesses within a subject being imaged, or the range of brightnesses capable of being captured by an imaging system.

Byte The standard unit of binary data storage in memory or disk files: a byte containing 8 bits can have any value between zero and 255.

CCD (charge-coupled device) A solid-state imaging device containing numerous light-sensitive picture elements (pixels) that produces an electrical output analogous to the amount of light striking each of the elements.

CD-I (Compact Disc Interactive) A version of the CD carrying text, audio and vision for interactive uses.

CD-R A recordable (once only) CD disc. See **WORM**.

CD-ROM A form of compact disc used for storing digital data of all types (e.g. Kodak PhotoCD). They are capable of storing 650 megabytes, but cannot be updated or changed by the user.

CD-RW A re-recordable version of the CD-ROM.

CIE (Commission Internationale de l'Eclairage) An international group set up to produce colour standards – the name given to a colour space model (see **Colour space**).

Clipping Loss of shadow or highlight detail due to the conversion of grey tones lighter than a certain value to white or darker than a certain value to black.

CLUT (Colour Look Up Table) See **LUT**.

CMOS (complementary metal oxide semiconductor) A type of imaging chip increasingly used in some digital cameras.

CMYK (cyan, magenta, yellow and black) The four colours used by printers to produce printed colour illustrations.

ColorSync A colour management system from Apple.

Colour fringing An artefact in CCDs where colour filtering conflicts with information in the subject.

Colour space A three-dimensional space or model where the three attributes of colour, hue, saturation and brightness can be represented, e.g. CIE colour space, Munsell colour space.

Colour trapping A printing term referring to the solution to slight misregistrations in the printing process. If two colours are misregistered, a white line will appear around the object. Trapping is the process of adding extra colour to fill in the gap created. Programs such as Photoshop have trapping capabilities.

CompactFlash card A removable storage card used in digital cameras.

Compression A digital process that allows data to be stored or transmitted using less than the normal number of bits. Video compression refers to techniques that reduce the number of bits required to store or transmit images. Compression can be lossless, lossy or visually lossless. There are several types, of which JPEG, a lossy system, is a widely accepted format for still imaging.

CRT (cathode ray tube) The device which forms the basis of television and computer monitor displays.

Curve A graphical representation of the contrast and colour of an image. Most image-processing programs offer the capability of modifying the image using the 'curves' control. Sometimes referred to as 'gamma curve'.

DCS (1) Digital Camera System The name for Kodak's digital camera range, based on the MegaPixel imager attached to conventional Nikon and other cameras. (2) Desktop Colour Separation: an image file format consisting of four separate CMYK PostScript files at full resolution plus a fifth EPS master for placement in documents.

Digital A signal that represents changes as a series of individual values rather than the infinitely variable analogue signal.

Digitize Convert into digital form. Digitization is subdivided into the processes of sampling the analogue signal at a moment in time, quantizing the sample (allocating it a numerical value) and coding the number in binary form. A digital image is made up of a grid of points. There is no continuous variation of colour or brightness. Each point on the grid has a specific value. Digital images are recorded as data, not as a signal.

Dithering A method for making digitized images appear smoother using alternate colours in a pattern to produce a new perceived colour, e.g. displaying an alternate pattern of black and white pixels produces grey. Has also become widely used as a reference to the process of converting greyscale data to bitmap data, and thus to a reduced grey tone content.

Dot gain The increase in the size of the halftone dot when it is printed onto paper with ink. The effect is caused by the ink spreading into the fibres of the paper.

Dpi (dots per inch) A measure of the resolution of a printer or imagesetter.

Drum scanner A 'high-end' scanning device for transparency, negative or print originals using photomultiplier (PMT) tubes rather than CCDs. Drum scanners usually have a higher dynamic range than flatbed or film scanners, and are capable of higher resolutions, though they are much more expensive.

Dynamic range A measurement of the range of light levels recorded by a CCD or other sensor.

EGA (enhanced graphics adapter) A standard that specifies 640×350 pixels with sixteen-colour capability from a palette of 64 colours.

EPS (Encapsulated PostScript format) Refers to a standardized disk file format used widely in desktop publishing software. It is a file containing PostScript commands, with additional data to enable it to be incorporated into other documents. The main data is 'encapsulated' by these additional commands.

Ethernet A system of networking computers and peripherals together to send data rapidly to each other.

Field Half of a picture, composed either of the odd or even line scans which interlace to form a complete frame.

FIF (fractal image format) An image file format which uses the principles of fractal mathematics for compressing the data.

File formats The format in which an image file is saved. Choosing the correct format for saving images is important to ensure that the files are compatible with various software packages and other computer platforms. Examples are: TIFF, EPS, PICT, BMP.

Filter In digital image processing, a software routine which modifies an image by changing the values of certain pixels. Examples are sharpening, blurring and distortion filters.

FireWire A relatively new system for connecting peripherals such as digital cameras and scanners to computers. It uses a single thin cable to carry data at speeds of up to 25 Mb per second.

FPO (for position only) A low-resolution version of an image used to indicate its placement within a document.

FlashPix An image file format developed by Kodak, Live Picture, Microsoft and Hewlett-Packard. It is a multi-resolution image file format in which the image is stored as a series of independent arrays, each representing the image at a different spatial resolution.

Flatbed scanner A scanner for both reflective and transparency materials, using a linear array CCD.

Floppy disk (or 'diskette') The name given to a 3.5-inch disk used for storing relatively small amounts of computer data. There are two capacities available, double density (storing approximately 700 Kb) and high density (storing approximately 1.4 Mb).

Frame Video data is transmitted as two interlaced fields which make up a frame. In a 50 Hz system a complete frame is transmitted every 1/25th second.

Frame-grabber Hardware that takes the analogue signal from an imaging device and digitizes the signal into RAM.

Gamma The relationship between input data from an electronic image and output data telling the monitor how to display an image.

Gamut The range of colours which can be displayed or printed on a particular imaging system.

GIF (graphics interchange format) An image file format developed in 1987 by CompuServe for compressing 8-bit images with the aim of transmitting them via modems. It defines a protocol for the on-line transmission and interchange of raster graphic data. GIF uses LZW compression but is limited to 256 colours. It is independent of the platform used either in the creation of the file or the display.

GUI (graphical user interface) A computer interface such as the Apple OS 9 or Microsoft Windows 2000, which uses graphical icons to represent computer functions.

Hard disk The term used either for an internal or external rigid disk used for reading and writing computer data. Many different capacities are available, including several types which are encased in plastic, and which can be removed from the drive mechanism (e.g. Zip, Jaz).

Histogram A graphical representation of an image showing the distribution of grey or colours' levels within an image.

HMI (hydrargyrum medium arc iodide) A specialist type of light source which is continuous and flicker free, and is recommended for 'scan-back' digital cameras.

ICC (International Color Consortium) A group of eight computer and digital imaging manufacturers which works to develop cross-platform colour management systems.

ICM Image Colour Management – the colour management system built into Windows-based PCs.

IEEE-1394 High Performance Serial Bus The technical name for the new FireWire interface.

Image processing Techniques that manipulate the pixel values of an image for some particular purpose, e.g. brightness or contrast correction, changing the size (scaling) or shape of images, or enhancing detail.

Imagesetter A high-resolution device producing output on film or photographic paper usually at resolutions greater than 1000 dpi. Usually a PostScript device.

Indexed colour A single-channel image with 8 bits of colour information per pixel. The index is a CLUT containing up to 256 colours. This range of colours can be edited to include those found within the image.

Internet The worldwide network which links computer systems together.

Interpolation A method for increasing the *apparent* resolution of an image whereby the software mathematically averages adjacent pixel densities and places a pixel of that density between the two.

ISDN (Integrated Services Digital Network) A telecommunications standard allowing digital information of all types to be transmitted via telephone lines.

ISO speed The rating applied to photographic emulsions to denote the relative sensitivity to light. The CCDs in digital cameras have 'equivalent' ISO ratings, to enable comparison with film.

IT8 An industry-standard colour reference chart, available as a print or transparency, used to help calibrate scanners and printing devices.

JPEG (Joint Photographic Experts Group) A widely used lossy compression routine used for still photographic images.

Lpi (lines per inch) The scale used by printers when specifying the halftone screen used in a printing process. This book uses a screen with 133 lines per inch.

LUT (Look Up Table) A preset number of colours used by an image (sometimes called CLUT, Colour LUT).

LZW (Lempel–Ziv–Welch) A lossless compression routine incorporated into the TIFF image file format.

MAVICA (Magnetic Video Camera) The name given to the first 'still video' camera, produced by Sony in 1981, but also used today for several models of Sony digital camera.

Modem (MOdulate and DEModulate) A device for converting digital signals into analogue for the purpose of sending data down telephone lines.

MPEG (Motion Picture Experts Group) Like JPEG, a standard compression routine, used for video, audio and animation sequences.

Multimedia The combination of various media, e.g. sound, text, graphics, video, still photography, into an integrated package.

Noise Random, incorrectly read pixel data, or extraneous signal generated by a CCD, even when no light is falling on it. May be caused by electrical interference.

NTSC The TV standard used in the USA and Japan. Has 525 lines/60 fields.

Object-oriented A graphics application, such as Adobe Illustrator, using mathematical points based on vectors to define lines and shapes.

OCR (optical character recognition) Software which, when used in conjunction with a digital scanner, converts pages of typescript text into editable computer data.

Paint A program which defines images in terms of bitmaps rather than vectors.

PAL The TV standard used in the UK and much of Western Europe using 625 lines/50 fields.

Parallel port (often referred to as the 'Centronics port') This port is most often used for connecting computers to printers. Parallel ports have eight parallel wires which send eight bits (1 byte) of information simultaneously, in the same amount of time which it takes the serial port to send one.

PCMCIA card The Personal Computer Memory Card International Association was formed in 1989 to establish worldwide standards for credit-card-sized memory devices. Various types are available including Types I, II and III.

PDF (portable document format) A platform-independent file written in Adobe Acrobat Distiller, which appears the same irrespective of the computer on which it is viewed. It is often used for instruction manuals or on-line journals.

PDL (page description language) A set of instructions which relays to the output device information relating to the placement of images, text and other data (e.g. PostScript).

PhotoCD Kodak's proprietary system of recording film images onto a CD disc. The Master PhotoCD has five versions of each image, whilst the Pro PhotoCD has six.

PICT The name given to Apple's internal binary format for a bitmap image. A PICT image can be directly displayed on a Macintosh screen or printed. The resolution is relatively low, and the images cannot be scaled to another size without loss of detail.

Picture CD A system for transferring images onto a CD-ROM at the time of processing the film. The single-resolution image is saved in JPEG format. It is aimed primarily at the amateur market.

Pixel (picture element) The smallest area capable of resolving detail in a pick-up device or displaying detail on a screen – fixing the maximum horizontal resolution. Conventional TV/video does not have pixels. The image from the CCD in an analogue camcorder is in the form of pixels, but is converted to a continuous video signal.

Pixellation A subjective impairment of the image in which the pixels are large enough to become visible individually.

Platform The type of computer system (e.g. Apple or IBM PC Compatible).

Plug-in A small piece of software often supplied with scanners and other peripherals, allowing the user to access and control those devices through an image-processing software package such as Adobe Photoshop. Many third-party manufacturers (such as Kai's Power Tools and Convolver) market extra filters and other special effects as plug-ins to programs like Photoshop. When installed, the plug-in becomes an item on one of the program's menus.

PMT (photomultiplier tube) A device used in 'high-end' drum scanners. They consist of an evacuated glass tube containing a light sensor (photocathode). Electrons released from the photocathode are multiplied by a process known as secondary emission. An analogue electrical signal is generated, in proportion to the light received. This is converted by an ADC into a digital signal.

PostScript A page description language (PDL) used in laser printers to simulate the operations of printing, including placing and sizing text, drawing and painting, graphics, and preparing halftones from digitized greyscale images. It has become a standard way of 'driving' high-quality printers.

Ppi (pixels per inch) The resolution of a scanner.

RAM (random access memory) Temporary memory created when the computer is switched on. The size of images which can be opened is dependent on how much RAM is installed in the computer.

Raster A series of scanning lines which provide uniform coverage of an area. The number and length of the lines are related to resolution.

Raster graphic A graphic image, created by scanners, digital cameras or 'paint' programs, whose individual components are individual pixels.

Replication A form of image resampling where the exact colours of neighbouring pixels are copied. This should only be used when doubling or quadrupling resolution, i.e. 200, 400, 800 per cent, etc.

Res A term used in place of ppi to define image resolution. Res 12 equals 12 pixels per millimetre.

Resampling Changing the resolution of an image, either by discarding unwanted pixels or interpolating new ones.

Resizing Changing the size of an image without altering the resolution. Increasing the size will lead to a decrease in image quality.

RGB (red, green, blue) The three primary colours used in monitor displays.

RIFF (raster image file format) An image file format for greyscale images. Has the chief advantage of offering significant disk space savings by using data-compression techniques.

RIP (raster image processor) A device which converts a page description language (PDL) such as PostScript into the raster form necessary for output by an imagesetter, film recorder or laser printer.

RISC (reduced instruction set computing) A modern microprocessor chip which works faster than previous versions by processing fewer instructions (found in the Apple Power PC computers, for example).

ROM (read only memory) A memory unit in which the data are stored permanently. The information is read out non-destructively, and no information can be written into memory.

Resolution (brightness) This refers to the number of bits of stored information per pixel. A pixel with 1 bit of information has only two possible values, white or black. A pixel with a bit depth of 8 has a possible 2^8, or 256 values, whilst a pixel with a bit depth of 24 has a possible 2^{24}, or over 16 million possible values.

Resolution (spatial) The ability of a recording system to record and reproduce fine detail. In digital imaging, the resolution of the final image is dependent upon the resolution of the image capture device (camera, scanner, etc.), any change made during image processing by computer, and the resolution of the output device. The term 'image resolution' refers to the number of pixels within an image, and is measured in pixels per inch. An image recorded with a Kodak DCS 660 camera, for example, has 2048×3072 pixels – 6 291 456 pixels in total. Because the number of pixels within an image is fixed, increasing or decreasing the image size (resizing) will alter the resolution. Increasing the size will cause a decrease in the resolution. Image-processing programs like Photoshop have the facility to both resize and resample the image. When looking at the resolution of imaging devices, in particular scanners it is important to distinguish between 'optical resolution', i.e. the actual number of picture elements on the CCD, and higher resolution created by the process of interpolation. A scanner may be advertised as having a resolution of 1200 dpi, where in fact it has an optical resolution of 600 dpi, interpolated to 1200 dpi by the scanning software. Video resolution is given as lines per picture height (e.g. 625 lines). CRT resolutions are usually given as number of pixels per scan line, and the number of scan lines, e.g. 640×480 (NTSC), 768×512 (PAL). Printer resolutions are usually given as dots per inch, e.g. 300 dpi.

Resolving power The ability of an imaging system to record fine detail, usually measured by its ability to maintain separation between close subject elements such as fine lines (usually quoted as 'line pairs per millimetre').

Scan-back A linear (or tri-linear) array CCD placed in the focal plane of a camera, to scan the image projected by a lens and record the image in terms of digital data rather than in analogue form on film.

SCSI (Small Computer Systems Interface) An industry standard for connecting peripheral devices to computers.

Serial port A multi-purpose port for connecting mice, modems and other devices to the computer. The basic principle of the serial port is to have one

line to send data, another to receive data, and several others to regulate the flow of that data.

Signal to noise ratio The relationship between the required electrical signal to the unwanted signals caused by interference (usually measured in decibels: dB).

SmartMedia A type of storage card used to store images from digital cameras.

Soft display The display of images on computer monitors or television screens.

Stochastic screening A new alternative to conventional screening that separates an image into very fine, randomly placed dots as opposed to a grid of geometrically aligned halftone cells.

Sublimation The process by which a solid becomes a gas without first passing through a liquid phase.

SV (still video) An electronic still camera employing a solid-state pick-up device in the focal plane, and recording the analogue signal onto a SV floppy disk (or memory card) for subsequent playback.

Thumbnail A very low-resolution version of an image used for sorting and finding images.

TIFF (tagged image file format) A standardized image file format, recognized by both Macs and PCs. It can use a lossless compression system called LZW.

TGA (Targa) A file format used for saving and transferring 24-bit files on PCs.

TWAIN A cross-platform interface for acquiring images with scanners and frame-grabbers.

Unsharp masking (USM) A procedure for increasing the apparent detail of an image, performed either by the input scanner or by computer processing.

USB (Universal Serial Bus) A new interface for Mac and PC computers for connecting cameras, scanners, printers and other peripheral devices.

VGA (Video-Graphics Array) An electronic display standard that defines a resolution of 640 × 480 pixels with a sixteen-colour capability and 320 × 200 pixels resolution with a 256-colour capability from a potential palette of 256 000 colours.

Vector graphic An image composed of geometric shapes such as curves, arcs and lines rather than the pixel-based bitmap.

Video The analogue electrical signal generated by an image sensor.

Virtual memory A technique for increasing the apparent size of memory available by using memory from the hard disk. It is generally very slow.

WORM (write once, read many times) An optical disk that can only be recorded once with data. This cannot be erased or changed.

WYSIWYG (what you see is what you get) Refers to the relationship between the screen display and final output.

YCC A colour model which is the basis of Kodak's PhotoCD system. Y is the luminance component of the image whilst C and C are the two chroma (colour) channels.

Appendix B
Further reading

This is not intended to be an exhaustive list of books on digital imaging, but more of a list of major references that we have found particularly useful ourselves.

Books
Adams, R. and Weisberg, J. (1998) *The GATF Practical Guide to Colour Management*, GATF Press.
Agfa Ltd: A series of booklets on various aspects of digital imaging, including:
 An Introduction to Digital Scanning
 Digital Colour Pre-Press, ols 1 and 2
 Digital Photo Imaging
 Guide to Digital Photography
 available from: Agfa Pre-press Education Resources, PO Box 200, Stephenson Road, Groundwell, Swindon, Wilts SN2 5AN. Some of the titles are available also on CD-ROM.
Baxes, G. (1994) *Digital Image Processing*, Wiley. A good, easy-to-understand account of the technicalities of image processing. Includes floppy disk with DIP program and test images for PCs.
Cost, F. (1993) *Using PhotoCD for Desktop Prepress*, RITC Research Corporation.
Davies, A. (1997) *The Digital Imaging A – Z*, Focal Press, Oxford. A full glossary of around 1000 imaging terms.
Evening, M. (2001) *Adobe Photoshop 6.0 for Photographers*, Focal Press, Oxford. The best book around for photographers using Photoshop, includes a very readable and understandable chapter on colour management.
Galbraith, R. (1999) *The Digital Photojournalist*, 4th edition. An excellent book for users of Kodak SLR type digital cameras.
Gosney, M. and Dayton, L. (1995) *The Desktop Colour Book*, MIS Press, New York. A good, easy-to-understand introductory guide.
Green, P. (1999) *Understanding Digital Colour*, 2nd edition, Graphic Arts Technical Foundation.
Hunt, R.W. (1995) *The Reproduction of Colour*, 5th edition, Fountain Press. One of the standard textbooks on colour photography and imaging systems
Jackson, R., MacDonald, L. and Freeman, K. (1995) *Computer Generated Colour*, Wiley. A good general introduction to colour on the computer.

McClelland, D. (2000) *The MacWorld Photoshop 5 Bible*, IDG Books, California. Excellent all-round book on technical and creative aspects of Adobe Photoshop.

Training CD-ROMs
A range is produced by VTC Inc. (Web site: www.vtco.com) including:

Adobe Photoshop 5.5
Photoshop 5.5 Techniques
Photoshop Filters
Scanning and PrePress

They are available in the UK from: Marrutt, Bellbrook Industrial Estate, Uckfield, East Sussex, TN22 1QL www.marrutt.co.uk

Appendix C
Useful Internet addresses

There are many thousands of sites containing material relating to digital imaging. This is a selective sample list of various Web sites of interest to those involved with digital imaging. It is not intended to be comprehensive, but merely to provide the reader with starting points for further exploration. Each site will have numerous links to related sites.

Adobe: www.adobe.com
A large site for all Adobe products, including try-out versions of programs (including Photoshop) and latest updates to software. Also, a tips and techniques section for Photoshop users. There are a large number of other Photoshop sites, some of which are listed below.

To obtain copies of **Image 1.6 and Scion Image** from the Internet, use the following addresses:

The NIH (National Institute of Health) Image home page is:
http://rsb.info.nih.gov/NIH-IMAGE/Default.html

This site includes manuals, tutorials and sample images which can be downloaded. Also, various pre-written macros and plug-ins for use with Image. There is an active user group who can be contacted through the site as well. The various Macintosh versions can be downloaded from:
http://rsb.info.nih.gov/NIH-IMAGE/download.html

The PC version, called Scion Image, can be downloaded from the Scion Corporation, whose site also contains useful information generally on scientific imaging. Their home page is:
http://www.scioncorp.com/ http://www.scioncorp.com/

The program can be downloaded from:
http://www.scioncorp.com/frames/fr_download_now.htm

Kodak: www.kodak.com
A huge Web site with much useful information on all aspects of digital imaging, including a Digital Learning Centre containing tutorials on various aspects of digital imaging. Also, download site for plug-ins for PhotoCD, digital cameras, etc.

Microsoft: www.microsoft.com
Apple: www.apple.com

Other imaging companies
Agfa: www.agfa.com
Epson: www.epson.com
Fuji: www.fujifilm.com

Digital cameras:
Nikon: www.nikon.co.uk
Leaf: www.scitex.com/leaf/products.html
Sinar: www.sinarbron.com/library.htm
PhaseOne: www.phaseone.com
MegaVision: www.mega-vision.com

For full details, and a 'try-out' copy of the Quantum Mechanics plug-in for digital cameras:
Camerabits: www.camerabits.com

Other sites of interest
Rob Galbraith: www.robgalbraith.com
Canadian photojournalist with a wealth of information on how to enhance images from digital cameras. His excellent book can be found in the book list. The site is full of up-to-date information and links to other good sites. A 'must' for all digital photographers!

For a good site comparing different digital cameras, as well as a host of other information:
http://photo.askey.net/

Photoshop sites
Photoshop 'Tip of the Week' site – some excellent techniques:
http://photoshoptips.i-us.com/photoshop4.htm

Compendium of Photoshop sites:
www.ultimate-photoshop.com

Royalty-free images
PhotoDisc: www.photodisc.com
DigitalVision: www.digitalvision.ltd.uk
Corel Professional Photos: www.cmm1.com/photos/receptn.html

Photographers with interesting sites
Steve Bloom: www.stevebloom.com
Martin Evening: www.evening.demon.co.uk/
Hannah Gal: www.cix.co.uk/~gal/

Other useful digital imaging sites
http://www.epicentre.co.uk/
This site is run by John Henshall, one of the UK's leading digital imaging experts, and contains a wealth of information about imaging technology and new products.

www.cyberramp.net/~fulton/basics1a.html
A site with some useful tips on scanning techniques.

http://www.best.com/~cgd/home/photolinks.htm
A 'links site' by Charles Daney with links to a multitude of photography and digital imaging sites.

Iterated systems
Good technical information and examples of fractally compressed images:
www.iterated.com/science/

Training
An excellent and comprehensive site with many tutorials on all aspects of digital imaging:
www.shortcourses.com

For a full range of books on all aspects of digital imaging:
Focal Press: www.focalpress.com

Colour
A wealth of information, including tutorials on ColorSync is available from:
www.colorsync.apple.com

Another site with a great deal of technical information on colour management:
International Color Consortium (ICC): www.color.org

Shareware sites
There are many sites on the Web where shareware and public domain programs can be downloaded. Useful programs include simple image editors, file converters and progams to animate GIF files for inclusion in Web sites. Two of the largest are:
www.rocketdownload.com
www.jumbo.com

There are numerous discussion groups on the Web concerning digital photography. One of the best is the ProDIG group:
http://image.merseyworld.com/prodig

Index

 Focal Press

www.focalpress.com

Join Focal Press on-line

As a member you will enjoy the following benefits:

- an email bulletin with **information on new books**
- a regular **Focal Press Newsletter**:
 - o featuring a selection of new titles
 - o keeps you informed of **special offers, discounts and freebies**
 - o alerts you to **Focal Press news and events** such as author signings and seminars
- complete access to **free content** and reference material on the focalpress site, such as the focalXtra articles and commentary from our authors
- a **Sneak Preview** of selected titles (sample chapters) *before* they publish
- a chance to have your say on our **discussion boards** and **review books** for other Focal readers

Focal Club Members are invited to give us feedback on our products and services. Email: worldmarketing@focalpress.com – we want to hear your views!

Membership is FREE. To join, visit our website and register. If you require any further information regarding the on-line club please contact:

> Emma Hales, Marketing Manager
> Email: emma.hales@repp.co.uk
> Tel: +44 (0) 1865 314556
> Fax: +44 (0)1865 315472
> Address: Focal Press, Linacre House,
> Jordan Hill, Oxford, UK, OX2 8DP

Catalogue

For information on all Focal Press titles, our full catalogue is available online at www.focalpress.com and all titles can be purchased here via secure online ordering, or contact us for a free printed version:

USA
Email: christine.degon@bhusa.com

Europe and rest of world
Email: jo.coleman@repp.co.uk
Tel: +44 (0)1865 314220

Potential authors

If you have an idea for a book, please get in touch:

USA
Lilly Roberts, Editorial Assistant
Email: lilly.roberts@bhusa.com
Tel: +1 781 904 2639
Fax: +1 781 904 2640

Europe and rest of world
Christina Donaldson, Editorial Assistant
Email: christina.donaldson@repp.co.uk
Tel: +44 (0)1865 314027
Fax: +44 (0)1865 314572